TOKYO
CLASH JAPANESE POP CULTURE

TOKYO
CLASH JAPANESE POP CULTURE

RALF BÄHREN

h.f.ullmann

目次 | *Table of contents* | *Inhalt*

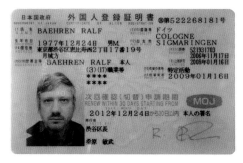

Certificate of Alien Registration

How does it feel to ride a crowded Tokyo train in the morning?..to be lost in the super-market, trying to decipher its dazzling array of choices?.. to walk bustling streets, exposed to sensory stimulation beyond anything you have ever experienced? There is no way to describe it. Words and pictures can only scratch the surface.

Seeing has to be learned entirely anew. Thousands of visual messages—stripped of any verbal content—rain down on us from every direction, and one is constantly busy trying to decipher them. Your brain will try to make sense of things you have never encountered before.

Wie fühlt man sich in einem überfüllten Pendlerzug morgens in Tokio? ... im Supermarkt, während man versucht, das grelle Angebot zu entziffern? ... inmitten lebendiger Straßenschluchten mit ungeahnten, überwältigenden Sinneseindrücken? Es ist schlichtweg unbeschreiblich. Wörter, selbst Fotos, kratzen gerade einmal an der Oberfläche.

Das Sehen will komplett neu gelernt werden. Tausende visuelle Botschaften prasseln – ihres sprachlichen Sinns entledigt – von allen Seiten auf uns ein, und man ist unaufhaltsam damit beschäftigt, sie zu entziffern. Das Gehirn versucht, einen Sinn aus Dingen zu konstruieren, denen man noch nie im Leben begegnet ist.

朝の通勤ラッシュ時、トウキョウの電車に乗るのはどんな気分だろう？ スーパーマーケットの色鮮やかな選択肢を解読しようと試みながら、迷子になるのはどんな気分だろう？ これまでの人生で味わったことがないほどのインパクトに満ちた、活気溢れる通りを歩くのはどんな気分だろう？ その気分を正確に表現する方法などない。言葉と写真が伝えられるのはその表層にすぎない。

「見る」という感覚について、もう一度考え直してみることが必要かもしれない。言語による浸食のない世界で、視線は右往左往を繰り返し、幾千ものビジュアルメッセージを解読しようとする。前例のない風景を理解しようと頭の中はフル回転を始める。

Of course, the global media keeps us up to date with all manner of Japanese curiosities, and much of Japanese culture has long found its way into the international mainstream, but these examples remain only peepholes into a distant world.

Up close, this world reveals itself as a paradise of marvel. We seem to be visitors from another planet, and yet we stumble upon familiar things. We rediscover our own culture, adopted and twisted around. While it may be impossible for a foreigner to ever grasp Japanese culture entirely, that's all the more reason to admire it. Astonishing, awful, adorable, and absurd, it is an endless source of inspiration for the playful mind.

Tokyo provides us with a unique post-modern reference to the global cultural mix. Its multitude of parallel cultures and styles blurs the boundaries between colorful chaos and retained tradition. It is a culture of NOW, an immediate presence that often lasts only the blink of an eye, changing faces as you advance, with yesterday and tomorrow somehow condensed into the moment.

This book is an interpretation. It is a respectful bow, as well as an invitation to a place which you have to experience yourself to fully grasp it.

Ralf Bähren

Die Medien halten uns zwar mit allerlei japanischen Kuriositäten auf dem Laufenden, und viele Elemente der japanischen Kultur gehören längst zum internationalen Mainstream, aber sie sind bestenfalls Versatzstücke eines fernen Universums.

Aus der Nähe entpuppt sich dieses Universum als ein Paradies des Staunens. Man fühlt sich wie ein Besucher von einem anderen Stern und stolpert dennoch über Vertrautes, entdeckt seine eigene Kultur, verdreht und den japanischen Verhältnissen angepasst. Als Fremder die japanische Kultur jemals völlig zu durchdringen ist unmöglich, umso mehr lässt sie sich bewundern. Anders, abstoßend, anziehend und absurd zugleich, ist sie eine unerschöpfliche Quelle für den spielerischen Geist.

Tokio ist eine einmalige postmoderne Referenz für die globale Vermischung der Kulturen. Die Vielzahl an parallelen Strömungen und Stilen verwischt die Grenzen zwischen kunterbuntem Chaos und überlieferter Tradition. Es herrscht eine Kultur der unmittelbaren Gegenwart, des Augenblicks, der sich bereits im Vorbeigehen wieder verändert und dennoch die Vergangenheit und Zukunft auf seltsame Weise beinhaltet.

Dieses Buch ist eine Interpretation. Es ist sowohl eine respektvolle Verbeugung als auch eine Einladung an einen Ort, den man selbst erleben sollte, um ihn wirklich zu begreifen.

Ralf Bähren

言うまでもなく、グローバルメディアは日本の風習に時として好奇の目を向け、日本文化は過去に幾度となく世界へ向けて紹介されてきた。しかし、これらで取り上げられる日本の側面は、遠い世界を小さな覗き穴から見ているにすぎない。

近づいてみると、この国はまさに不思議に満ちたパラダイスだ。我々はまるで他の惑星からやって来た観光客のようでありながら、そこかしこで見慣れたモノに遭遇する。我々はここで、日本向けにアレンジされ適応化された自分たちの文化を再発見する。外国人が本当の意味で日本の文化を理解することはできないのかもしれない。だけれども、この文化に感服する方法は無数にあるはずだ。そこには遊び心をくすぐる高度な驚きがあり、不快さがあり、かわいさがあり、不条理さがある。

トウキョウはグローバルカルチャーの衝突によってもたらされるポストモダンのユニークな未来絵図だ。受け継がれてきた伝統と色鮮やかなカオスの間にあるはずの境界線は、パラレルカルチャーとスタイルの大衆化によってひどく曖昧なものになる。それは「今、現在」というカルチャーであり、まばたきをする間に何か他のものに置き換えられ、視界を変化させ続ける。刹那そのものに、過去と未来が凝縮されている。

本書は一つの解釈にすぎない。これは敬意を示すためのお辞儀であると同時に、招待状でもある。信じるためには体験してみるしかないのだから。

ラルフ・ベーレン

トウキョウ

Tokyo | Tokio

"Megalopolis" is the only characterization that doesn't understate the sheer dimensions of the urban agglomeration around Tokyo. The 35-million metropolitan region surrouding the capital is not merely a city—it is dozens of them, coalescing into a single, never-ending concrete horizon, with the only reminder of its former natural surroundings being the occasional glimpse of holy Mount Fuji beyond hazy skies. Toyko's center is equally scattered with a multitude of giant hubs emerging around the ceaselessly pumping railway arteries, every single one competing for the massive economical potential that arrives with the millions of passengers.

Surprisingly, leaving the major trails quickly leads into tiny and quiet residential neighborhoods, with two-story buildings even in the central heart of Tokyo. The contrast between the two worlds couldn't be stronger, the one often just a block or two away from the other. Having found a peaceful spot around one of the thousand little shrines within the city, only the helicopters remind you of being in one of the fastest, fullest, craziest, and most colorful places on this planet. Get ready for the ride of your life.

„Megalopolis" ist die einzige Umschreibung, die die schiere Größe der urbanen Ansammlung rund um Tokio nicht untertreibt. Die Metropolregion, die mit ihren 35 Millionen Einwohnern die japanische Hauptstadt umfasst, ist keine Stadt – es sind Dutzende, die zu einem nicht enden wollenden Beton-Horizont verschmelzen. Der einzige Hinweis auf ihre ursprünglich natürliche Umgebung ist der gelegentliche Blick auf den heiligen Fuji weit hinter den Nebelschwaden. Selbst das Zentrum Tokios ist in eine ganze Reihe von riesigen Subzentren zerstückelt, die sich rund um die ununterbrochen pumpenden Bahn-Arterien abzeichnen. Sie alle wollen von dem gewaltigen wirtschaftlichen Potenzial der millionenfach einströmenden Pendler profitieren.

Überraschenderweise landet man schnell in kleinen, ruhigeren Vierteln, sobald man die Hauptverkehrsadern verlässt – und das selbst im zentralen Tokio. Der Kontrast zwischen den Welten könnte größer nicht sein, manchmal sind sie nur ein bis zwei Blocks voneinander entfernt. Hat man ein lauschiges Plätzchen an einem der tausend kleinen Tempel gefunden, dann erinnern nur noch die Hubschrauber daran, dass man an einem der schnellsten, vollsten, durchgeknalltesten und farbenfrohesten Flecken auf dem ganzen Planeten gelandet ist. Auf ins Abenteuer deines Lebens.

「メガロポリス」以外の言葉で表すには、トウキョウという街のスケールはあまりにも巨大すぎる。3500万人が暮らす首都圏都心部は、トウキョウという一つの街ではない。果てしなく続くコンクリートの地平線上にたたずむ複数の街の集合体を便宜的にトウキョウと呼んでいるにすぎない。くすんだ空の彼方に見え隠れする富士山の神聖さだけが、かつてはここにも自然があった、という事実を証明している。トウキョウに中心部という概念はなく、個々の街はそれぞれの中心であり、動脈のように張り巡らされた休むことのない線路によってつながっている。それぞれに独立した商圏を持つ100万単位の経済競争は、とどまるところを知らない。

驚くべきことに大通りから一歩離れると、たとえ都心部であっても、二階建ての小さな住宅が並ぶ閑静な住宅街が姿を現す。目と鼻の先にあるこの二つの表情の豹変ぶりは、この上なく極端だ。街中の至る所に点在する1000以上はあるであろう小さな神社の一つに足を踏み入れると、空から響くヘリコプター音以外に、この場所が今この星で最もスピーディーで、最も成熟し、カラフルでクレージーな街であることを思い出させる要素は何一つない。

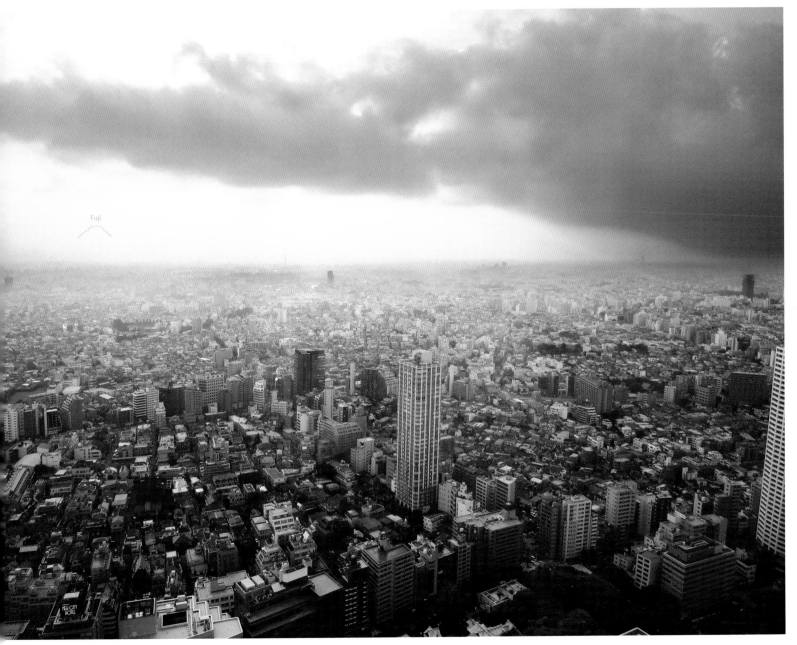

Fuji

センター

se n ta

Center | Zentrum

As soon as you manage to be washed out of one of the major train stations such as Shibuya or Shinjuku, the full impact of an overabundance of sensory stimulations pelts down on you. The shrill, colorful facades seem to lean towards you, while the latest economical opportunities are delivered through giant screens, loud-speakers, and blinking neon signs in indecipherable writing. As if that wasn't enough, the crowd keeps pushing forward towards the giant intersections that, like big hearts with traffic light vents, empty and fill the surrounding streets with pulsing motion. The biggest crossings have what you could call an "all-walk pedestrian scramble" where all traffic is stopped, and during peak times more than 15,000 people can cross in a single phase.

Kaum hat man es geschafft, sich aus einer der großen Bahnstationen wie Shibuya oder Shinjuku freizuschwimmen, trifft einen die Reizüberflutung mit voller Wucht. Die grellbunten Fassaden beugen sich förmlich vornüber und präsentieren die neuesten Angebote über Lautsprecher, riesige Bildschirme und unleserlich blinkende Neonschilder. Hat man sich gerade daran gewöhnt, wird man von den nachströmenden Massen direkt auf die nächste Kreuzung geschoben. Wie pumpende Herzklappen verteilen die Ampeln den Strom auf die umliegenden Straßen. Die größten der vierarmigen Kreuzungen gehorchen dabei dem Alle-drängeln-sich-irgendwie-durch-Prinzip: Der Verkehr wird angehalten, und die Fußgänger kreuzen die Straße in allen Richtungen. In Stoßzeiten quetschen sich so bis zu 15 000 Menschen durch eine einzige Ampelphase.

渋谷駅や新宿駅といった主要駅から押し流されるように外へ出た瞬間に感じるインパクトは壮絶だ。瞬きを続けるビル群が視界を占拠し、誰かが仕掛けたヒット商品予備軍たちが巨大なスクリーンに映し出される。大音量で歌い続けるスピーカー、光り輝くネオンによって描き出される解読不能のメッセージ。それだけではない。巨大な交差点へ向かって足を進める人の群れは辺り一面を埋め尽くし、そこにたまっていく人々の固まりは青信号の合図により、心臓の動きに合わせて血が流れるごとく、堰を切ったように交差点の中心に向かって吐き出されていく。巨大なスクランブル交差点ではすべてのトラフィックの流れが止まり、人が一斉に歩き始める。ピーク時にはたった一度の信号の切り替えで1万5000人以上もの人間が交差点の海を渡るという。

Shinjuku station towards Kabukicho | Shinjuku Bahnhof Richtung Kabukicho | 新宿駅から歌舞伎町へ向かって ▶

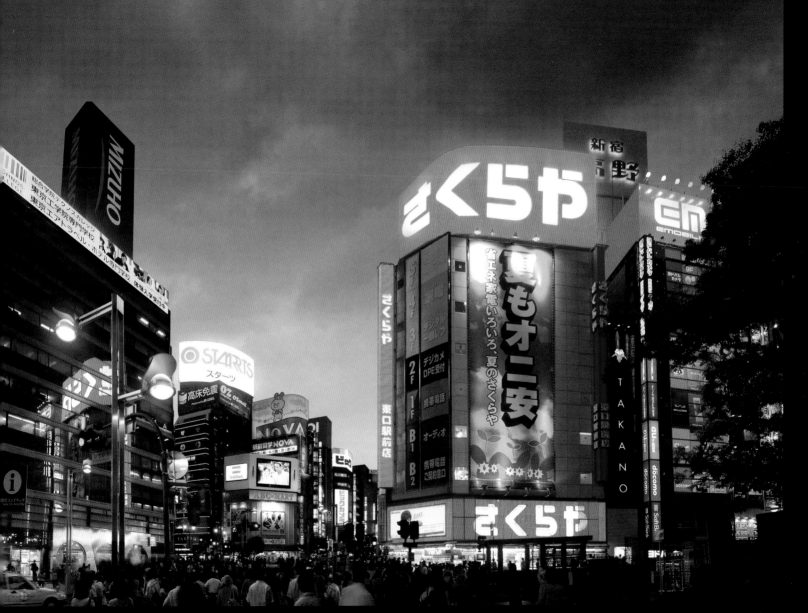

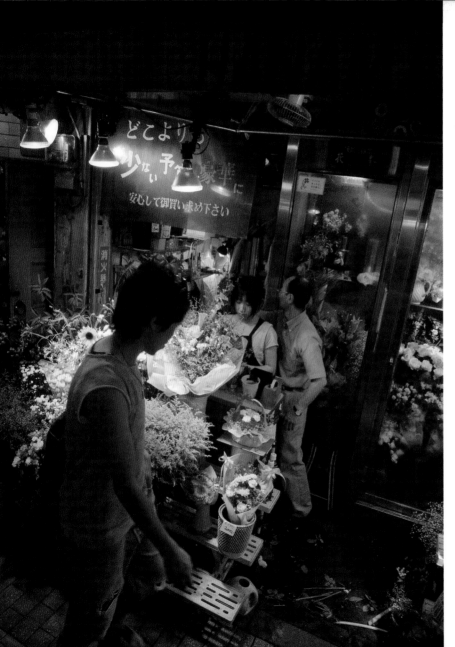

<ruby>は<rt>ha</rt></ruby><ruby>な<rt>na</rt></ruby>

Flowers | Blumen

Tokyo is a grey, contourless concrete mass
if you take a look out of the window. Massive,
earthquake-proof buildings cover up almost
all the finer, flourishing details that make up
its lively spirit. You have to walk the streets
to enjoy its colorful bouquet, popping up here
and there amid the grey.

Durchs Fenster wirkt Tokio wie eine graue Be-
tonwüste: Massiv gebaute, erdbebensichere Ge-
bäude versperren den Blick auf die bunten und
spielerischen Details der pulsierenden Stadt.
Erst wenn man anfängt durch die Straßen zu
spazieren, nimmt man das blühende, zwischen
all den dicken Mauern sprießende Treiben wahr.

窓から見下ろすトウキョウは灰色のコンクリートで出
来たノッペラボウの集合体だ。この街の繊細さを、
その表情の多様さを、巨大な耐震ビル群から想像す
るのは難しい。その色彩が描き出す世界は、競うよ
うにそびえたつ壁と壁の隙間に確かに息づく人々の
生活にふれて初めて理解できるだろう。

◄ Flower shop (Kabukicho) | Blumenladen | 花屋 (歌舞伎町)

Flowers near a waste-burning plant (Ebisu) | Pflanzen vor ►
einer Müllverbrennungsanlage | ゴミ焼却場付近の花屋 (恵比寿)

セーフティー

Safety | *Sicherheit*

There is always a lot to fix in the earthquake-ridden metropolis. The city's construction crews politely make sure that nobody falls into one of their holes, apologizing for disruptions with such joyful designs that they make you want to join their party.

Die ständig von Erdbeben durchgeschüttelte Metropole wird ununterbrochen instand gesetzt. Die jeweiligen Bautrupps stellen dabei höflich sicher, dass niemand in eines ihrer Löcher fällt. Und die bunten Bildchen entschuldigen die Störung so nett, dass man am liebsten mithelfen würde.

地震の恐怖と常に背中合わせにある首都トウキョウ。修復工事は終わることを知らない。工事現場で働く人たちは通行人が誤って入って来ないよう礼儀正しく注意を促し、迷惑と知りながらも作業をしていることについて詫び、友好的な雰囲気を醸し出す看板を掲げる。その迷惑の代償として、工事を手伝いたくなるほどかわいらしいキャラクターが道案内。

◀ Construction site (Ueno) | Baustelle | 工事現場 (上野付近)

Safety barrier (Nakameguro) | Sicherheitszaun ▶
立ち入り禁止区域 (中目黒)

Among a wide range of idealised styles, "cute" is definitely one of the most prominent. Cultivating that innocent, huggable, babyface tenderness seems to offer the ultimate refuge from harsh worklife reality.

Kawaii – die allumfassende Verniedlichung – ist definitiv Spitzenreiter der vielen verschiedenen Stilkonzepte Japans. Als willkommener Kontrast zur rationalisierten Arbeits- und Sozialkultur bietet die unschuldig knuddelige Weichspüler-Romantik die perfekte Zuflucht.

お気に入りのスタイルは十人十色。だけど日本では「かわいさ」がとっても大事。厳しい現実の中で、純粋無垢で思わず守ってあげたくなるようなキュートさを誰もが求めてる。きっとそれは厳しいワークライフからの現実逃避。

ka wa i i
かわいい

Cute | Niedlich

◀ Photo girls (Odaiba) | Fotogirls | プリクラ (お台場)

Dog in a bank (Ebisu) | Hündchen in einer Bank ▶
銀行を訪問中のお犬様 (恵比寿)

SUNLEO
ドラえもんの黄金ブロンズA
DR-5A
税込 ¥8,400

¥1,575

Cute does not only apply to living beings, but even more to inanimate objects. Whether you are looking for a really sweet gift or just a model to tune up your fantasies—a good dose of sweetener will turn even the cheapest plastic trophy into gold.

Niedlichkeit lässt sich nicht nur auf lebendige, sondern noch besser auf unbelebte Objekte anwenden. Ob man auf der Suche nach einem echt netten Geschenk ist oder einfach nur seine Fantasie anregen will – mit reichlich Süßstoff wird selbst das billigste Plastik zur goldenen Trophäe.

「かわいい」は生き物だけでなく、無生物にもしっくりくる言葉。気の利いたプレゼントを探すときも、幻想を満たしてくれる模型を探すときも、たっぷりと甘味料を加えれば、ちゃちなトロフィーだって黄金の輝きを放ち出す。

▲ Harmless cute alien (Tokyo toy fair) │ Niedlicher, völlig harmloser Alien │ 人畜無害のキュートな宇宙人（トウキョウトイフェア）

◀ Doraemon trophy │ Doraemon-Pokal │ ドラえもんトロフィー

◀◀ Hello Kitty Mouse & Mousepad │ ハローキティマウス／マウスパッド

The softest building in Tokyo │ Das kuscheligste Gebäude Tokios ▶
東京で最も柔らかいビル

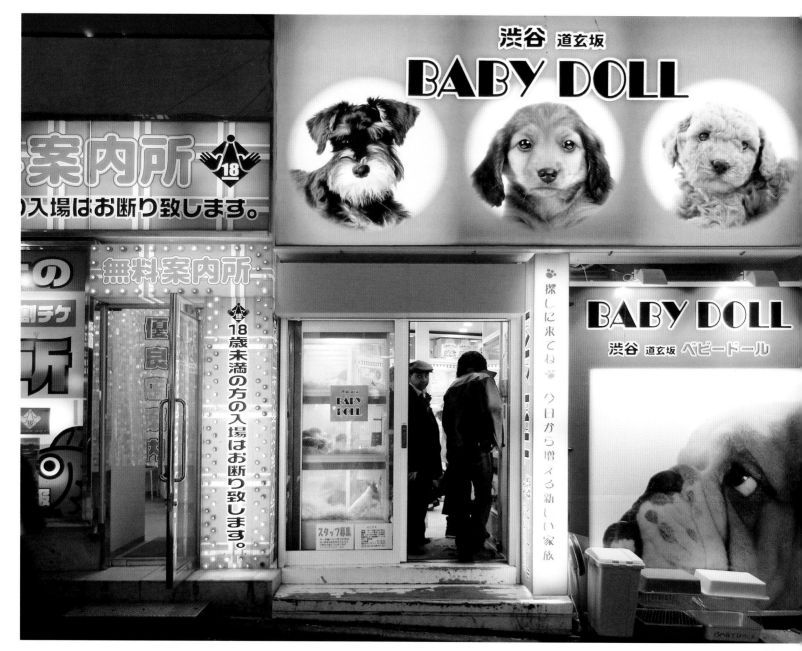

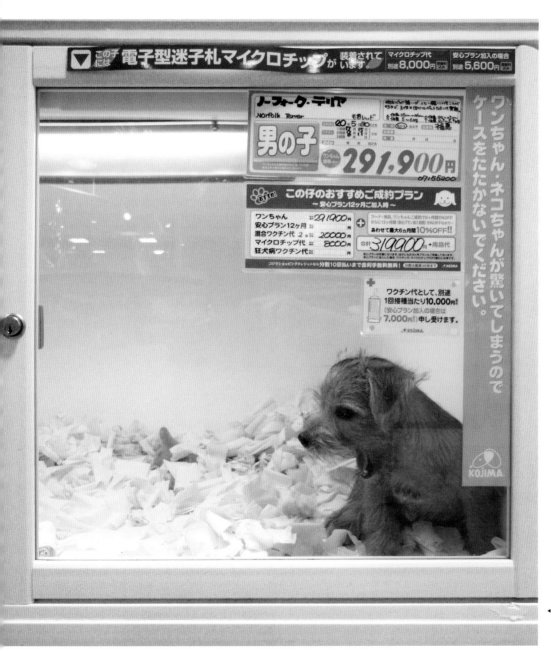

If the name doesn't sell, the content will. These cute inhabitants will instantly hook you with their tiny snub noses, whining looks, and clumsy paws, and just might make you want to spend the price of your next laptop on one of these yawning creatures: Rescue me!

Wenn dich hier weder Name noch Schild überzeugen, dann der Inhalt: herzerweichende Bewohner, die dich mit Näschen, Pfötchen und Hundeblick davon überzeugen, den Preis deines neuen Laptops besser in eins dieser gähnenden, knuffigen Geschöpfe zu investieren: Holt mich hier raus!

名前で売れないならば内容で勝負。小さな団子鼻、ふくよかな肉球。あくびをしている姿なんて目撃しようものなら、次のノートパソコン用に貯金していたお金のすべてを注ぎこんででも彼らを手に入れてしまうかも。「助けて！」って言っているように見えませんか？

pe　to　sh(i)　yo　pu

ペット ショップ

Petshop | Tierhandlung

◀ Puppy in a pet shop box (Odaiba) | Welpe in einer Tierhandlung | ペットショップの箱入りワンコ (お台場)

◀◀ Pet shop (Shibuya) | Tierhandlung | ペットショップ (渋谷)

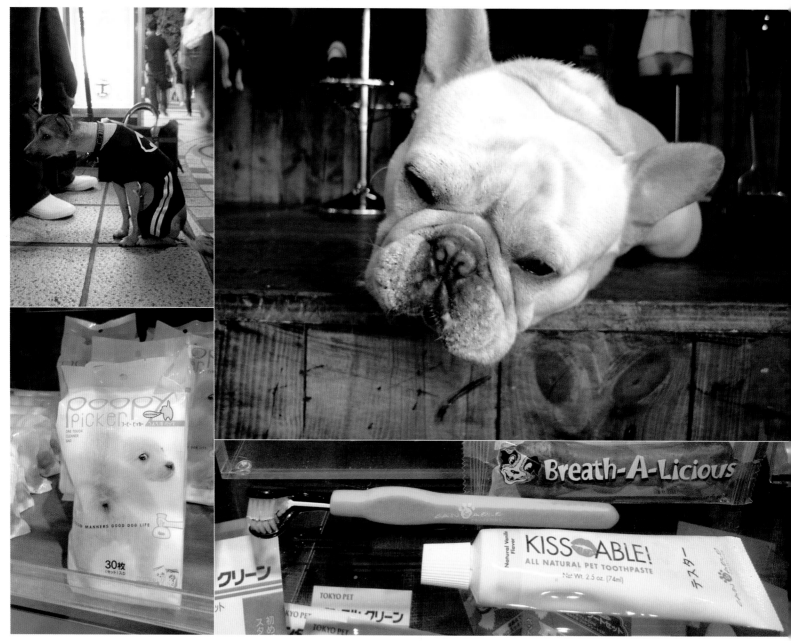

<ruby>ペ<rt>pe</rt></ruby><ruby>ット<rt>to</rt></ruby>

Pets | Haustiere

Indeed: dogs are huggable creatures. As most japanese breeds are quite tiny, they fit in just everywhere that a small baby usually would. And thanks to equal devotion and care, there is a whole market to fulfill the demand. There are even pet diapers.

Zugegeben: Hunde sind niedliche Tiere. Und da fast alle japanischen Rassen so schön klein sind, passen sie perfekt überall dorthin, wo man eigentlich ein Baby erwarten würde. Und weil die Hingabe, Liebe und Nachfrage mindestens genauso groß sind, gibt's den passenden Markt gleich dazu. Von Anzug bis Zahnbürste.

確かにそうだ。犬を見ると、ぎゅっとしたくなる。日本の犬の多くは小型犬で、赤ちゃんが入れるくらいの場所があれば十分。日本で飼われる犬のほとんどは小型犬で、赤ん坊と同じくらいのスペースしか必要としない。そしてペットオーナーの献身的な愛情とケアは多様なペット産業を生み出した。ペット用の紙おむつだって簡単に入手できる。

Dog spa & coiffeur (Roppongi) | Hunde-Spa ▲
&Coiffeur | 犬用ホテル／スパ／美容室 (六本木)

Dog drink | Hundegetränk | 犬用ドリンク ▶▶

◀◀ Pickup bags | Häufchentüten | 落とし物袋

◀ Toothbrush & toothpaste | Zahnbürste und
-pasta | 歯ブラシと歯磨き剤

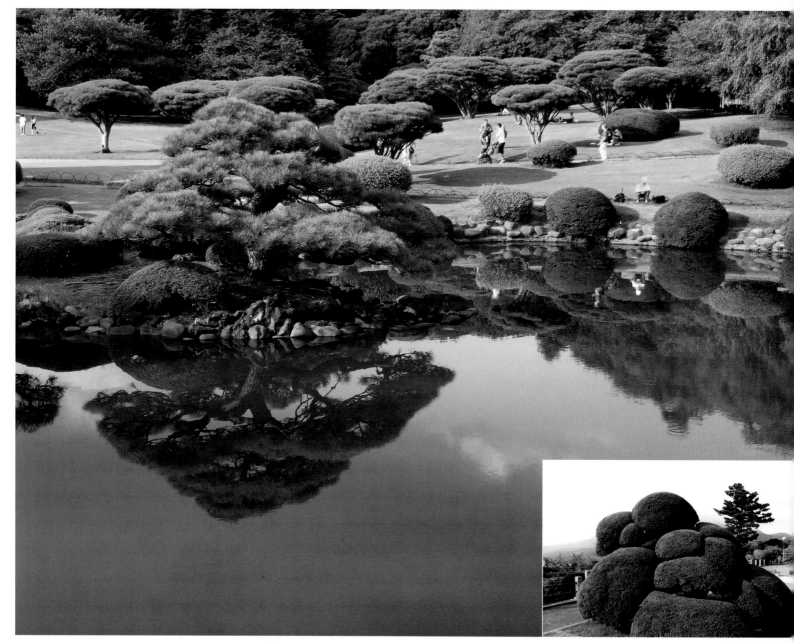

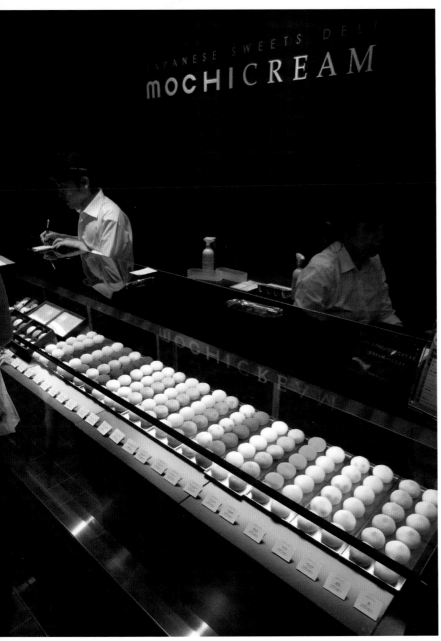

ラウンド

Round | Rund

Round, chubby and cozy. That is what it must be like in paradise. The ubiquity of these sweet little balls can't be just chance in a country where friendliness is a nationwide imperative. Hey let's play nice, ok? Look, I brought some sweets, too!

Rund, mollig und gemütlich, fast wie im Paradies. Im Land der unbegrenzten Freund-lichkeiten gewinnt man den Eindruck, dass diese wohlgeformten Bällchen nicht einfach nur zufällig überall herumkugeln. Seid nett zueinander! Esst Süßigkeiten!

角がなく、やわらかくて安らげる。楽園はそんな場所に違いない。フレンドリーさが国民行事であるこの国の風景がすべて丸く収められているのは決して偶然ではない。まぁまぁ、楽しくやりましょうよ。お菓子も持ってきましたし。

◀ *Mochi* (Japanese rice cake), filled with ice cream
Mit Eiscreme gefüllte *Mochi* (japanische Reisküchlein) ｜ モチクリーム

◀◀ The tea house view in Shinjuku Gyoen
Ausblick vom Teehaus im Shinjuku Gyoen ｜ 新宿御苑

◀◀ Tree sculpture (Hakone) ｜ Baumskulptur
植木アート (箱根近辺)

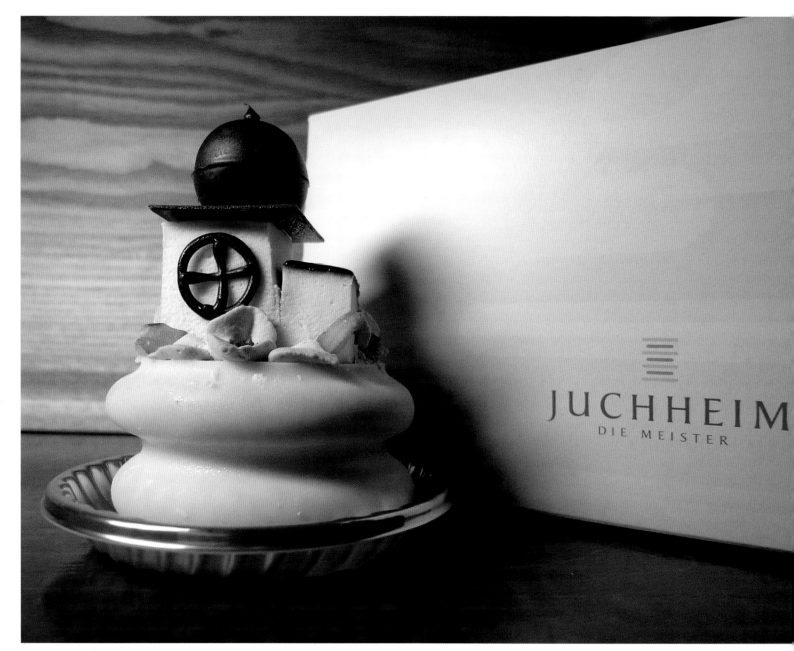

ケーキ
ke ki

Cake | Küchlein

Tokyo has presumably the greatest variety of sweet cakes on the whole planet. And most of them are destined to serve as gifts demonstrating the utmost respect, which explains the ingenuity and excellence with which some of them are crafted. This is not mere cake—it's a personal homage to its recipient.

Tokio hat die wohl weltgrößte Auswahl an Zuckergebäck. Der Großteil dient als Respekt bezeugendes Mitbringsel, was die Qualität und den ausufernden Einfallsreichtum erklärt, mit dem viele der Törtchen gestaltet sind. Solch persönliche Würdigung ist eigentlich fast zu schade zum Essen.

この星のどこを探しても、トウキョウほどケーキの種類が豊富な街はないだろう。ケーキが歓迎される贈り物ランキングの上位に君臨し続ける理由、それは創造性に裏付けられたケーキ職人たちの卓越した技にある。写真のケーキはどこにでもあるケーキではなく、このケーキを受け取る人へ向けたパーソナルオマージュ。

◄ Romantic church cake │ „Kirch-Kuchen" │ ロマンチックな教会形ケーキ

German pastry shop Juchheim (Shibuya) │ Deutsche Konditorei ►
Juchheim │ ドイツ菓子の老舗「ユーハイム」(渋谷)

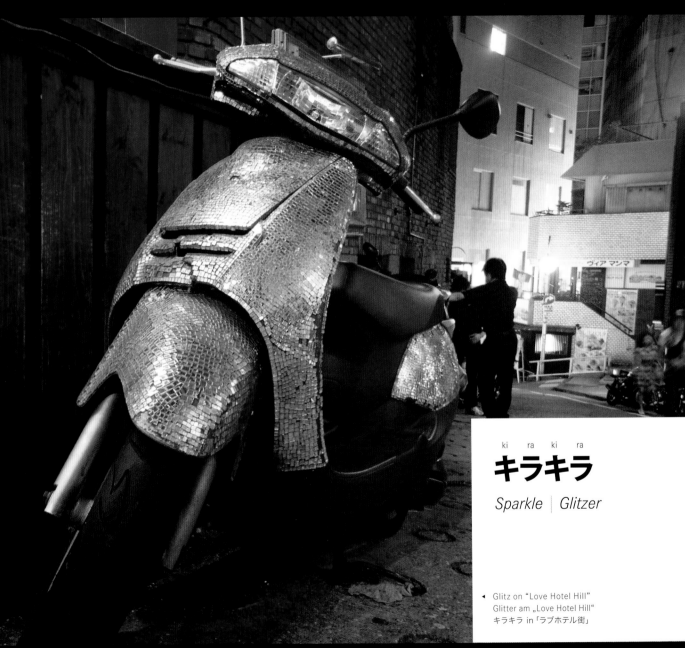

ra ki ra

キラキラ

Sparkle | *Glitzer*

◂ Glitz on "Love Hotel Hill"
Glitter am „Love Hotel Hill"
キラキラ in「ラブホテル街」

28

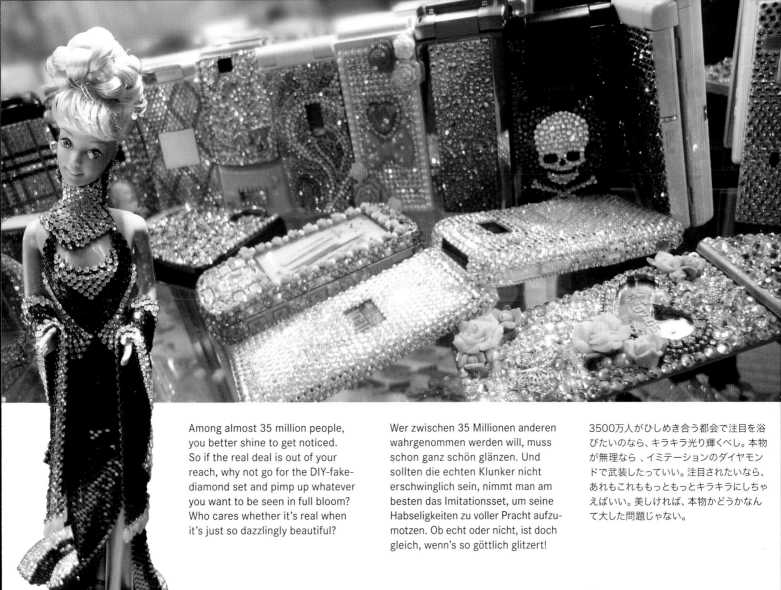

Among almost 35 million people, you better shine to get noticed. So if the real deal is out of your reach, why not go for the DIY-fake-diamond set and pimp up whatever you want to be seen in full bloom? Who cares whether it's real when it's just so dazzlingly beautiful?

Wer zwischen 35 Millionen anderen wahrgenommen werden will, muss schon ganz schön glänzen. Und sollten die echten Klunker nicht erschwinglich sein, nimmt man am besten das Imitationsset, um seine Habseligkeiten zu voller Pracht aufzu-motzen. Ob echt oder nicht, ist doch gleich, wenn's so göttlich glitzert!

3500万人がひしめき合う都会で注目を浴びたいのなら、キラキラ光り輝くべし。本物が無理なら 、イミテーションのダイヤモンドで武装したっていい。注目されたいなら、あれもこれももっともっとキラキラにしちゃえばいい。美しければ、本物かどうかなんて大した問題じゃない。

Posh Barbie doll | Aufgetakelte Barbie | キャバ嬢風バービー人形

Pimp your mobile! | 携帯だってもれなくキラキラ

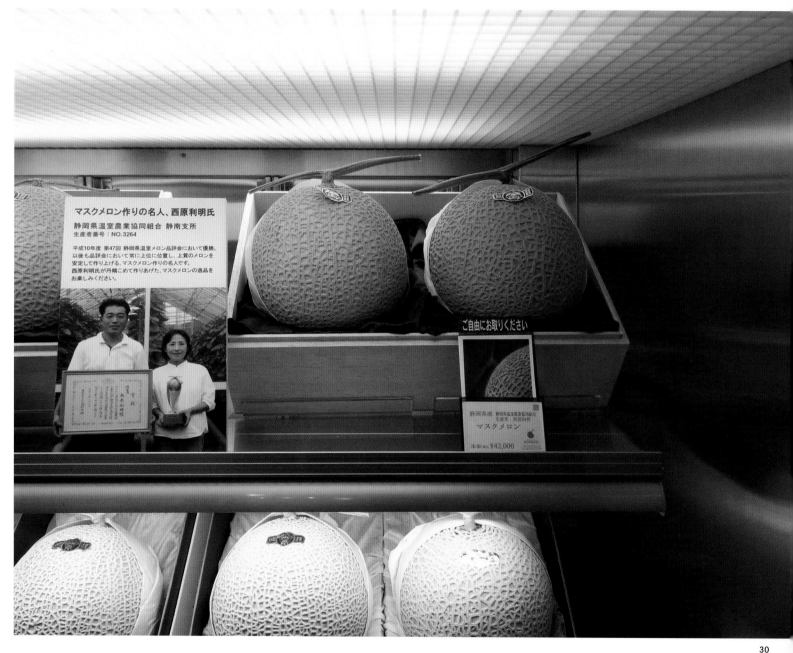

マスクメロン作りの名人、西原利明氏

静岡県温室農業協同組合 静南支所
生産者番号：NO.3264

平成10年度 第47回 静岡県温室メロン品評会において優勝。
以後も品評会において常に上位に位置し、上質のメロンを
安定して作り上げる、マスクメロン作りの名人です。
西原利明氏が丹精こめて作りあげた、マスクメロンの逸品を
お楽しみください。

ご自由にお取りください

静岡県産　静岡県温室農業協同組合
生産者：西原利明
マスクメロン

（1玉入）size ¥42,000

パーフェクト

Perfect | Perfekt

From hundred-euro fruits, grown in a glass building in the most optically-perfect conditions that humans can generate, to the glass buildings themselves (the ones that don't grow melons, but salarymen), perfection is not an art, it is a standard. After all, if you're going to do it—do it right.

Von hunderte Euro teurem, absolut makellosem Obst aus dem Glashaus bis hin zu den Glashäusern selbst (in denen ergebene Mitarbeiter statt Melonen gezüchtet werden) – Perfektion ist keine Kunst, sondern der Maßstab. Wennschon, dennschon.

ガラス張りのグリーンハウスの中で人工的に最適化された状態で育てられた数百ユーロのフルーツからガラス張りのビルそのもの（主な作物はメロンではなくサラリーマン）まで、「完璧であること」は芸術ではなく、当たり前のことなのだ。同じやるなら巧くやれ。

◄　Hermès Flagship Store by Renzo Piano (Ginza)
　　レンゾ・ピアノが設計した「メゾン・エルメス」（銀座）

◄◄　Melons for ¥ 42,000 (Roppongi) | Melonen für
　　42 000 YEN | 4万2000円の最高級メロン（六本木）

Graffiti is still rare compared to other mega-cities like London or New York, but the occasional street sticker is a fairly common sight. Despite questionable artistic charm, it serves the same purpose as those traditionally left behind by temple visitors: I have been here.

Man sieht, verglichen mit anderen Mega-städten wie London oder New York, zwar verhältnismäßig wenig Graffiti, aber Street-Art-Sticker sind ziemlich verbreitet. Unabhängig von der jeweiligen künstlerischen Qualität erfüllen sie den gleichen Zweck wie der traditionelle Tempel-Aufkleber: Ich war hier.

ロンドンやニューヨークなどの大都市と比較すると、街で目にする落書きは少ない。代わりに、あらゆる場所でベタベタと貼り付けられたステッカーに遭遇する。その品位は疑わしいが、寺院参拝の記念に残されたステッカーと同じ意味を持つ。自分がそこに確かに存在したことの証し。

<su> <te> <ka>
ステッカー
Sticker

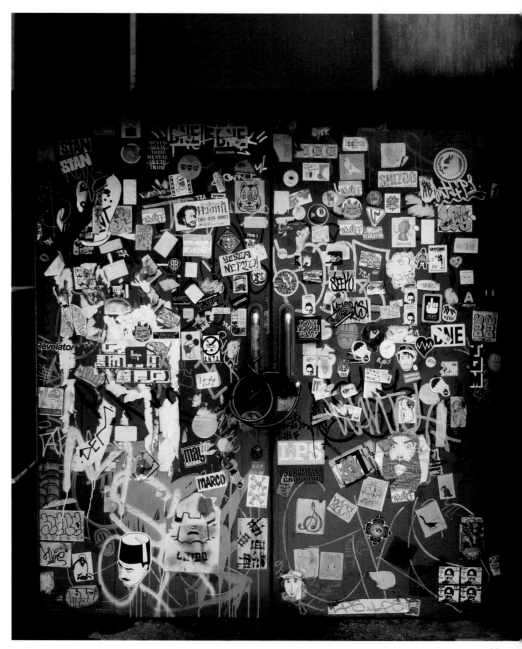

▲ Temple with pilgrim stickers (Narita) │ Pilgeraufkleber am Tempel │ 参拝札シールが貼られた寺 (成田)

◀ Dirty sticker (Shibuya) │ Obszöner Sticker │ やらしいシール (渋谷)

◀◀ Nightclub door (Ebisu) │ Nachtclubtür │ ナイトクラブのドア (恵比寿)

オカルト

o ka ru to

Cult | Kult

This is not a Japanese temple, although its colorful and splendid decorations could tempt you to believe so. However, Japan seems to happily honor religious co-existence, broad interpretations, and even commercial marketing support by heavenly spirits. If Jesus can sell a violin, why not gamble on spiritual fortune at your local shrine. A washout? Have another try!

Obwohl es die prächtige, bunte Dekoration irgendwie vermuten lässt: Dies ist kein japanischer Tempel. Religiöse Toleranz dagegen ist typisch japanisch – breite Auslegung und selbst kommerziell-himmlische Marketingmaßnahmen sind völlig in Ordnung. Wenn selbst Jesus Geigen verkauft, dann kann ich mein heiliges Glückslos auch ruhig mal am Automaten kaufen. Niete? Zieh noch mal!

日本にあることに何の違和感もないけれど、このカラフルで華麗な装飾は日本の伝統的なお寺ではない。むしろそれを歓迎しているように思えるほど、日本には様々な宗教や解釈が共存している。神様がマーケティングツールとして活躍することだってしばしば。キリストがバイオリンを売るのなら、近所の神社で幸運を賭けてギャンブルしたっていいだろう？ この運勢は気に入らない？ それならコインをもう一枚投入すればいいさ！

Jesus relief on a violin store (Daikanyama) | Jesus-Relief an einem ▲
Geigengeschäft | バイオリン専門店の看板娘ならぬ看板キリスト (代官山)

Fortune ticket vending machine at a temple (Narita) | Automati- ▶
scher Glücksspender an einem Tempel | おみくじ販売機 (成田)

Chinese temple (Chinatown, Yokohama) | Chinesischer Tempel ▶▶
中国寺院 (横浜中華街)

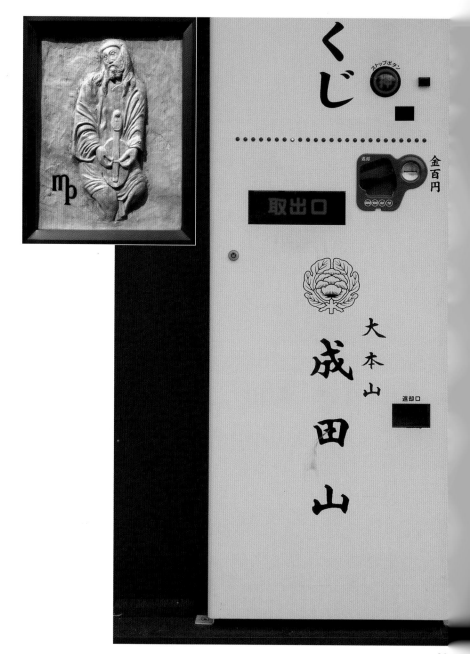

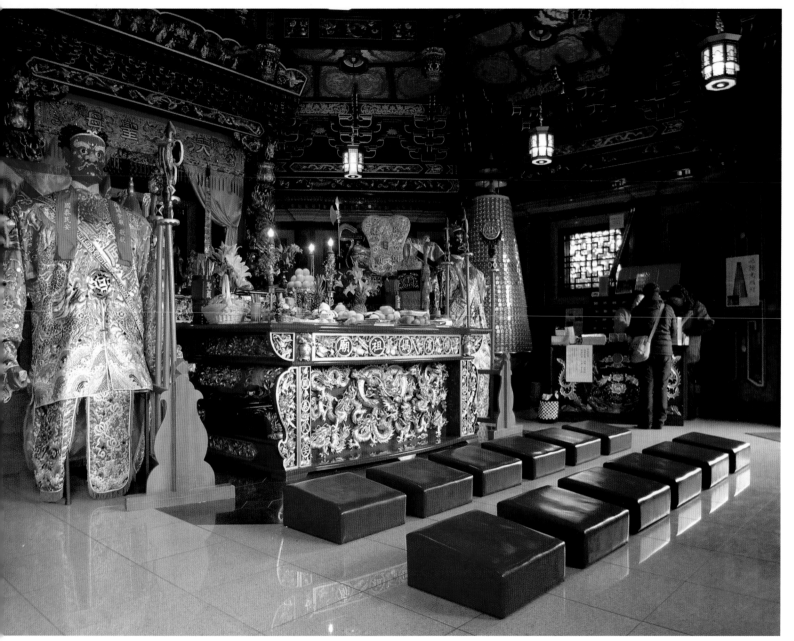

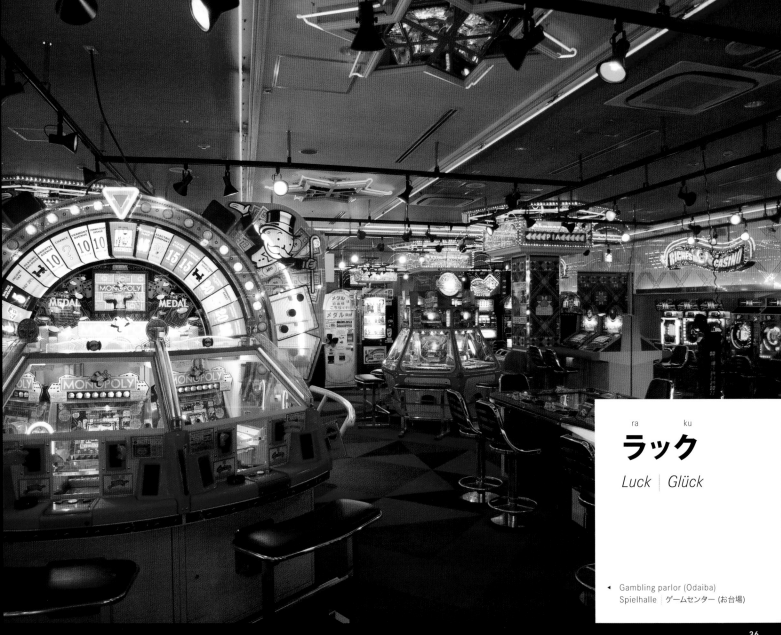

ra ku

ラック

Luck | Glück

◀ Gambling parlor (Odaiba)
Spielhalle | ゲームセンター (お台場)

Luck is a great seller. And luck is a great excuse if you can't keep away from the shining, blinking, and noise-and-metal-spitting machines that can actually bring it. At least they may be more promising than the fortune tickets from your local shrine.

Glück hat einen unwiderstehlichen Reiz. Und die Aussicht darauf ist eine hervorragende Rechtfertigung, wenn dich die glänzenden, Lärm und Metall spuckenden Spielautomaten nicht mehr loslassen. Und hierbei lässt sich vermutlich noch mehr rausholen, als bei der Glückslotterie am nächstbesten Tempel.

幸運は最高の広告塔。輝き、瞬き、雑音と共にメダルを吐き出す機械から離れられなくなってしまったなら、運を口実に使うのもいいだろう。運試しなら、近所の神社で手に入るおみくじよりも、こっちのほうがずっとリアルな現実なのだから。

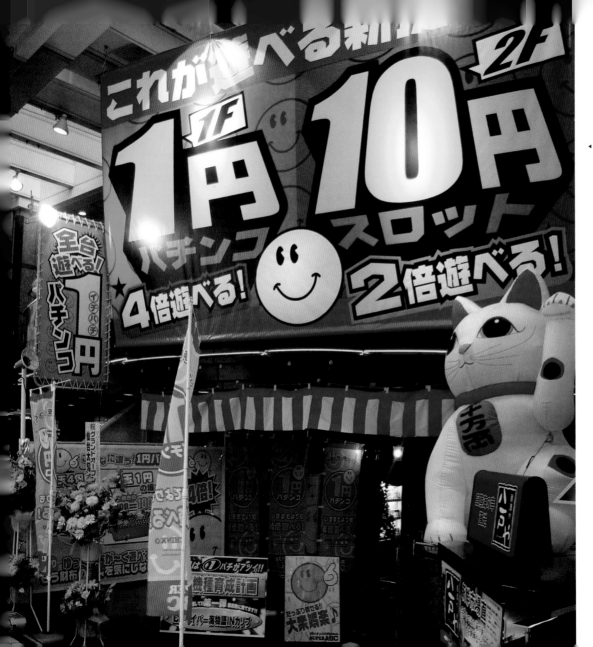

パチンコ

Pachinko

◄ *Pachinko* parlor. The giant cat helps financial luck. (Sendai) | *Pachinko*-Spielhalle. Die riesige Katze verhilft zum Geldsegen. | 仙台のパチンコ屋の前で金運を呼ぶ招き猫

Pachinko with famous TV starlets ► *Pachinko*-Automat mit Fernsehstars 有名人を題材としたパチンコ台

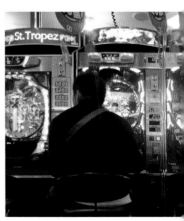

Pachinko gambling parlors provide the most over-whelming splashes of color (and noise) throughout the entire city, with venues on almost every corner. The expressively neon-styled gambling devices suggest highly interactive gameplay—which it just isn't: simply drop in hundreds of metal balls, watch them roll downstream along the nails, and wait for one to hit the jackpot. Wildly blinking lights, sounds, and more balls make up for the missing interaction.

Pachinko-Spielhallen sind die wohl lautesten Farb- und Lärmquellen der Stadt – und es gibt sie an fast jeder Ecke. Die grell neonfarbig gestylten Spielgeräte lassen ein abwechslungsreiches Spielgeschehen vermuten. Aber ganz im Gegen-teil: Es reicht, ein paar hundert Metallkügelchen einzufüllen, zu beobachten, wie sie über die Nägelchen hüpfen, und darauf zu warten, dass eine den Jackpot erwischt. Wild blinkende Lämp-chen, grelle Musik und immer mehr Kügelchen entschädigen für den fehlenden Spielspaß.

トウキョウのどこよりも攻撃的な色と音が入り交じる空間はパチンコ場。トウキョウのどこを歩いていても、角を曲がれば一軒くらいはすぐに視界に飛び込んでくるだろう。自己主張の塊のようなネオンを装備したこのギャンブルマシンは一見激しいインタラクティブプレーを要求しそうだが、実は全くもってその逆。無数の鉄の玉を飛ばし、釘の間を抜けて玉が続々と落ちてくる様をじっと見守り、ジャックポットに入るのを待つのみ。狂ったように瞬く光や爆音や数えきれないほどの玉数は、このゲームから欠落しているインタラクティブな要素を埋め合わせるために存在するのだ。

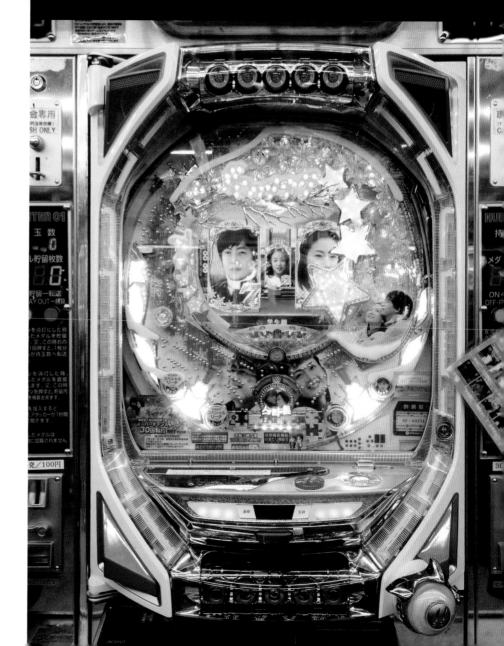

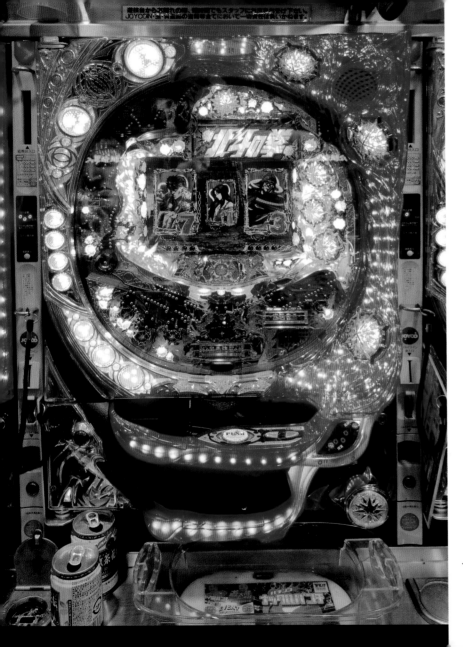

Pachinko is neither the latest nor the greatest game in Japan's long tradition of gambling, but it's definitely the most addictive. Unfortunately, all you can win at the machines is more metal balls for continuous gameplay. Fortunately, these winnings can be exchanged for prizes at the counter. Even more fortunately, these prizes can be exchanged for money at the dark alley door around the corner. This prospect provides a steady revenue for the force behind the parlour halls, the Yakuza.

Pachinko ist weder neu noch ein besonders ausgetüftel-tes Spiel, aber dennoch in Japans langer Glücksspieltradi-tion sicherlich dasjenige mit dem höchsten Suchtpotenzial. Und das, obwohl an den Geräten eigentlich nur weitere Kugeln zu gewinnen sind. Dafür gibt's am Counter ledig-lich Sachpreise, die man jedoch am verdächtig dunklen Fenster um die Ecke gegen Bares eintauschen kann. Und genau dieses Fenster sowie das gesamte Prinzip bescheren vor allem den inoffiziellen Kräften dahinter (der Yakuza) ein prächtiges Einkommen.

日本の長いギャンブルの歴史において、パチンコは最新でもなければ最も優れたギャンブルでもない。しかし、その中毒性は格別。残念なことに、費やした時間の見返りとしてもらえるのはパチンコ玉だけ。幸いなことに、この勝ち取ったパチンコ玉は賞品と交換することができ、そしてもっと幸いなことに、裏道の路地の窓口ではこれらの景品を現金と交換することも可能。この仕組みはパチンコパーラーを司る裏の組織の安定した資金源となっているとのこと。

◀ Spectacular *new* *pachinko* machine | Das neueste Modell | 豪華な新型パチンコ台

Players in Kabukicho | Spieler in Kabukicho ▶
パチンコ打ちたちの日常風景 (歌舞伎町)

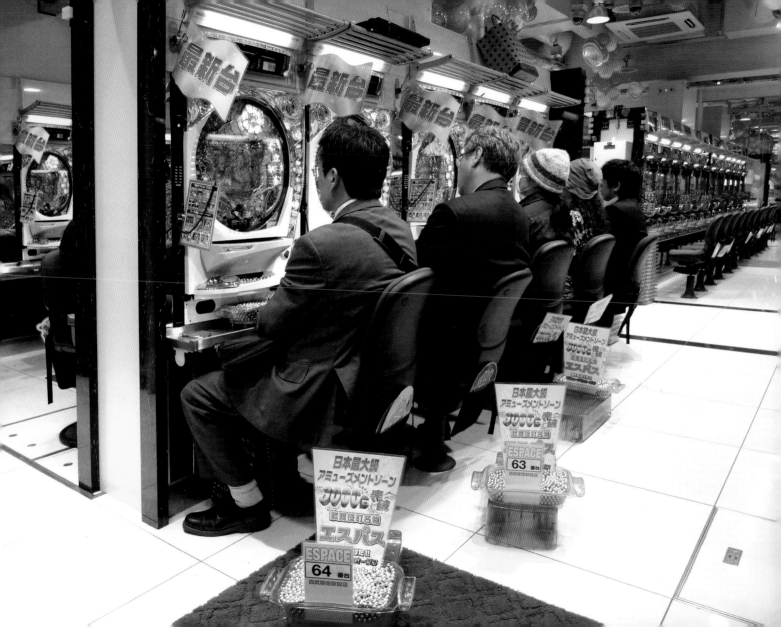

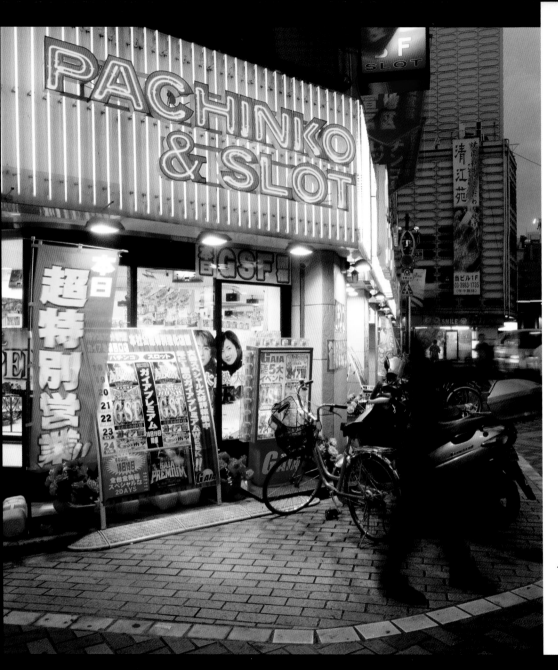

ネオン

Neon

You'll only see better in Paris. Neon signs come in all shapes, colors, and sizes here, but the most important highlight of all is the ceaseless blinking: the ultimate retinal challange. Beautiful.

Stilechter geht's nur in Paris. Neon-beleuchtung kann sämtliche Formen, Farben und Größen annehmen, aber ihr eigentliches Highlight ist ununter-brochenes Blinken – eine ziemlich sportliche Herausforderung für die Netzhaut. Aber hinreißend schön.

パリよりもすごい風景がある。形、色、大きさ不問、ネオンサインの種類は無限。しかし最も特筆すべきは、その点滅性能。チカチカと瞬く様子はことさら美しく、そしてそれはヒトの網膜の限界に挑戦する。

◄ Blinking *pachinko* parlor (Ikebukuro)
Blinkender *Pachinko*-Palast｜光を放つ
パチンコ店 (池袋)

Neon lights (Ebisu, Ikebukuro)｜Neon- ►
beleuchtung｜ネオンサイン (恵比寿／池袋)

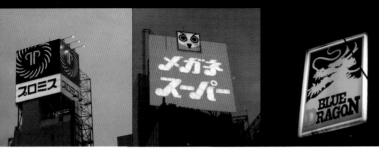

From left to right: Luminous advertisements for real estate (*Tama-Home*), financial services (*Promise*), eye glasses (*Megane-Super*) and a night club (all Shinjuku) │ Von links nach rechts: Leuchtreklame für Immobilien (*Tama-Home*), Finanzdienstleistungen (*Promise*), Brillen (*Megane-Super*) und eine Bar │ 光輝く看板、左から：不動産屋の看板 (タマホーム)、消費者金融サービス (プロミス)、眼鏡 (メガネスーパー)、ナイトクラブ (すべて新宿)

Telephone-dating (*Tele-Club*, right) and navigation services for the redlight district *(Navi,* below) │ Telefon-Dating (*Tele-Club*, rechts) und Navigationshilfe für den Rotlichtbezirk *(Navi,* unten) │ テレクラ(右)／風俗案内所 (下)

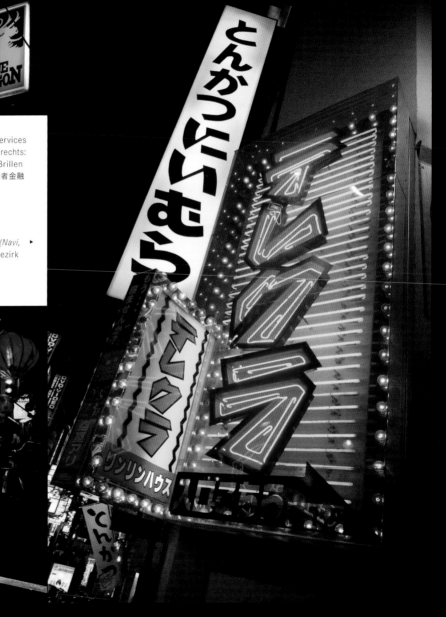

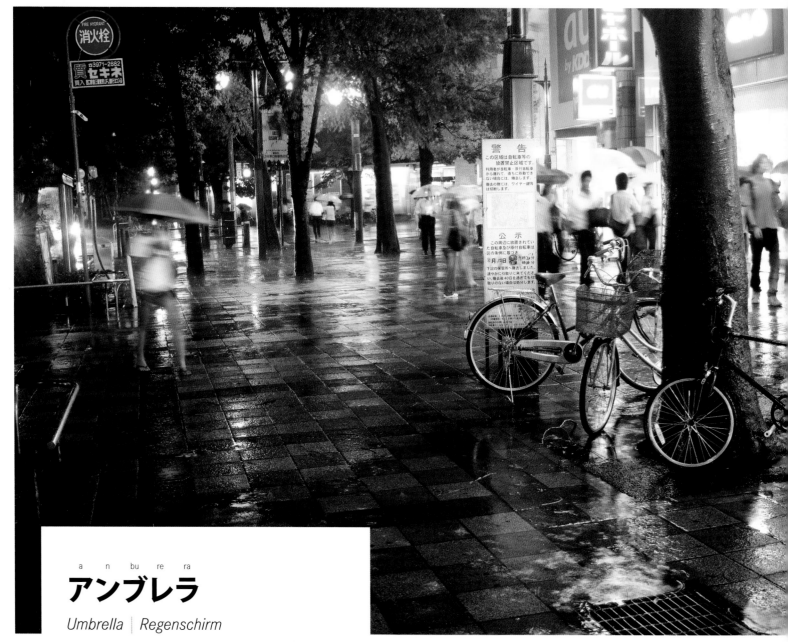

a n bu re ra

アンブレラ

Umbrella | *Regenschirm*

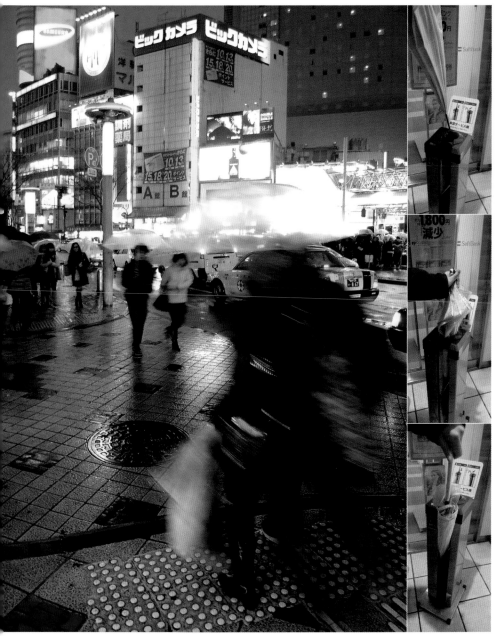

One of the great wonders for Tokyo newcomers is the mysterious appearance of umbrellas once it starts raining. At the first drop they pop up within seconds and soon you'll be the only stranger left in the rain. If you wonder where the umbrellas suddenly came from, check the store fronts and see them sold for a nickel. And don't hesitate to grab the one left behind, as it'll make a great part of your front-door collection.

Ein großes Rätsel für Neuankömmlinge ist die unglaubliche Menge an Regenschirmen. Kaum fallen die ersten Tropfen, klappen sie in Sekundenschnelle überall auf, und schon steht man als Letzter im Regen. Wer sich fragt, wo die Schirme so urplötzlich herkommen, sollte mal einen Blick in die Auslagen werfen, wo sie überraschenderweise überall gerade im Angebot sind. Herrenlose Schirme kann man getrost mitnehmen, sie passen ganz prächtig in die Sammlung vor der Haustür.

トウキョウに来たばかりの外国人が不思議に思う現象の一つが、雨が降り始めたときの傘のミステリアスな出現だ。最初の一滴が舞い落ちると傘がほぼ一斉に開かれ、辺りを見回しても雨に濡れているのは自分だけ、という状況が瞬時に出来上がる。この傘が一体どこからやってくるのかを知りたければ、店先を注意して観察してみると、格安で売られていることに気が付くはず。置き去りにされた傘を見つけたなら、それを持ち帰ることに躊躇する必要はない。こうして手に入れた傘は、玄関先のインテリアとして末永く活躍してくれるのだから。

◄ Wet umbrella wrap dispenser │ Praktischer Schirmhüllenautomat
濡れた傘は袋に入れてお持ちください

◄ Rain shopping (Shibuya) │ Schirmshopping │ 雨の日ショッピング (渋谷)

◄◄ Sudden rainfall (Ikebukuro) │ Sturzregen │ 突然の雨 (池袋)

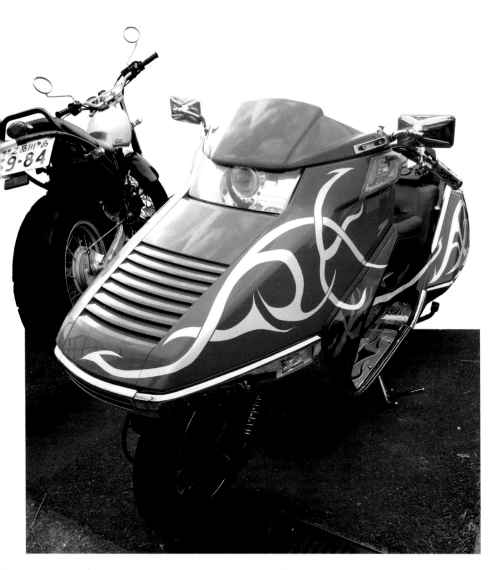

Custom scooter (Suzuki Majesty) | Aufgemotzter Roller ▶
カスタム「スズキ・マジェスティ」スクーター

Custom old-school bike | Aufgemotzte Retro-Maschine ▼
型式不明、クラシックバイク

Military-style scooter (Honda PS250) | Roller im Military-
Look | Honda PS 250 ミリタリースタイルスクーター

Deep inside the motherland of hardcore racing bikes, one barely sees them on the streets. Instead, there are all kinds of retro-style choppers, stripped-naked bikes, military-styled utility scooters, and laid-back upholstered seats, to show off the lazy cool breeze around your chin while weaving elegantly through crowded Tokyo traffic.

Mitten im Land der hochgezüchteten Straßenmaschinen sind genau diese kaum auszumachen. Ganz im Gegenteil, man stößt überall auf gestylte Retro-Chopper, Naked Bikes, Straßenroller im Military-Look und fahrende Sofas, in denen man in der frischen Brise sein lässiges Gesicht zur Schau stellt, während man sich elegant durch den dichten Verkehr schlängelt.

ハードコアレーシングバイクの祖国でも、街角ではなかなかそんなバイクは目にしない。目に入るのはレトロスタイルの改造バイク、ストリップダウンされ原型をとどめないバイク、ミリタリースタイルのユーティリティスクーター。革張りされたシートに深く座り、あごをなでる心地良い風を感じながら、トウキョウのひしめき合う車の波をエレガントに抜けていく様を見せつけるバイカーたち。

ba i ku
バイク

Bike | *Motorrad*

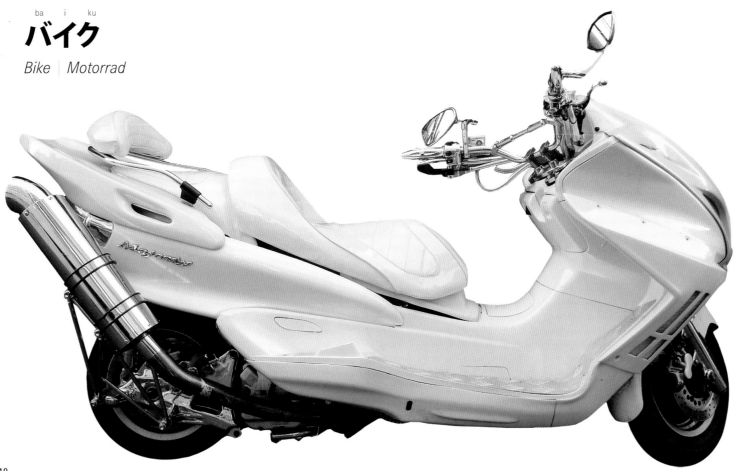

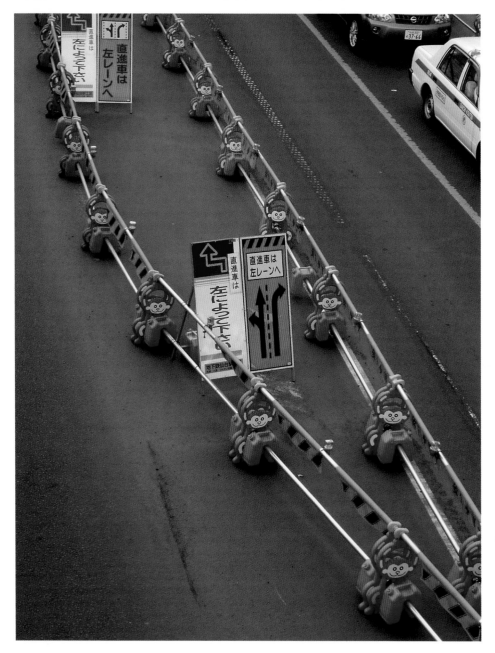

<ruby>ハ<rt>ha</rt></ruby><ruby>ッピー<rt>pi</rt></ruby>

Happy | Glücklich

Work life is rough enough, and all you need is another traffic jam blocking the road on your way home. But relax: there are creatures in the city jungle to put a smile on your face as you wait in line with the others. Or as the pot-bellied gods would say: happiness must come from within.

Als wäre das Arbeitsleben nicht hart genug, blockiert schon die nächste Baustelle den Weg in den Feierabend. Entspann dich: Es gibt schon genug Affen im Drängel-Dschungel. Lächle, sei froh und stell dich einfach mal hinten an. Oder wie die dickbäuchigen Buddhas sagen würden: Wahres Glück kommt immer von innen.

サラリーマン生活の現実は決して甘くない。せめて帰り道くらいスムーズに、と願うのが心情。しかし、トウキョウの交通事情はそれすら許してくれないこともある。でも大丈夫。渋滞の列に巻き込まれても、こんな風に都会の生き物たちが笑顔を分けてくれるだろう。多勢に紛れて列に並んで待つ間は、なるべく明るく元気な顔で。立派なおなかの神様の言うところでは「幸せはおなかの底からわいてくる」のだから。

◀ Plastic monkeys for traffic control | Affenfiguren zur Verkehrsumleitung | 交通整理用プラスチックモンキー

Stone gods near Mt. Takao | Götterfiguren am Berg Takao ▶
七福神 (高尾山付近)

Tanuki (Japanese raccoon dog) beckoning drinkers and diners ▶
Der *Tanuki* (jap. Marderhund) heißt die Gäste willkommen
客寄せたぬき

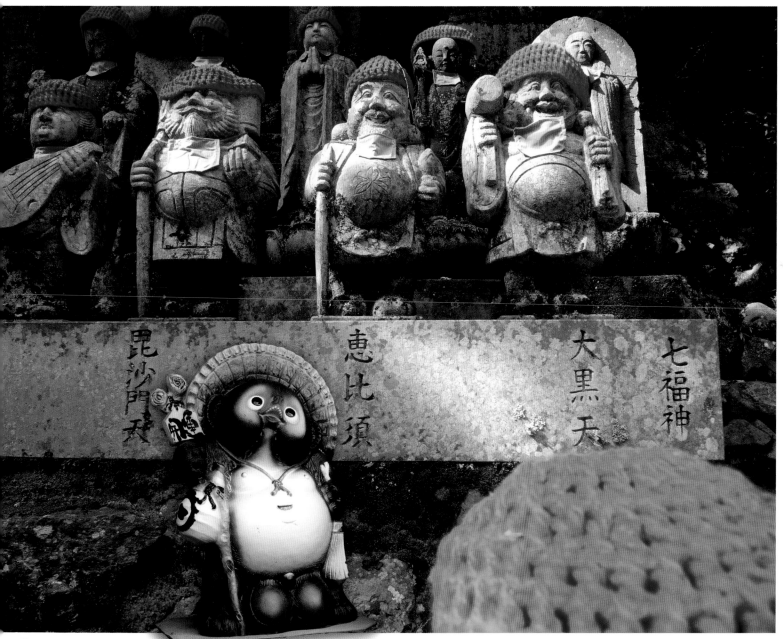

ロマンチック

Romance | Romantik

You will wish you were back in the old days, when wheels were made from wood, cars had chrome bumpers, and the blue sky over Venice was not simply painted on the panoramic ceiling in a large entertainment and shopping complex.

Man könnte meinen, es wäre alles wie früher. Als die Räder noch aus echtem Holz waren, Autos verchromte Stoßstangen hatten und der blaue Himmel über Venedig nicht einfach nur an die Panoramadecke eines riesigen Einkaufs- und Vergnügungszentrums gemalt war.

古き良き時代に戻りたくなってしまうかもしれない。木製の車輪や自動車のクロームバンパーが活躍していた時代、美しいベニスの空が巨大なショッピングモールの天井に描かれたパノラマペイントではなかった時代に。

◄ A french-style pastry shop (Ebisu) │ Konditorei nach französischem Vorbild │ フレンチスタイルのペストリーショップ (恵比寿)

Pseudo Italian shopping flair in *Venus Fort* mall, complete with ► artificial blue sky (Odaiba) │ Pseudo-italienisches Flair im *Venus Fort*-Einkaufscenter mit künstlichem blauem Himmel │ 青い空まで完璧に模倣した、イタリアのショッピング街風お台場ヴィーナスフォート

Retro-style Nissan Figaro from the early 90's │ Nissan Figaro im ► Retro-Stil aus den 1990ern │ 90年代初期レトロスタイル日産フィガロ

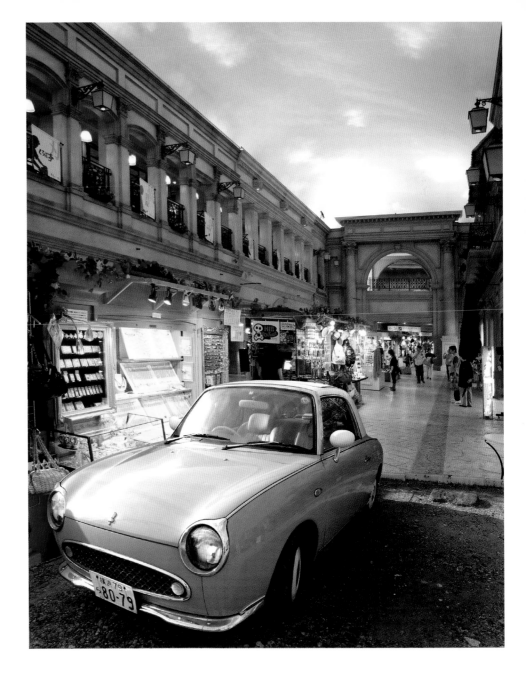

フェイク

Fake

Despite thousand-year-old Buddhist ideals of nature, calm, and authenticity, many Japanese happily fall for lustrous, fancy fakes—often somewhere between the romantic and the ridiculous. Of course, this duality has a twist: you can look at it from both angles.

Trotz der jahrtausendealten buddhistischen Ideale von Natur, Ruhe und Authentizität gibt es jede Menge Japaner, die sich hinreißend für schillernden Fake begeistern können. Der liegt oft irgendwo zwischen Romantik und Komik – eine Dualität, die Methode hat: Man kann es halt so oder so sehen.

1000年にも及ぶ仏教観念に基づく自然への敬意、穏やかな心、そして真の理念を持ちながらも、多くの日本人はよく出来た偽物を好む傾向がある。そういうものは大抵の場合「ロマンチック」と「コミカル」のちょうど真ん中あたりに位置づけられる。この二面性の方法論なら、それぞれを二倍楽しめる。

◄ Subaru Sumber with Citroën camouflage kit | Als Citroën getarnter Subaru | シトロエンのふりをするスバルサンバー

The fake pirate ship on lake Ashi (Hakone) | Das Piratenschiff auf dem See Ashi | 芦ノ湖に浮かぶ有名な海賊船 ►

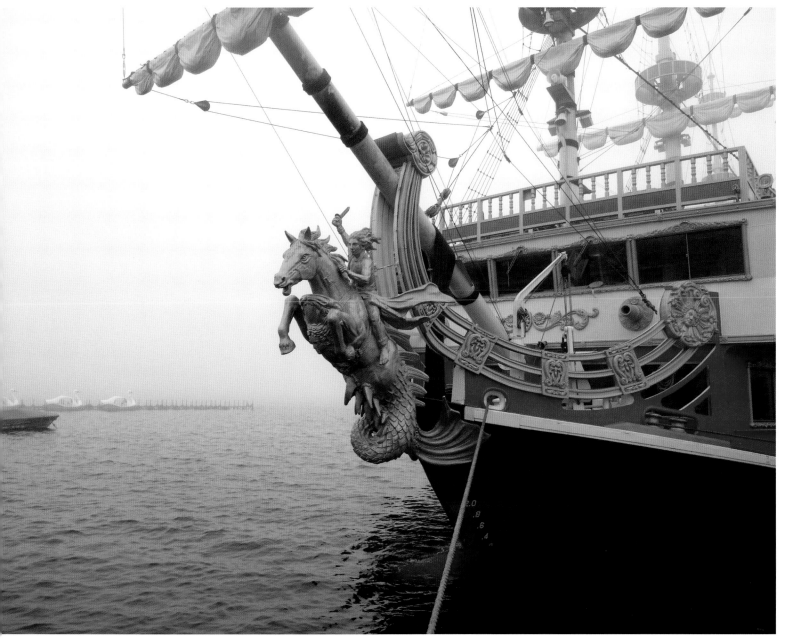

コピー
ko pi

Copy | *Kopie*

Better to copy the master: perfected replicas can out-value authentic originals, as they not only honor the original, they also reveal the devoted skills of the passionate apprentice.

Immer erst einmal nachmachen: Manchmal können die perfekten Replikate sogar das Original in den Schatten stellen. Schließlich wird uns dadurch die hingebungsvolle Leidenschaft des Lehrlings vor Augen geführt.

偉大なる先人に近づくためには完全なるコピーを目指すべし。完璧なレプリカは時として本物よりも価値がある。それは本物への敬愛だけでなく、熱心な弟子たちの高度な技術までをも映し出している。

Elvis lookalikes (Yoyogi Park, Harajuku) | Elvis-Lookalikes ▶
日本製 エルビス (原宿、代々木公園)

Imitating Mother Nature: patina-style facade (Daikanyama) ▶▶
Nach dem Vorbild der Natur: Fassade mit künstlicher Patina
まるで本物！ 年月によって出来る風格を模倣したファサード (代官山)

Wood-style concrete pillars (Hakone) | Betonholz |「木目調」▶▶
のコンクリート支柱 (箱根付近)

56

STRAMA

<ruby>パ<rt>pa</rt></ruby><ruby>ー<rt>ki</rt></ruby><ruby>キ<rt>n</rt></ruby><ruby>ン<rt>gu</rt></ruby>グ

Parking | Parken

Here is the choice: either you leave your vehicle where it is, or you start getting adjusted to expenses that easily double the bill of that lunch meal you just stopped for.

Du hast die Wahl: Entweder lass dein Fahrzeug stehen, oder gewöhne dich an Preise, die locker die Rechnung des Essens übersteigen, für das du gerade geparkt hast.

選択肢は二つ：車を置いて出かけるか、あるいは昼食代の二倍の金額を払って駐車することに目くじらを立てず腹を据えるか。

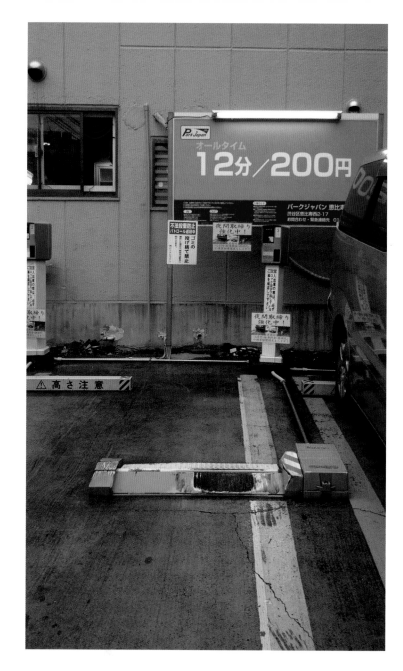

12 minutes for ¥ 200 (Ebisu) | 12 Minuten für 200 YEN ▸
12分で200円 (恵比寿)

Parking tower with paternoster lift | Parkhaus-Turm mit ▸
Paternoster-Aufzug | エレベーター付きパーキングタワー

Private garden & parking lot (Ebisu) | Privater Garten mit ▸▸
Parkplatz | 民家の駐車スペース (恵比寿)

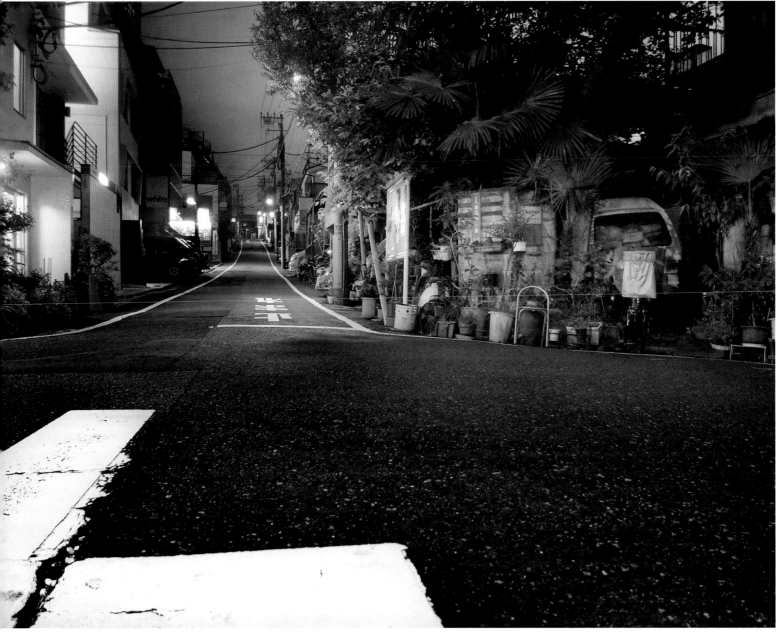

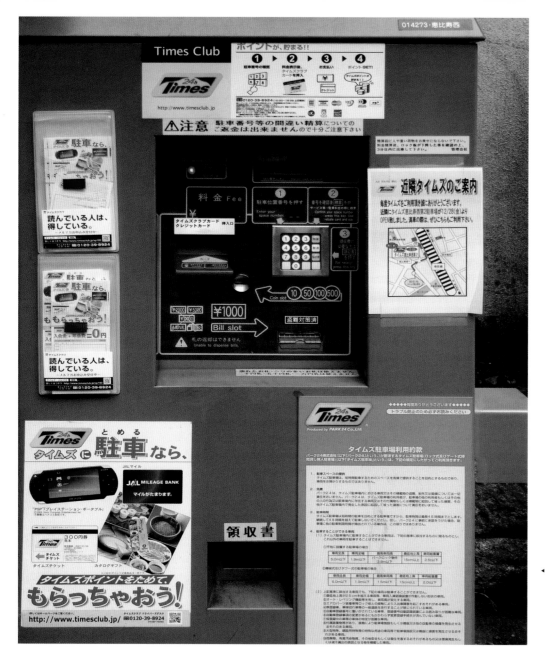

Gone are the times of simple parking meters. These *coin parks* mean serious business: Either you pay (if you can figure out how) or you stay. Parking space is such a valuable resource that these two lots might drive more revenue than the old apartment building that stood here before.

Die Zeiten der Parkuhr sind hier endgültig vorbei. Bei solchen vollautomatisierten Parkplätzen geht's ums Geschäft: Entweder du bezahlst (sofern du rausfindest, wie) oder du bleibst hier stehen. Parkplätze sind derart rar, dass zwei bereits mehr abwerfen als das renovierungsbedürftige Wohnhaus, das dort abgerissen wurde.

シンプルなパーキングメーターの時代は過ぎ去り、現代のコインパーキングは冗談の通じないビジネス。払うか（支払い方法を探り出すことができれば）、または居座るか。駐車場は大切なリソース。この二台分の駐車スペースによる収益は、以前ここにあった古いアパートを改築するよりも効率的。

◄ Automated car park teller (Ebisu) | Parkautomat
自動駐車料金支払機 (恵比寿)

Minimal parking lot | Kleinstparkplatz | 極小駐車場 ►

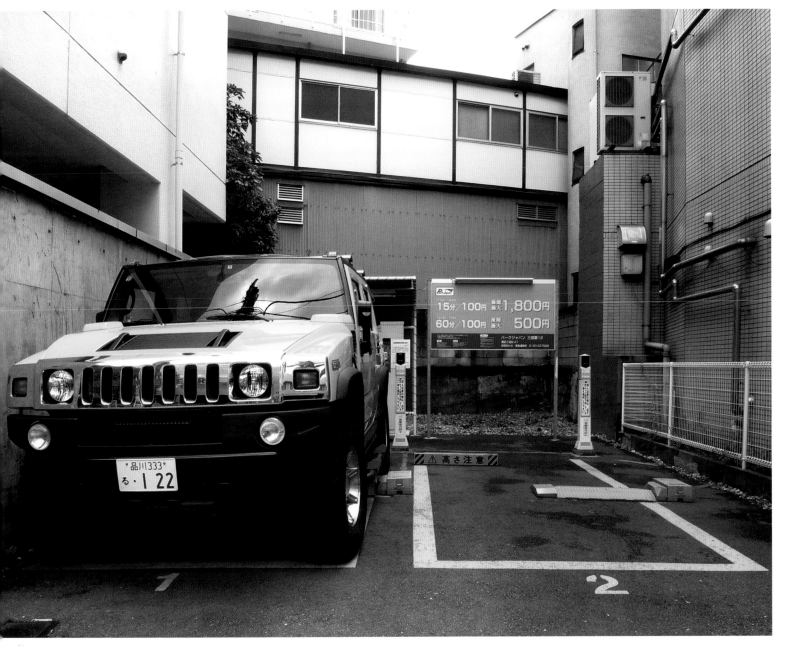

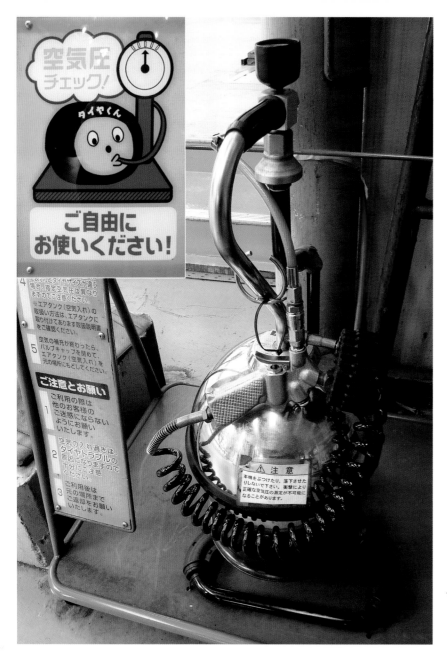

カー サービス

Car service │ Werkstatt

Cars are not just inanimate objects. They have a soul of their own, which had better not be insulted by dirty and greasy back-alley workshops. A nice, oily massage in a happy atmosphere is just what your baby needs to start humming again.

Autos sind nicht einfach nur leblose Dinge. Sie haben Charakter, und der sollte nicht von schmierigen Hinterhof-Werkstätten beleidigt werden. Nach ölig-fröhlicher Massage in freundlicher Umgebung schnurrt dein Baby bestimmt wieder wie neu.

車は意思を持つ生き物。埃と油にまみれた路地裏の作業場で屈辱を味わわせるべきではない。快適な場所でしっかりマッサージしてやれば、きっとまた素敵な歌声を街に響かせてくれるはず。

◄ Compressed air unit │ Druckluftspender │ 空気圧チェックはご自由にどうぞ

Car service garage (Chiba) │ Werkstatt │ 自動車ワークショップ（千葉） ►

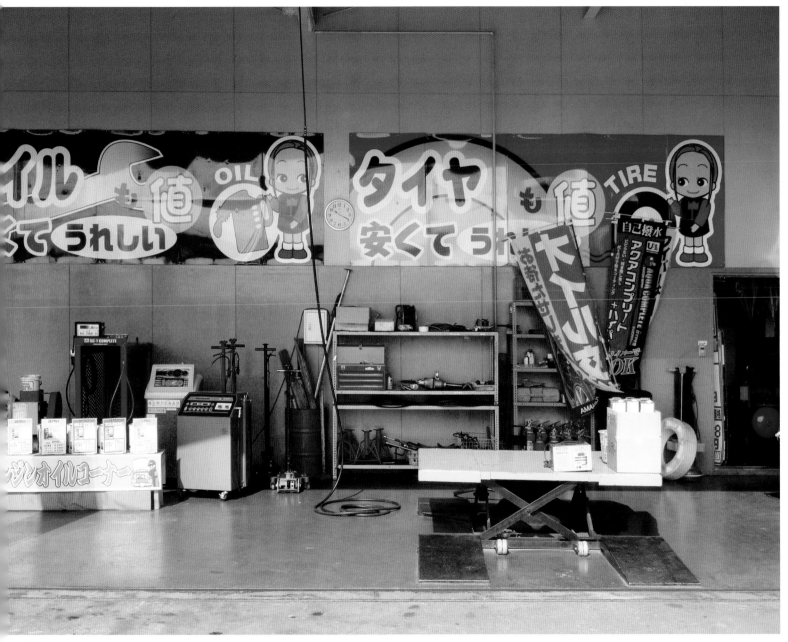

コンストラクション

Construction | *Baustelle*

It's both the visual pleasure and the ridiculously-extensive security precautions that make one smile about Tokyo road construction. However, the impressive speed with which these colorful crews can change a street surface is going to turn that belittling smile into an astounded "O".

Über die knallbunten und völlig übertriebenen Sicherheitsvorkehrungen der Tokioter Baustellen möchte man eigentlich nur milde lächeln. Aber wenn man sieht, mit welch atemberaubender Geschwindigkeit die bunten Männlein den Straßenbelag auswechseln, kann man nur anerkennend staunen.

トウキョウの道路工事現場。視覚的に滑稽な注意書きや大げさにもほどがあるセキュリティー対策に吹き出してしまったとしても、派手な色に身を包んだ作業員が道路を構築していくスピードを目にすると、その笑顔も驚嘆の表情に一変してしまうだろう。

Safety precaution in a public park (Hakone) | Hinweisschild im Park | 公立公園に設置された安全標識 (箱根) ▲

Lit-up construction site (Shibuya) | Beleuchtete Baustelle 明かりのついた夜間工事現場 (渋谷) ▶

Busy night shift at 3 am (Daikanyama) | Baustellenarbeit um 3 Uhr morgens | せわしなく作業が続けられる、午前3時の夜間工事現場 (代官山) ▶▶

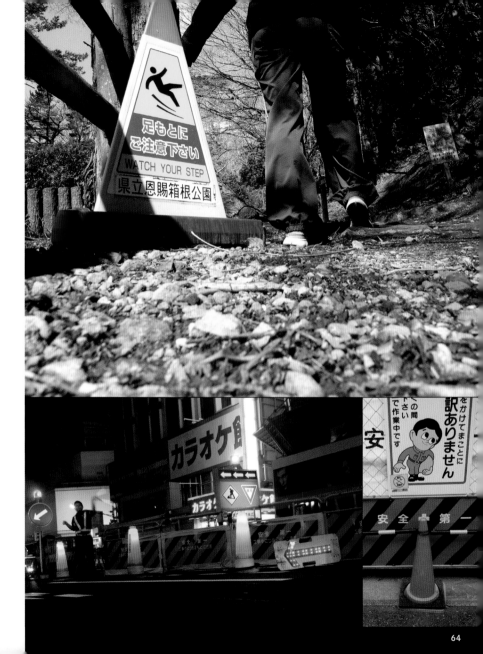

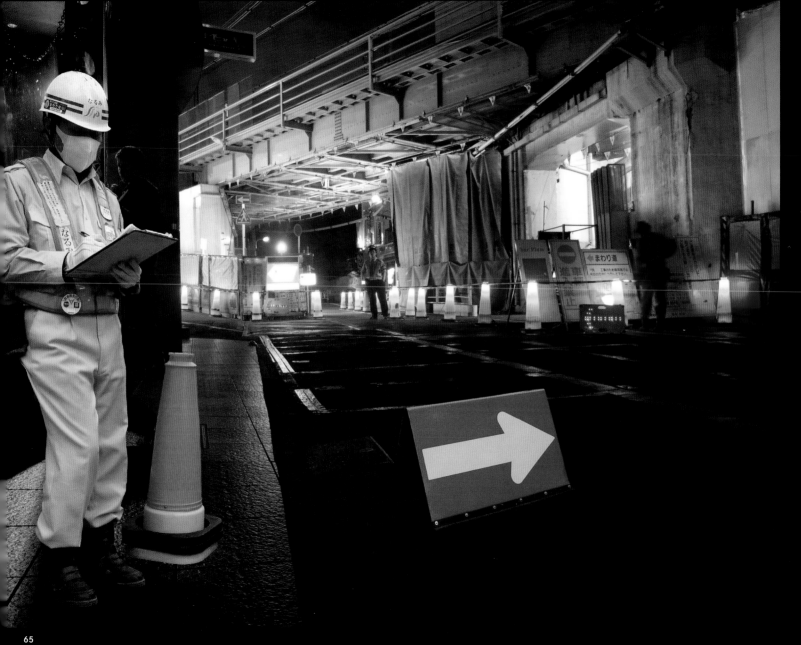

不審物を発見した際は、お手をふれずに
駅係員・乗務員までご連絡ください。

Do not touch doubtful things

發現可疑物品時，請不要觸摸，立即告知車站職員或乘務員。

의심스러운 물건을 발견하셨을 경우에는 다치지 마시고 인차 역의 계원 혹은 승무원한테 연락 주십시오.

◄ Blackmarket sales are forbidden, touching is forbidden, and don't smoke while walking. Schwarzmarkthandel verboten, anfassen verboten, nicht im Gehen rauchen. | あれも禁止、これも禁止

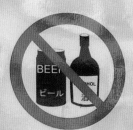

アルコールの
持ち込み
Do not carry on alcoholic
beverages.

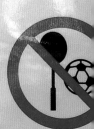

スポーツ遊
の使用
Do not use
play equipment

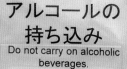

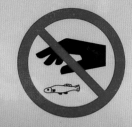

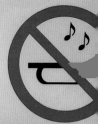

The persistant presence of prohibition signs seems a bit immoderate at first, but they pretty much reflect the Japanese habit of constant social anticipation. Whatever you do, try to put yourself in the position of the bothered, and that's as Japanese as it gets.

Die Unmenge an Verbotsschildern wirkt zwar übertrieben, aber kaum etwas reflektiert die japanische Höflichkeit besser. Was auch immer du tust, versuche dir vorzustellen, wen du damit möglicherweise stören könntest. Japanischer geht's nicht.

あれもだめ、これもだめ。禁止事項が書かれた看板の多さに最初は理解に苦しむが、これは社会的なルールに囲まれた日本人の習慣そのもの。何においてもまずは他人に迷惑をかけないこと。それが日本的美学の真髄なり。

No smoking at a wooden temple (Shibuya) │ Rauchverbot am Holz-Tempel │ 木造神社の境内での歩きたばこを禁止するのぼり旗 (渋谷) ▼
▼ Prohibited actions (Shinjuku Gyoen) │ Verbote │ 禁止事項一覧 (新宿御苑)

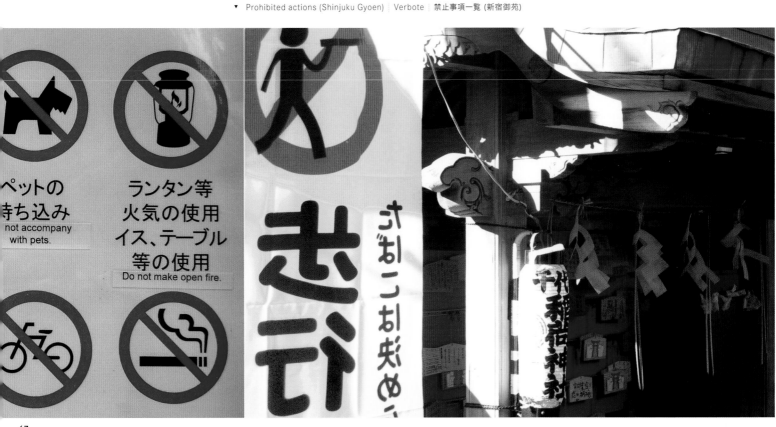

スモーキング

Smoking | *Rauchen*

A common sight in Tokyo: smoking outside is only allowed in designated smoking areas
Ein typisches Bild in Tokio, wo das Rauchen nur an dafür eingerichteten Raucherecken
gestattet ist | トウキョウでよく見かける光景：戸外での喫煙は決められた場所で

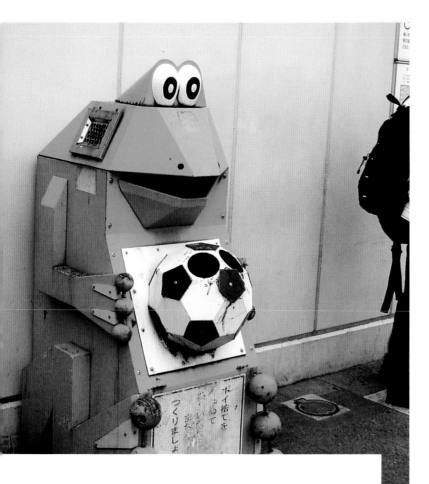

Smoking is generally allowed in most bars and restaurants, but once you step outside, be on your guard: anti-smoking officers and the manners-sensitive public are keeping a sharp eye on those who dare to befoul the precious air around smoke-free grounds within the city center. However—I never knew that soccer and smoking were so closely related.

In Bars und Restaurants zu rauchen, ist generell kein Problem, aber Vorsicht, sobald man auf die Straße tritt: Die sensible Öffentlichkeit und die Polizei werfen ein scharfes Auge auf jeden, der es wagt, die städtischen rauchfreien Schutzzonen zu verpesten. Was das mit Fußball zu tun hat, bleibt allerdings schleierhaft.

ほぼすべてのバーやレストランでは喫煙可能だが、いったん建物の外に足を踏み出すと事情は変わる。街頭で公共の空気に煙をひと吐きでもすれば、加熱する禁煙ブームや禁煙支持派の突き刺すような視線を感じるだろう。

Building asks a smoked visitor in the outside smoking section that you cannot smoke in.

Smoking corner outside the train station (Nara) | Raucherecke an einem Bahnhof | 駅の外に配置された喫煙コーナー (奈良) ▲

Sign at Lake Ashi | Aushang am See Ashi | 禁煙のお願い (芦ノ湖) ►

"Smoker's Style" campain to promote harmony between smokers and non-smokers | Kampagne für mehr Harmonie zwischen Rauchern und Nichtrauchern | 喫煙者と非喫煙者間の調和共存を目的としたスモーカーズスタイルキャンペーン ►

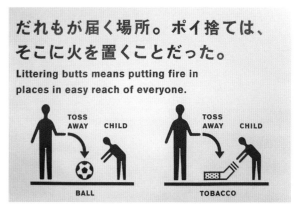

だれもが届く場所。ポイ捨ては、そこに火を置くことだった。
Littering butts means putting fire in places in easy reach of everyone.

マナー
_{ma} _{na}

Manners | Manieren

Surveillance cameras are as ubiquitious as lights and loudspeakers and hardly any Japanese person seems to worry much about their privacy implications. In a world where implicit public manners maintain peace amongst millions, police officers seem friendly helpers and the only eyes one really has to worry about are those of your neighbors.

Überwachungskameras sind genauso normal wie Leuchten und Lautsprecher, und es gibt kaum Japaner, die sich deshalb ernsthaft um ihre Privatsphäre sorgen. Hier ordnen ungeschriebene Verhaltensregeln das friedliche Miteinander der Massen, die Polizei ist dein freundlicher Helfer und dein Nachbar der einzige, der dich wirklich beobachtet.

監視カメラは照明や拡声器と同じくらい避けて通れない存在。日本人のほとんどが、それによるプライバシーの侵害について無頓着だ。暗黙の公共ルールが百万人単位の人々をまとめているこの国で、警察官はフレンドリーな存在。心配の種は、ご近所の人々のみか。

Poster campaign for better public manners | Poster-Kampagne für ▶ bessere Manieren in der Metro | 公共マナー向上を呼びかけるポスター

Gas station under surveillance | Überwachte Tankstelle | ガソリ ▶▶ ンスタンド 監視下 (千葉)

The friendly Metro security force | Die freundlichen Sicherheits- ▶▶ beauftragten der Metro | フレンドリーな地下鉄警備員

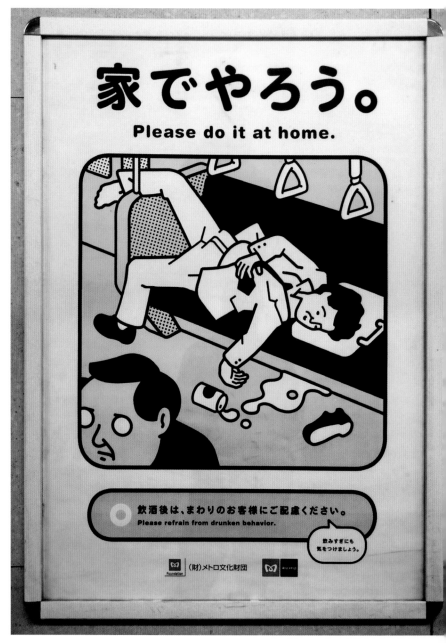

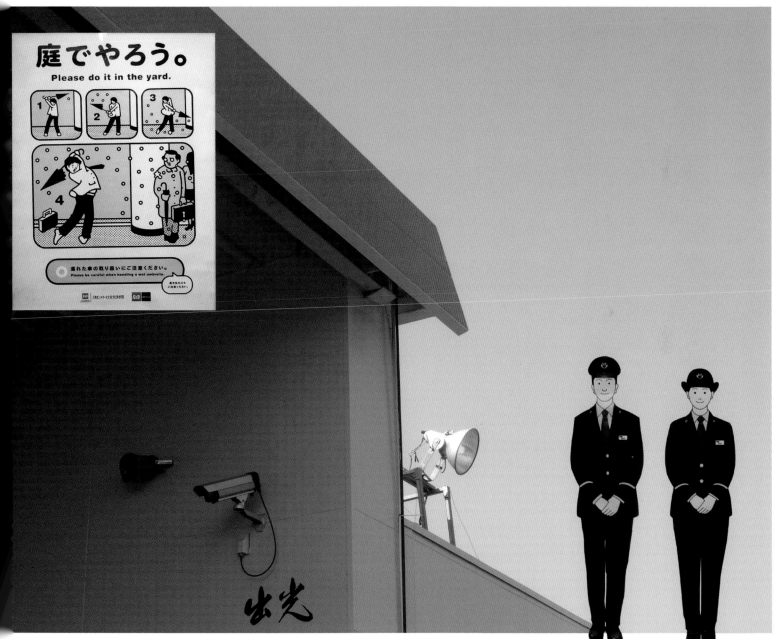

アイシー カード

IC card | *Chipkarte*

Tokyo's overcrowded train stations can truly feel like a giant battleground sometimes. But the real battle is iconic and electronic here: despite being technically identical, these two smart heroes fight for your attention. Their weapons are the electronic smartcards used for the ticket gates for either the Japanese Railway (Suica penguin) or the Tokyo Metro (Pasmo robot). Both of them usually work with both systems, but information about this fact reveals whose territory you are about to enter. What they don't notice: they are actually fighting on the same side.

Die Tokioter U-Bahn fühlt sich mitunter an wie ein riesiges Schlachtfeld. Aber der größte Kampf ist der zwischen zwei elektronischen Superhelden, die technisch eigentlich völlig identisch sind. Ihre Chip-Waffen funktionieren sowohl für die Eingänge zur Japan Railway (Suica Pinguin) als auch zur Tokio Metro (Pasmo Roboter). Beide Karten funktionieren bei beiden Systemen, aber der entsprechende Hinweis macht unmissverständlich klar, auf wessen Terrain man sich befindet. Dass die beiden dabei eigentlich für die gleiche Sache kämpfen, scheint völlig nebensächlich.

見渡す限り人、人、人が溢れかえるトウキョウの電車の駅は、時としてまるで巨大な戦場のよう。けれど真のバトルは、もっと電子的で象徴的。実体は全く同じものであるにもかかわらず、この2種類の英雄は人の注意を引くことに必死。この電子カードは、JR (Suica ペンギン) または東京メトロ (PASMOロボット) の改札で切符の代わりに使うもの。機能も同じなら、双方のシステムに対する互換性も備えている。唯一の違いはデザインのみ。果たしてこの戦いに意味はあるだろうか。

A typical metro gate with PASMO branding (Suica works, too) | Typische Metro-Schranke mit ▶
PASMO-Branding (Suica funktioniert hier auch) | 一般的なPASMO版地下鉄改札 (Suicaも使える)

Japan Railways Suica IC card and flyer on Suica-enabled mobile phone | Suica-Karte und -Flyer, ▶▶
für Handys mit Suica-Funktion | JRのSuica ICカード、Suica機能付き携帯電話を宣伝するフライヤー

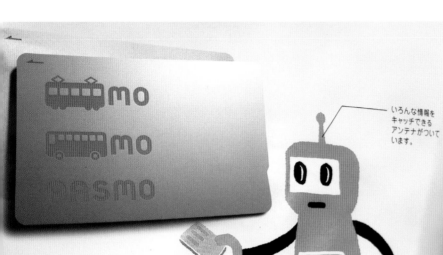

PASMOのロボット

首都圏の街をキビキビ移動するのが
大好きなロボット。
普段はPASMOを使って移動しますが、
急いでいる時は自らバスや電車に
変身して移動します。

いろんな情報を
キャッチできる
アンテナがついて
います。

足にはタイヤが
ついていて、
どこでもキビキ
移動できます。

体にはふたがあり、
ここからPASMOを
取り出して利用します。

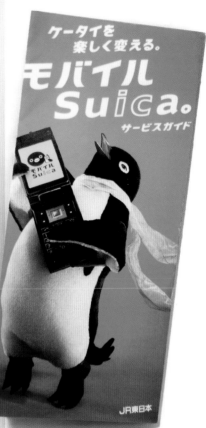

ケータイを
楽しく変える。

モバイル
Suica。
サービスガイド

JR東日本

Suica

Suica

PASMO card, typical branding and mascot | PASMO-Karte mit typischem Branding und Maskottchen
PASMOカード、典型的なブランディング＆マスコット

do ru f(u) i n he do

ドルフィン ヘッド

Dolphin's head | *Delfinschnauze*

Though it seriously improves the aerodynamics of Japanese *Shinkansen* bullet trains, one can't avoid the impression that its futuristic nose design translates to other industries as well. It might also apply to flow in general.

Die futuristisch ausgeprägte Nase des japanischen *Shinkansen*-Zuges ist aerodynamisch von enormem Vorteil, und da man ihr das so deutlich ansieht, wird sie von anderen Produkten nur allzu gerne interpretiert. Die Form scheint den „Flow" im Allgemeinen zu begünstigen.

新幹線の空気力学設計が確固たる進歩を続ける中、この近未来的な機首デザインが他の業態でも同様に採用されているという印象を拭いきれない。「流れ」というキーワードが共通であれば、応用できる概念なのかもしれない。

▲ The famous *Shinkansen* series of bullet trains | Die berühmte Schnellzug-Serie *Shinkansen* | 海外でも有名な新幹線シリーズ

◀ A custom Yamaha Maxam | Aufgemotzte Yamaha Maxam カスタム「ヤマハ・マグザム」

The *"Shinkansen"* of toilets: TOTO Neorest X for ¥ 416,850 ▶
Der *„Shinkansen"* der Toiletten: TOTO Neorest X für 416 850 YEN
新幹線型トイレ「TOTOネオレストX」(41万6850円)

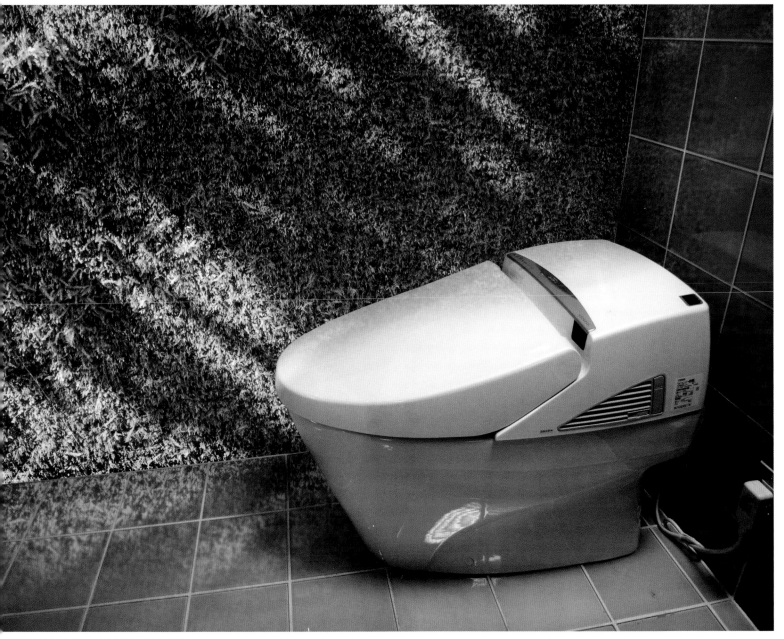

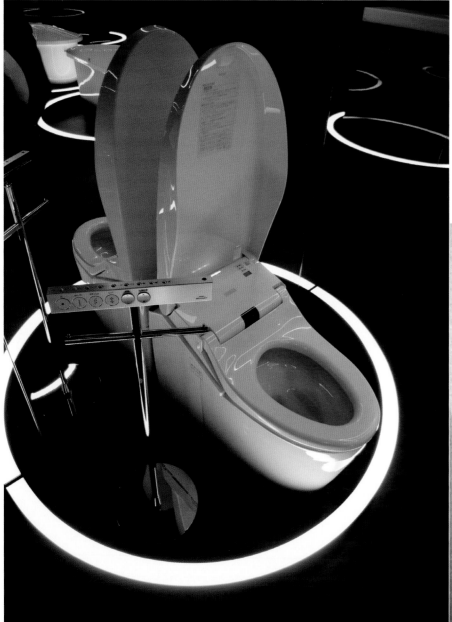

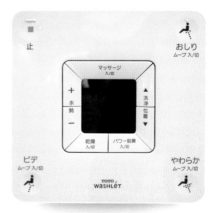

トイレ *Toilet | Toilette*

If you have ever enjoyed the comfort of a heated toilet seat in an uninsulated Tokyo house in winter, you will at least grasp the general intention behind the innovative features of modern Japanese toilets. Not that we all need noise-cancelling water sounds, three warm water spray options with adjustable force, or infrared-controlled, self-lifting toilet seats—but they are really nice to have.

Wer jemals die behagliche Wärme einer beheizten Klobrille im schlecht isolierten WC mitten im Tokioter Winter gespürt hat, kann zumindest grundsätzlich die innovativen Features der durchschnittlichen japanischen Toilette verstehen. Zwar sind geräuschüberlagerndes Wasserblubbern, drei Warmwasser-Spray-Optionen mit einstellbarer Stärke oder infrarotgesteuerte, sich selbst öffnende Toilettendeckel nicht wirklich notwendig – aber es schadet ja nix, oder?

セントラルヒーティングのない冬場のトウキョウの住居で、一度でも暖房付き便座の快適さを体験したならば、現代日本の革新的トイレ事情のあらましをつかむことができるだろう。ノイズキャンセリング機能や、三段階の温水シャワー強度調節、赤外線センサーにより自動開閉するシート。必需品ではないけれど、「あったらいいな」がある快適さ。

▲ A toilet command unit | Toiletten-Bedienungseinheit | トイレ操作パネル

◄◄ Top model of lavatory luxury (TOTO) | Topmodell der Luxustoiletten 最高級便器モデル (TOTO)

◄ Eco standard in Japan since the 60's | Wassersparmaßnahme seit den 1960ern | 60年代から続くジャパニーズ・エコ・スタンダード

Designer's vision of a self-cleaning eco toilet at "100% Design Toyko" ►
Designer-Vision der selbstreinigenden Toilette auf „100% Design Toyko"
デザイナー視点のセルフクリーニングエコトイレ（「100% Design Tokyo」）

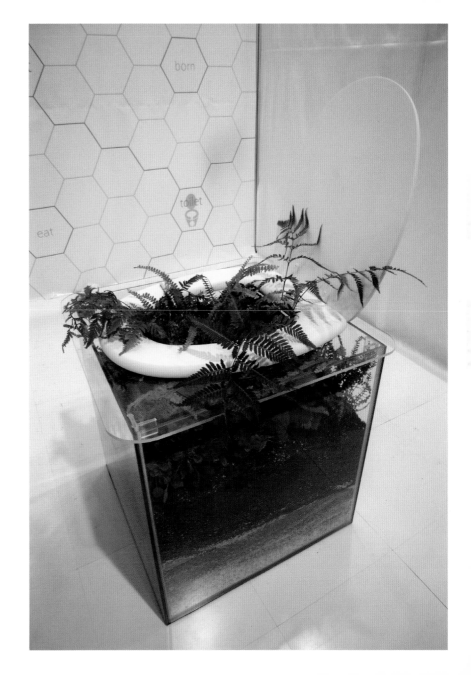

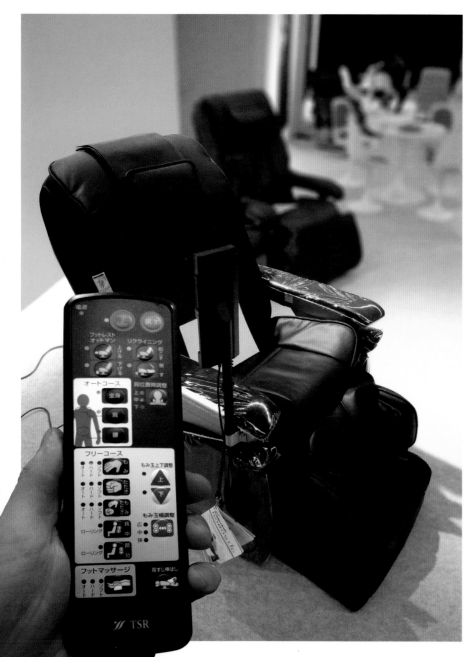

<ruby>ボタン<rt>bo ta n</rt></ruby> *Button | Knopf*

We know that the Japanese are aces at complicated electronics. But here is the trade-off: cramping in gazillions of features means cramping a button for every one of them onto the panels, making you wonder how to start the damn thing in the first place. And things can get worse, when you're stuck in the chair, being squeezed, and wondering how to stop it again.

Was komplexe Elektronik angeht, sind uns die Japaner um Welten voraus. Aber es gibt da einen Haken: Je mehr Wunderfunktionen nämlich eingebaut werden, desto mehr und umso kleinere Knöpfchen wollen richtig bedient werden. Da fragt man sich schon mal, wie das verflixte Ding überhaupt angeht – oder aus, wenn dich der Sessel gerade zerquetscht.

日本人は複雑で多機能な電化製品を生み出す名人である、というのは有名だが、その代償もある。無数の機能を詰め込むということは、つまりその機能一つ一つに対してそれだけたくさんのボタンがパネル上に押し込まれるということだ。一体どのボタンでこの機械が動き出すのか、皆目見当もつかない。ようやく動いたと思ったら、今度は止める方法が分からず、マッサージチェアに押しつぶされるはめに。

◄ *Inada* massage chair "robostic" | *Inada*-Massagesessel „robostic"
INADAマッサージチェア「ロボスティック」

◄ Typical remote for controlled Shiatsu massage | Typische Fernbedienung für kontrollierte Shiatsu-Massage | 一般的な指圧マッサージ機のリモコン

Hitachi's top washer model with Good Design Award | Hitachi's Vor-zeige-Automat mit Good Design Award | 日立洗濯機のトップモデル。赤地にGのマークは「グッドデザイン賞」受賞の証明 ►

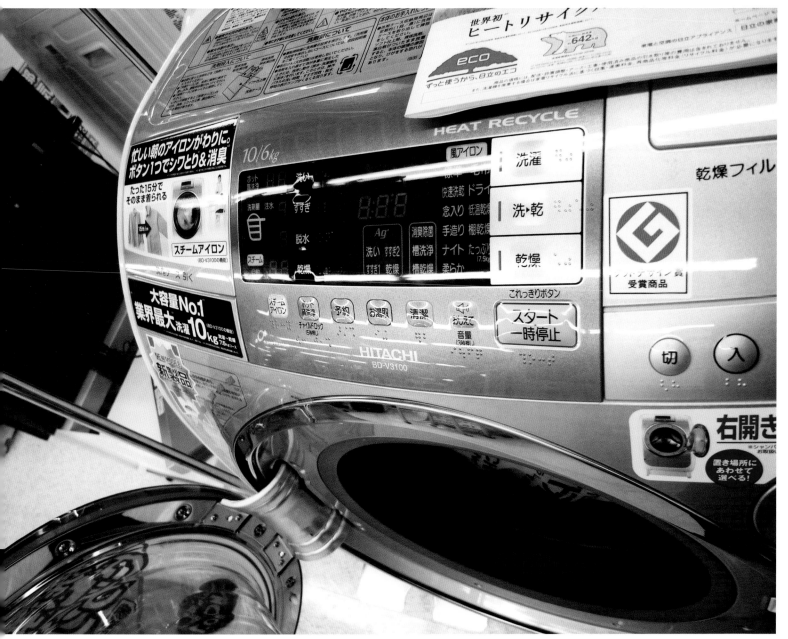

Public bus ticket system (Hakone) | Fahrkarten-
automat im Bus | 公共バスの料金精算機 (箱根) ▶

◀ Gasoline dispenser | Zapfsäule | ガソリン給油機

Tokyo Metro ticket vendor | Fahrkartenautomat
in der Tokioter Metro | 東京メトロ券売機
▼

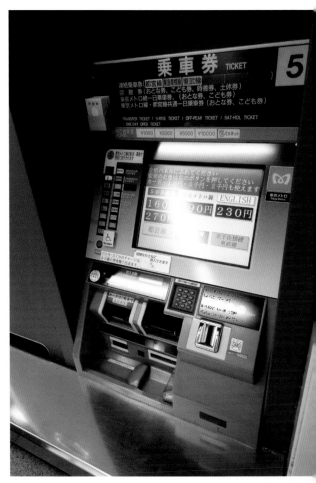

ユーザビリティ

Usability | Bedienerfreundlichkeit

Japanese technology is intentionally developed with the user in mind. If, under any circumstances, a product can possibly simplify human life, it will ultimately be deployed. Expect contact-free payments, scanning technology or talking computers everywhere. But don't expect to understand how to use them. There will be enough staff to guide you through the hidden secrets.

Bei japanischer Technologie steht der Nutzer immer im Vordergrund. Sofern ein Produkt, unter welchen Umständen auch immer, grundsätzlich in der Lage wäre, das Leben der Menschen zu vereinfachen, dann wird es auf jeden Fall entwickelt. Berührungsloses Bezahlen, Scan-Technologien jeglicher Art oder sprechende Maschinen gibt es demnach fast überall. Man darf nur nicht erwarten, dass man versteht, wie das alles zu bedienen ist. Aber das freundliche Servicepersonal wird uns da sicher weiterhelfen.

日本のテクノロジーは意図的にユーザー視点で開発されている。ある商品が生活をより楽にしてくれるという可能性を秘めているならば、それは最終的には実現される。ワイヤレスでの支払い、スキャン技術、話しかけてくるコンピュータなどが至る所に。ただし、それらを使いこなせるなんて思わないほうがいい。そこらじゅうにいるスタッフたちに聞けば、隠された秘密を暴くための手ほどきをしてくれるだろう。

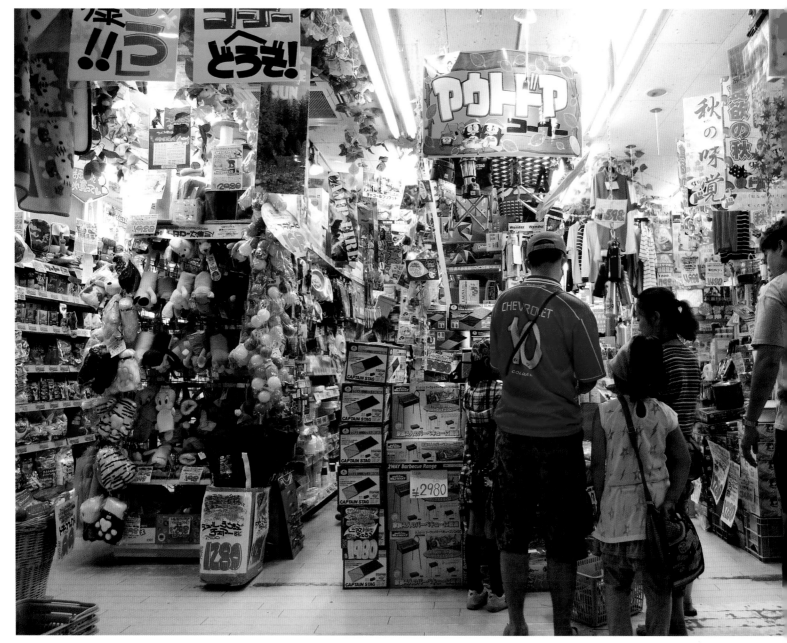

カオス

Chaos

If 1000-page-catalog-shopping were a store, Shibuya's "Don Quijote" would be it. On five absurdly cramped floors, it appears to sell every single item ever invented. If you want to educate a kid about everyday life, this is the place to bring him for a crash course. Even a fully-trained linguist would be lost for words.

„Don Quijote" in Shibuya ist das perfekte Äquivalent zum Versandkatalog. Als echtes Geschäft, versteht sich. Auf fünf hoffnungslos überfüllten Etagen gibt es ungefähr alles, was jemals erfunden wurde. Wer seinem Kind den Alltag erklären will, der sollte hier mal zum Crashkurs vorbeischauen. Dabei würden selbst einem Sprachgenie die Worte fehlen.

もしも1000ページのショッピングカタログが実際に店となって存在するとしたら、それは渋谷のドンキホーテみたいな場所に違いない。五階建てのビルの中にはありとあらゆるものが所狭しと陳列されていて、これまでに人類が発明したすべての品々が一つ残らず取り扱われているかのよう。子供に日常生活を学ばせるなら、短期集中コースの場として最もふさわしいのはこの店だ。どんなに経験を積んだ言語学者だって言葉を失うことだろう。

◄ Popular sticker corner (note the two holes in the middle: it is actually a bottle bank) (Center Gai, Shibuya) | Beliebte Stickerecke (die zwei Löcher beweisen: Dies ist eigentlich ein Flaschencontainer) | 渋谷センター街のステッカースポット（真ん中にある二つの穴はこれが実際はペットボトル用のゴミ箱だということを示す）

◄◄ Family shopping at "Donki" (Shibuya) | Familieneinkauf bei „Donki" 渋谷の「ドンキ」で家族そろってお買い物

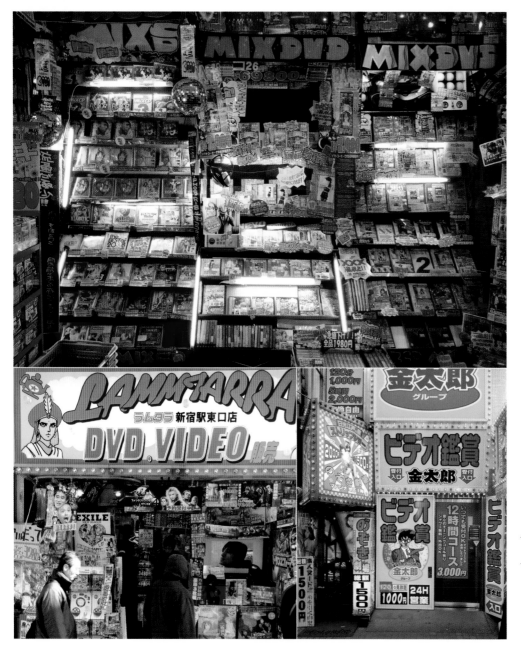

ビデオ

Video

It's hard to describe movies in words or even pictures. But that doesn't mean it isn't worth trying. Apart from being a reader's nightmare, these displays probably deliver the greatest amount of visual information per shelf this world has to offer. If it wasn't for sale, it would definitely make a great piece of art.

Filme lassen sich ja nur schwer in Worte fassen. Das heißt aber noch lange nicht, dass man es nicht versuchen könnte. Ungeachtet der unstrittigen Tatsache, dass sie etwas unleserlich sind, generieren diese Schilder die vermutlich weltweit höchste Informationsdichte pro Regalmeter. Wenn's keine Preisschilder wären, dann bestimmt tolle Kunstwerke.

映画を言葉や写真で説明することは難しいけれど、トライする価値はある。可読性は限りなく低いものの、この陳列棚の情報量は世界で有数の凝縮率を誇ることとだろう。もしも売り物でなければ、あるいは芸術作品として認められたかも。

◄ DVD racks at "Donki" (Shibuya) │ DVD-Regale im „Donki"
渋谷「ドンキ」のDVD棚

◄ Video stores (Shinjuku) │ Videotheken │ ビデオショップ (新宿)

It's little hard to make out the actual video title, isn't it? ►
Etwas schwierig, die eigentlichen Titel zu finden, oder?
一体どれが映画のタイトル？

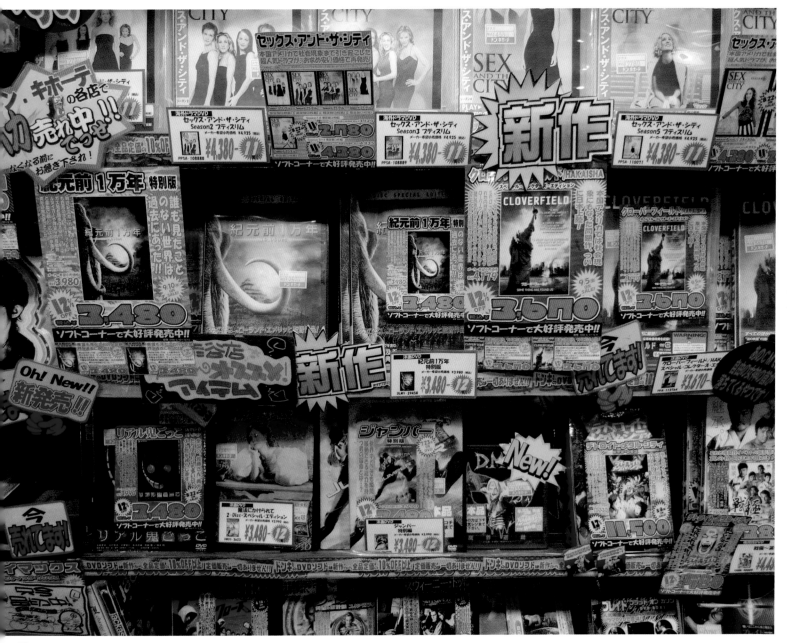

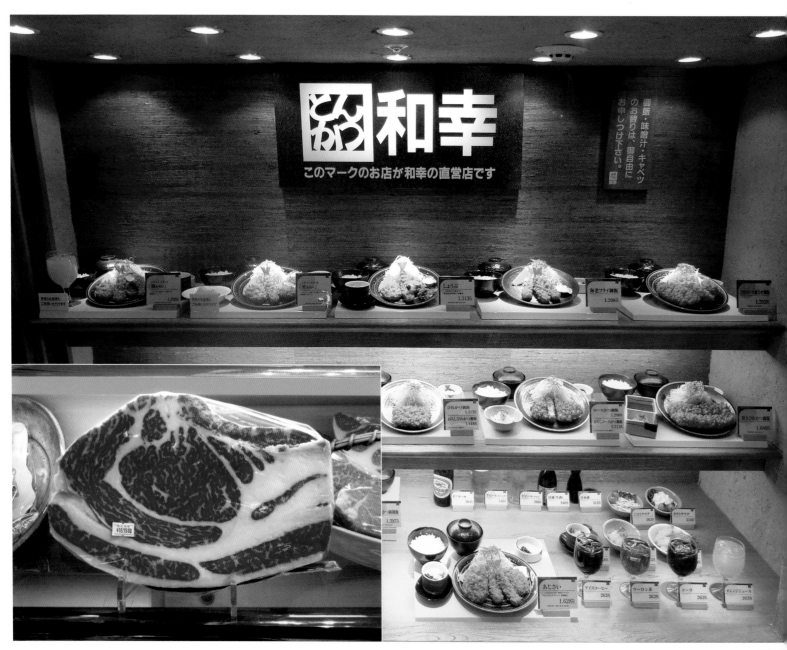

86

w(u) i ji w(u) i gu
ウィジウィグ

What you see is what you get

The better it looks, the better it sells. This is not only true for the tremendously well-crafted food mock-ups seen in nearly every single restaurant window, but for every other product, too. It doesn't always have to be the real thing (as seen with mobile phone mock-ups), but at least you need a trigger for your imagination. The more, the better.

Was hübsch aussieht, verkauft sich auch gut. Das gilt für die naturgetreuen, handgemachten Speise-Attrappen vor nahezu jedem Restaurant wie für jedes andere Produkt. Es muss ja nicht immer gleich echt sein (Handy-Attrappen tun's ja auch), aber es sollte zumindest die Fantasie anregen. Je mehr, desto besser.

ビジネス用途の場合、見栄えが良いに越したことなし。ほとんどのレストランでウィンドウに飾られた精巧な料理のサンプルはもちろん、それ以外も同様。携帯電話のモデル機でも分かるように、常に本物である必要はないにせよ、想像力への引き金が必要なのは確か。引き金が強ければなおよし。

◄ *Tonkatsu* (deep-fried schnitzel and seafood) display (Odaiba)
Tonkatsu-Auslage (frittiertes Schnitzel und Meeresfrüchte)
とんかつサンプル (お台場)

◄ A beautiful beef cut (plastic version) │ Ein herrliches Stück Fleisch (aus Plastik) │ 美しい牛肉サンプル

Wig display at a hairdresser (Shibuya) │ Perücken im Schaufenster eines Friseurs │ かつらのディスプレイ (渋谷の美容室) ►

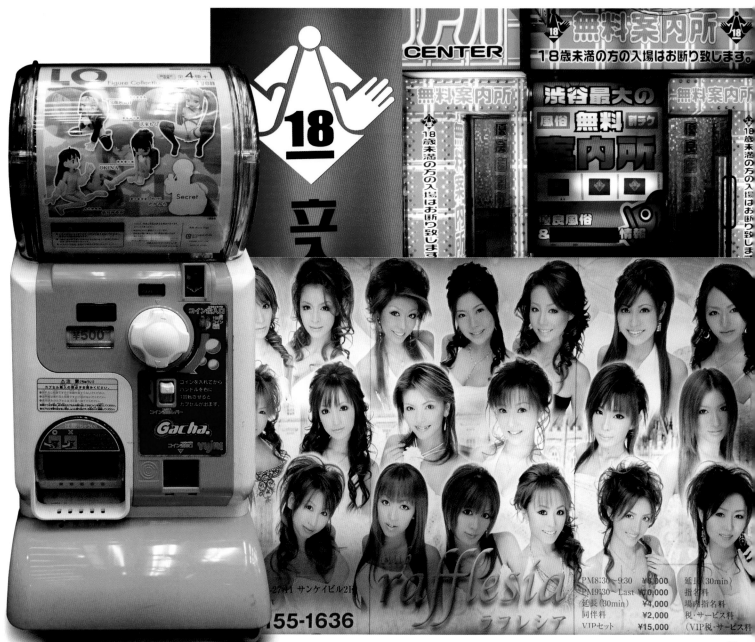

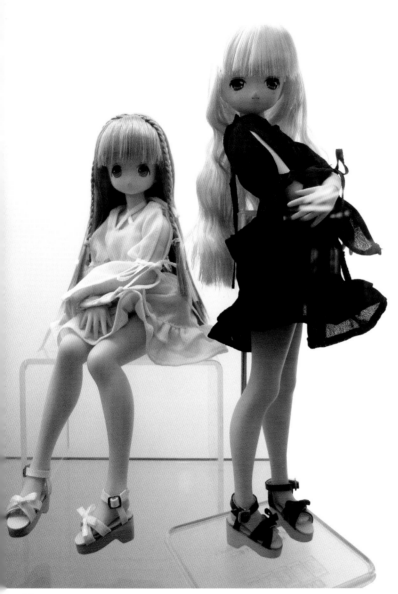

se ku su a pi ru

セックスアピール

Sex appeal

Cute young girls' looks sell well around the world, but these large-eyed, pale-faced innocent bunny fantasies take it to a whole new level: some of these dressed-up twenty-somethings try so hard to look like their plastic, fantasy counterparts that you can't even be sure who came first. Or which one to fancy.

Der niedlich-verführerische Blick junger Mädchen verkauft sich wohl überall auf der Welt, aber diese püppchenhaft blassen, großäugigen Häschen-Fantasien legen da noch einen drauf: Einige der auftoupierten Teenies scheinen sich derart mit ihren Plastikpüppchen zu messen, dass man am Ende gar nicht mehr weiß, wer zuerst da war. Oder in wen man sich verlieben soll.

女の子のかわいさがビジネスになるのは世界共通だけれど、こんな人形みたいな大きな目と青白い肌の無垢なウサギ顔は次元を超えた幻想ワールド。二十代の女の子たちは、お人形のようなルックスを必死で目指す。幻想とリアル。どちらが先にあったのか、そもそもどちらが好きなのか、だんだん区別もつかなくなる。

◄ High-class doll fetish figures (Akihabara) │ Hochwertige Fetischpuppen │ ドールマニア向け高級フィギュア (秋葉原)

◄◄ Plastic sexy toy dispenser (Akihabara) │ Spielzeugautomat mit erotischen Figuren セクシー人形の自販機 (秋葉原)

◄◄ *Navi* information booth for various sexual services (Shibuya) │ *Navi*-Auskunft über verschiedenste Sex-Service-Angebote │ 風俗案内所 (渋谷)

◄◄ Illuminated billboard covering the facade of club Rafflesia (Kabukicho) Leuchtreklame am Rafflesia Club │ クラブ「ラフレシア」のキラキラした看板 (歌舞伎町)

アダルトエンタメ

Adult entertainment
Nur für Erwachsene

Behind the busy skyscrapers of Shinjuku, next to the city's busiest station, lurks its busiest entertainment market—ready to quench your darkest desires. Just don't fool around, as most of its business is controlled by the infamously humorless Yakuza.

Hinter den Wolkenkratzern von Shinjuku, unmittelbar neben dem lebendigsten Bahnhof der Stadt, liegt deren tüchtigstes Freizeitgewerbe – bereit für besonders ausgefallene Wünsche. Aber man sollte es nicht zu bunt treiben, da fast überall die als humorlos berüchtigte Yakuza ihre Hände im Spiel hat.

高層ビル群の裏、新宿駅の横に潜む東京一の混雑を見せる歓楽街。欲望を抑制する準備が必要だ。郷に入れば郷に従え。このエリアはユーモアとは無縁な裏の世界の人々の縄張り。

Enlightening facade (Kabukicho) │ Leuchtreklamen-Fassade ▶
啓発的なファサード（歌舞伎町）

The highest award for underworld activity: black Mercedes SL ▶▶
Höchste Auszeichnung der Unterwelt: schwarzer Mercedes SL
チューンナップ済みの黒のベンツSLクラスは裏の世界の最高の栄誉

Lit billboard for handsome company (Kabukicho) │ Leuchtreklame ▶▶
für attraktive Gesellschaft │ 歌舞伎町の色男たちを照らし出す看板

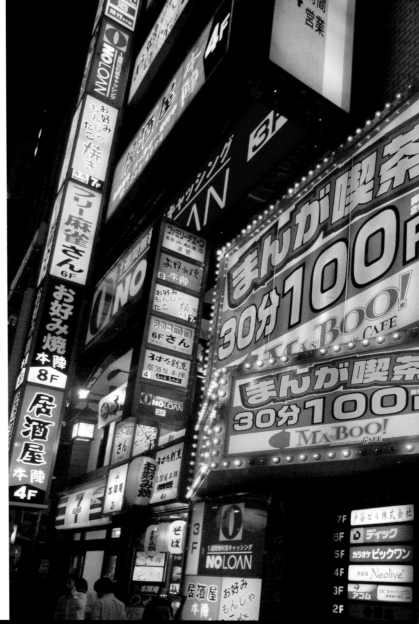

BRABUS

YAMATO HARU YUTO KEIGO RAN KAZUYA MAKI

JUNPEI SHIDOU TENMA REO YUU JIN SEIYA KUU

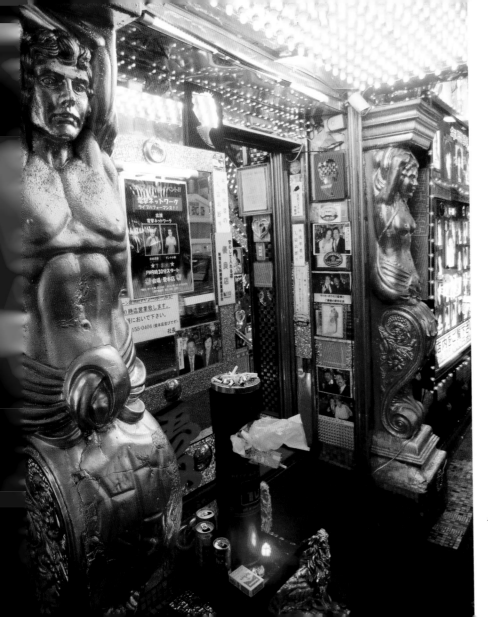

While most of Kabukicho's streets target the male "sarari man" (salaryman) seeking relief from a stressful day job, there are some places for the ladies, too. Sadly, the female customers are often hostesses themselves, spending their preciously-earned money for fake affection and absurdly expensive conversation, digging their way deeper and deeper into dependency.

Die meisten Gassen in Kabukicho bedienen männliches Publikum, das sich vom anstrengenden Arbeitstag erholen will, aber es gibt auch Etablissements für weibliche Kundschaft. Diese wiederum entstammt fast ausschließlich selbst dem Gewerbe, auf der Suche nach vorgetäuschter Zuneigung und abstrus teurer Unterhaltung, in die sie ihr tapfer verdientes Geld wieder investiert und sich so immer tiefer in Abhängigkeit begibt.

歌舞伎町にある多くの店がストレスフルな日中の仕事からの解放感を求める男性サラリーマン客を対象とする中、女性客を対象とした店も。悲しいことに、こういった女性客の多くはホステスたち。稼いだお金を偽りの愛情と理不尽なほどに高額な会話と時間に注ぎ込む。深く深く、彼女たちは依存スパイラルへとはまっていく。

◀ The Ladies Club – one of the oldest and most illustrious venues (Kabukicho) | Der Ladies Club – eine der ältesten und berühmtesten Lokalitäten | 歌舞伎町でも有名な老舗のレディースクラブ

Dazzling interiour decoration of a host club (Kabukicho) | Beeindruckende Host-Club-Innenarchitektur | ホストクラブの幻惑的な内装 ▶

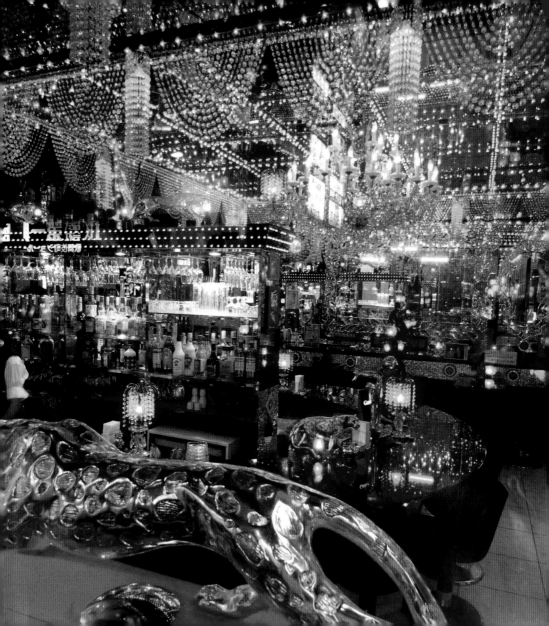

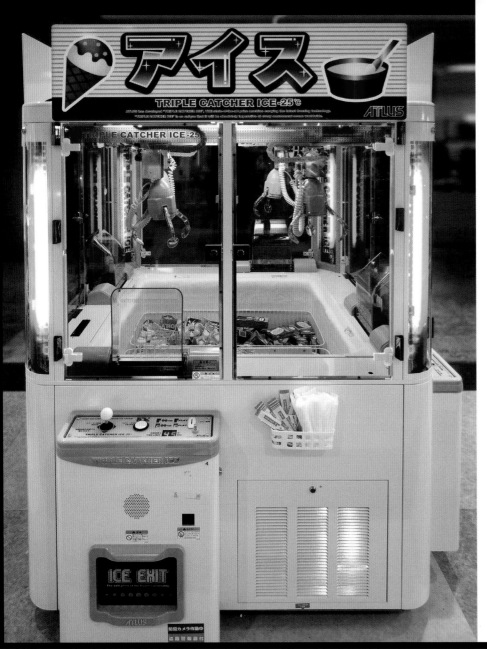

ge mu

ゲーム

Game | *Spiele*

Apart from all the virtual jungles you might get tangled up in, there's a great deal of the real deal in one of Tokyo's colorful game centers: from punching to smashing to batting to scoring soccer goals, driving action or even ice cream vending machines with built-in difficulties. Lets get physical!

Jenseits der virtuellen Flimmerwelten, gibt's in Tokios kunterbunten Spielhöllen jede Menge waschechten Spaß: Boxen, Baseball, Torwand-schießen, Autofahren oder Eisautomaten mit erhöhtem Schwierigkeitsgrad. Hau rein.

カラフルなトウキョウのゲームセンターではバーチャルジャングルに迷い込む以外にも面白いゲームが盛りだくさん。パンチしたり、思い切りたたいたり、バットで打ったり、サッカーのゴールを決めたり、車に乗ったり、ゲーム自販機でアイスクリームを買ったり。ゲームはもはやスポーツだ。

◄ Sweet temptations united: ice-cream and gambles (Odaiba)
Zwei der süßesten Verführungen vereint: Eis und Spiele
甘すぎる二つの誘惑：アイスクリームとギャンブルの融合 (お台場)

Old-school batting for the kids | Spiele-Klassiker für Kinder ►
昔懐かしモグラたたき

Manga version of the punching ball (Odaiba) | Mangaversion ►
von „Hau den Lukas" | 漫画のキャラクターで出来たパンチングマシーン (お台場)

94

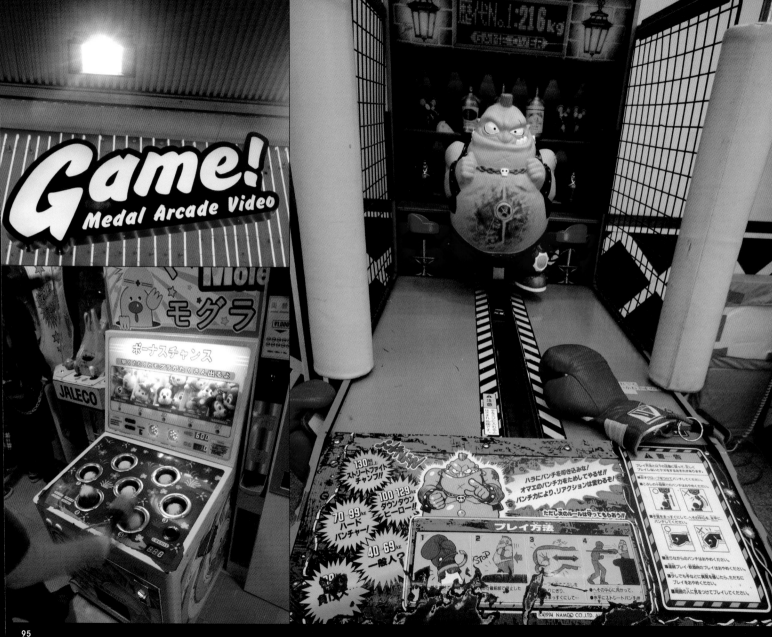

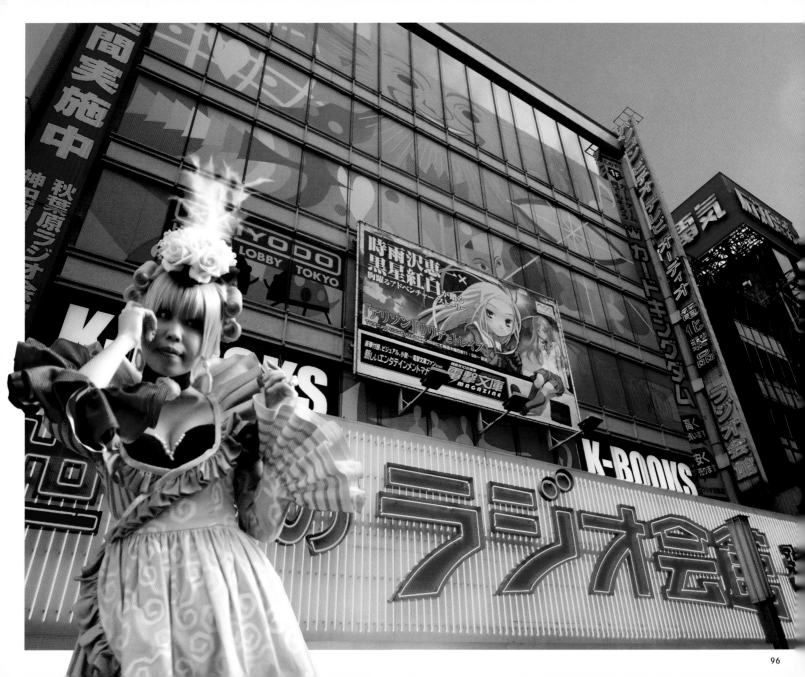

オタク

_{o ta ku}

Freaks

For every heart there is a treasure. At least in Akihabara—the wider area around the "Electric Town" district in northeastern Tokyo. With all imaginable sorts of electronic goods being just an alibi for much quirkier passions like manga, cosplay, half-naked toy beauties or even military style airsoft guns that fulfil the ultimate dream for the *Otaku*— ordinary people with extraordinary interests.

Jeder Wunsch sehnt sich nach Erfüllung. Jedenfalls in Akihabara, dem Viertel rund um „Electric Town" im Nordosten Tokios. Dabei sind all die elektronischen Spielereien dort oft nur Alibi für viel kuriosere Hobbys wie Manga-Comics, Cos(tume)-Play, halbnackte Plastikfigürchen oder täuschend echte Softair-Waffen. Eine wahre Fundgrube für *Otakus* – ganz gewöhnliche Leute mit ganz außergewöhnlichen Interessen.

心の数だけ宝物がある。少なくとも、トウキョウの北東部に位置する秋葉原電気街の周辺一帯には。「電子機器の聖地」という秋葉原の顔は、漫画の同人誌、コスプレ、半裸の人形たち、エアガンと、非凡な趣味を持つ平凡な人々、つまりオタクたちがディープな夢を存分に追求するための隠れみのだ。

◄ Large *otaku* mall with hundreds of specialized stores near Akihabara station | Großes *Otaku*-Einkaufszentrum bei der Bahnstation Akihabara オタク向け専門店が密集する秋葉原駅付近のショッピングモール

Deceptively real-looking airsoft guns | Täuschend echte Soft-Air-Pistolen | 本物と見まがうばかりの戦略スポーツゲーム用エアガン ►

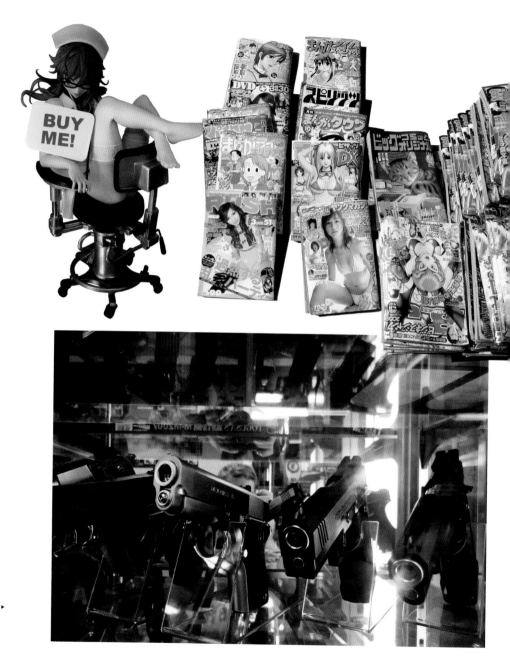

プリクラ
pu ri ku ra

Print club | Fotokabine

For the ultimate Japanese dating experience, take your darling to one of the print-it-yourself photo boxes at your local amusement arcade. There is no sweeter way of keeping your shared memories, and there is no sweeter way to say "print club" in Japanese: *puri kura*.

Als klassisches Highlight des japanischen Rendez-vous darf ein kurzer Abstecher in die Fotokabine nicht fehlen. Entzückender lassen sich gemeinsame Erinnerungen kaum festhalten, und noch entzückender als mit *puri kura* lässt sich das englische „Print Club" wohl auch nicht ins Japanische übersetzen.

日本で究極のデートを体験したいなら、プリクラへパートナーを連れて行ってみよう。街中のゲームセンターでプリクラの撮影ボックスに入り、二人の姿を写真にパチリ。プリントクラブという英語をこれ以上かわいく日本語で表現（プリクラ）できないように、二人の思い出を共有するのにこれ以上かわいい方法はない。

Inserting the coin is the easy part | Geld einwerfen ist hier noch das Einfachste | コイン投入は一番簡単な手順 ▲

Editing the final shots via pen and touchscreen | Bildbearbeitung mit Stift und Touchscreen | 写真をペンとタッチスクリーン画面で編集中 ▶

The typical print result | Ein typischer Ausdruck | プリクラ写真の一例 ▶▶

◀ A *purikura* with green chroma key background and fancy graphics (Odaiba) | Ein *purikura* mit Chroma-Key-Hintergrund und flippiger Grafik | 緑のクロマキーの背景ときれいなグラフィックを合成できる一般的プリクラマシン（お台場）

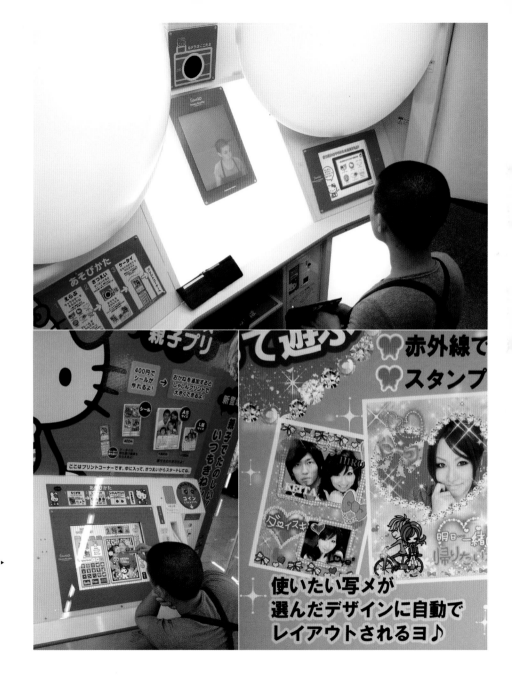

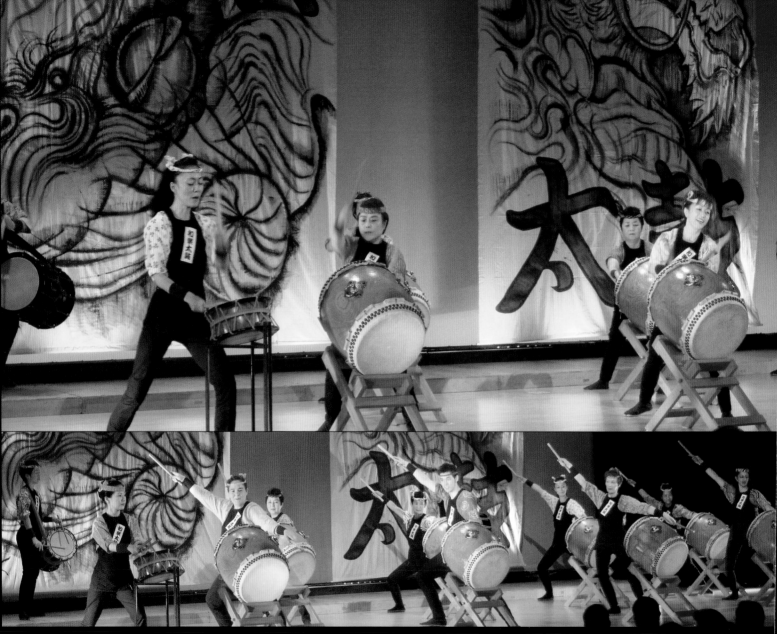

タイコ

Taiko drums | Taiko-Trommeln

The "DON-DO-DON-KA" bumping beats of a group of enthusiastic taiko drummers will shake your stomach and make you order for more. If that is not enough, go hit some beats yourself, if you don't mind the squeaking Japanese pop melodies. And please: put the sticks back.

Das satte, rhythmische „DON-DO-DON-KA" einer ausgelassenen Taiko-Performance trifft mit voller Wucht in die Magengrube, und das fühlt sich gar nicht schlecht an. Willst du noch mehr, dann probier's doch mal selbst – sofern dich die quiekenden Pop-Melodien nicht abschrecken. Aber danach bitte schön die Stöckchen zurücklegen.

情熱的な太鼓奏者のグループが「ドン・ド・ドン・カ」と刻むビートは内側から心を揺さぶり、もっと聴いていたいと思うはず。もしそれだけでは満足できないなら、自分でビートを刻んでみては？ J-Popのきしむような高音の響きにアレルギーがなければ、一度試してみるとはまってしまうかも。そして終わったら、バチは必ず元の場所へ戻してください！ お願いします。

◄ The "wagaku daiko" group (Edo-Tokyo Museum) | „Wagaku Daiko"-Gruppe | 江戸東京博物館で演奏する「和楽太鼓」

Popular taiko drum game from NAMCO | Beliebtes Taiko-Spiel von ► NAMCO | 人気のNAMCO製太鼓ゲーム

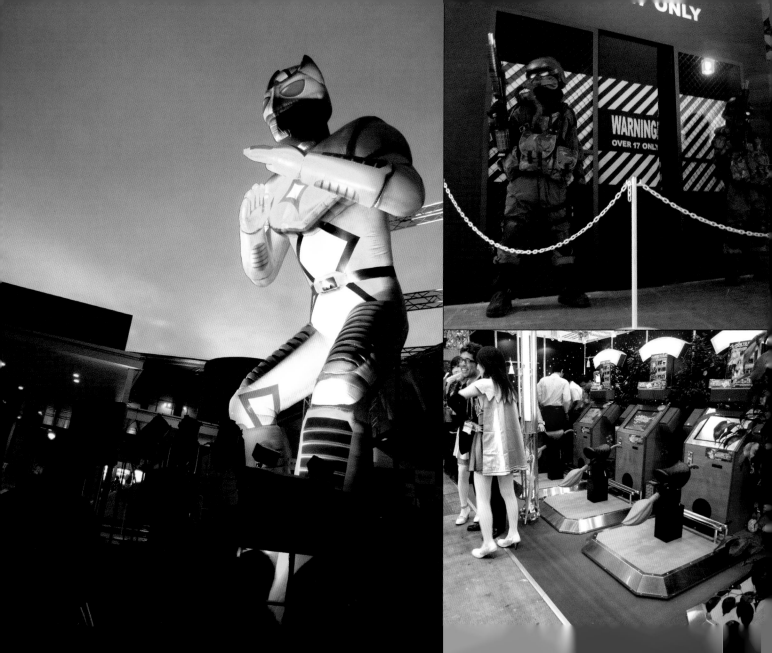

コンピュータゲーム

Computer games | *Videospiele*

After decades of sore thumbs, simple button-pressing is finally getting out of fashion. The industry is reaching for sensations beyond the screen, like cooking, gardening, witchcraft, and, of course—cuddling. There is a whole new generation waiting in line to play the latest at the Tokyo Game Show 2008.

Nach Jahrzehnten voller Blasen am Daumen wird das end-lose Knöpfchendrücken langsam altmodisch. Der Markt sehnt sich nach Sensationen jenseits des Bildschirms: kochen, gärtnern, Hexenbesen reiten und natürlich – knuddeln. All das gibt's zum Anfassen auf der Tokyo Game Show – die nächste Generation steht schon Schlange.

親指疲労と戦いながらのボタン操作という数十年の歴史が、とうとう過去の時代のものとなりつつある。この業界の挑戦は、ついに画面を飛び出した。料理、ガーデニング、魔法、そしてもちろん恋愛。「東京ゲームショウ2008」では新世代ゲーマーたちが最新ゲームをいち早く体験するべく列を連ねる。

▲　Securing new game releases from minors | Kein Zutritt für Minderjährige 新しいゲームリリースを未成年者から守るための警備体制

◄　Broom flight simulator | Hexenbesen-Simulator | 箒フライトシミュレーター

◄◄　Inflated super hero (Tokyo Game Show) | Aufgeblasener Superheld スーパーヒーロー風船 (東京ゲームショウ)

Computer cooking | Kochen am Computer | クッキングゲーム　　　　　▲

Cute pet game for the little ones | Spiel mit niedlichen Haustieren für die Kleinen | 小さい子向けのペットゲーム　　　▶

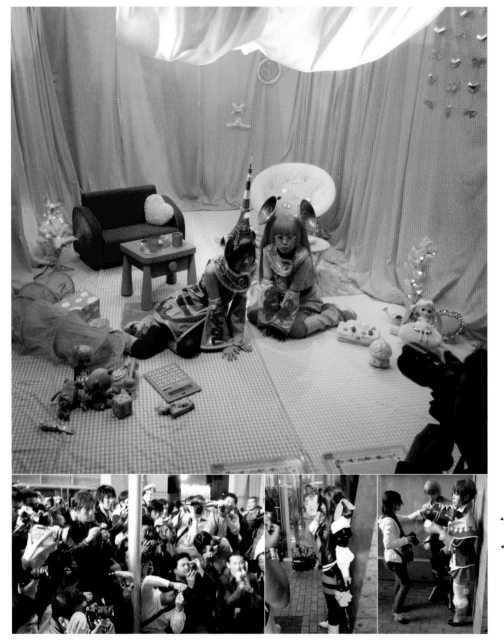

ポーズ

po zu

Pose

The bigger the camera, the smaller the man: while he sees without being seen, his large apparatus is also a safety barrier for the starlets, as the best angle is always a few feet away. Professional photographers are typically scarce in these converging encounters, but the picture itself might not be the essence at play here.

Je größer die Kamera, desto kleiner der Mann. Da dieser sich meist hinter dem Objektiv verschanzt, wirkt sein riesiges Gerät für die Mädels wie eine Sicherheitsbarriere – der beste Winkel ist schließlich immer ein paar Schritte entfernt. Professionelle Fotografen sind hier ohnehin selten, denn das Foto an sich ist vielleicht gar nicht das zentrale Motiv.

カメラが大きければ大きいほど、カメラマンは小さく見える。レンズを覗き込んでいる彼に、誰も目を向けやしない。そしてカメラの大きさは被写体となる女性たちにとってもセーフティーバリアーとして機能する。ベストショットを狙うなら、近づきすぎてはならないからだ。プロのフォトグラファーがこんな風に混み合った場所で撮影することは稀。いずれにしてもこの場合、写真の出来栄えは大した問題ではないのかもしれない。

▲ Cosplay installation (at Design Festa, Harajuku) │ Cosplay-Installation │ コスプレインスタレーション (原宿デザイン・フェスタ)
◀ Game geeks shooting female cosplayers (Tokyo Game Show) │ Computerspielefans fotografieren weibliche Cosplayer │ コスプレした女の子を撮影するゲームオタク (東京ゲームショウ)

Fair hostess lineup (Tokyo Game Show) │ Messe-Hostessen ▶
整列したキャンペーンガール (東京ゲームショウ)

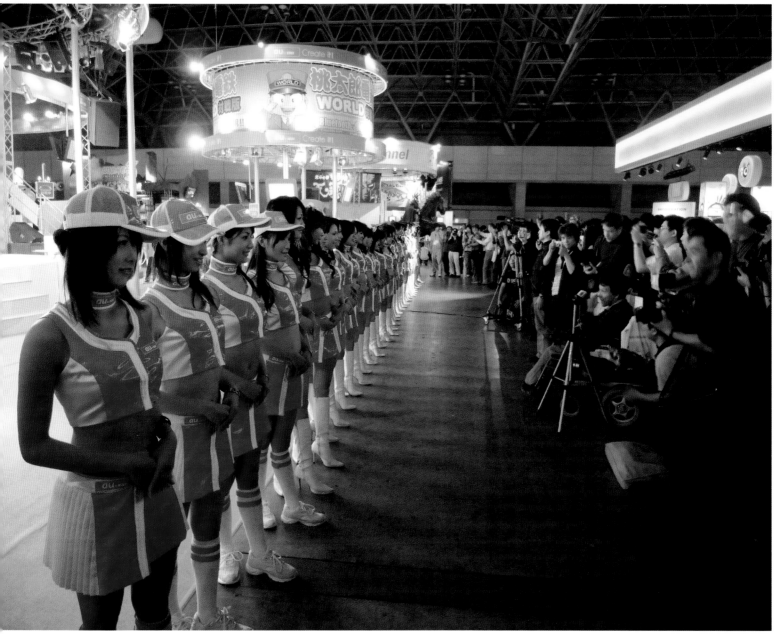

コスプレ

Cosplay

Need relief from restrictive social conventions and dull daytime jobs? Flash a fancy costume and go wild as your favourite manga star, or whatever comes to your mind. Apart from being a dazzling subculture, Cos(tume)-play and masquerade are widely accepted as expressions of personal and emotional freedom. If you dress up well enough, your co-workers won't even notice.

Raus aus dem langweiligen, überzivilisierten Arbeitsalltag? Zieh dir was Knallbuntes über, und schon bist du dein Lieblings-Manga-Star, Elvis oder einfach nur durchgeknallt. Cos(tume)play ist eine ziemlich schillernde Subkultur, gilt aber gemeinhin als akzeptierte Ausflucht, um persönliche und emotionale Freiheit zu genießen. Wenn du deine Rolle gut spielst, dann kriegen es deine Arbeitskollegen sowieso nicht mit.

ルールまみれの社会生活や気だるい日々の仕事からの現実逃避が必要？ それなら、お気に入りのアニメキャラとか、思いつくまま何にでも扮装して、ぴかぴかのコスチュームで心ゆくまで騒いでみたら。きらびやかなサブカルチャーとしてだけでなく、コスプレや仮装は自己表現や感情表現の自由として広く受け入れられている。職場の仲間に気付かれたくないなら、完璧な衣装をまとい徹底的に演じ切るのみ。

Cosplay couple (Takeshita Dori, Harajuku) | Cosplay-Paar | 竹下通りのコスプレカップル (原宿) ▶

Old man with funny hat (Harajuku) | Älterer Herr mit absurdem Hut | 不思議な帽子をかぶった老人 ▶▶

Fancy costumes (Tokyu Hands) | Ausgefallene Kostüme | 「東急ハンズ」で売られているファンシーコスチューム ▶▶

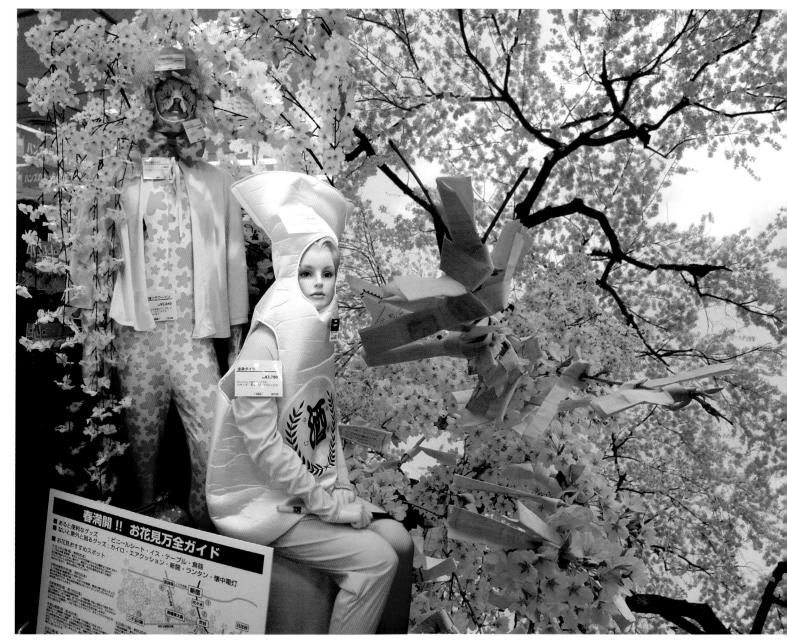

108

さくら

Sakura | *Kirschblüte*

The true natural beauty of a blooming alley of Japanese cherry trees can scarcely be beaten. So the overwhelming presence of man-made pink blossom motifs during spring should be seen as a deep bow to nature, not as a cheap copy.

Eine Allee voll blühender Kirschbäume ist an natürlicher Schönheit kaum zu übertreffen. Daher lassen sich die ganzen kitschig-pinken Blütenmotive im japanischen Frühling getrost als Verneigung vor der Natur interpretieren. Nicht als billiger Abklatsch.

満開の桜並木の美しさに勝るものはまずない。春先に街を埋め尽くす人工的な桜のモチーフは安易なコピーではなく、桜の美しさを敬愛する日本人の心の表れだ。

◀ Real sakura trees (Nara) | Echte Kirschblüten
　本物の桜の木 (奈良)

◀◀ Sakura sales (Tokyu Hands, Shinjuku) | Kirschblüte im Verkauf |「東急ハンズ」新宿店の花見セール

Sakura Bonsai imitation on display (Ueno) ▶
Eine ausgestellte Sakura-Bonsai-Imitation
桜盆栽展示会 (上野)

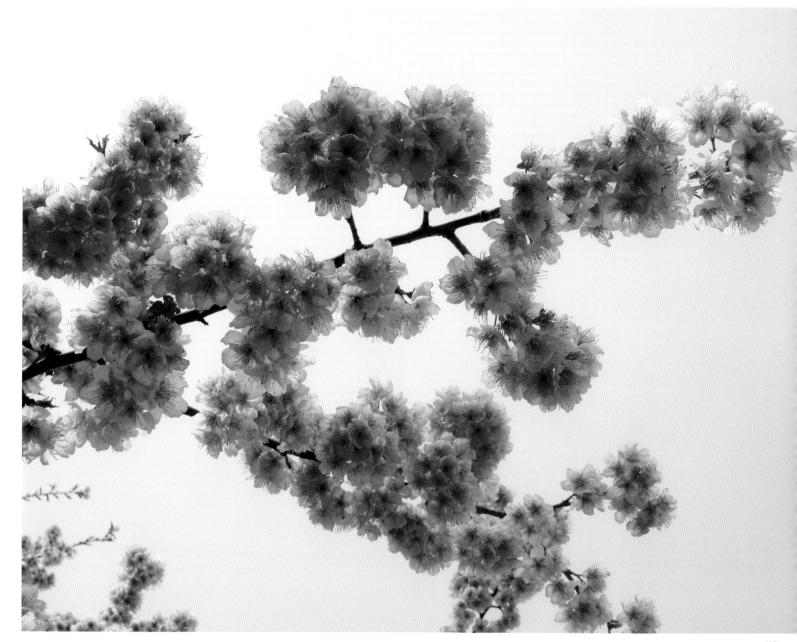

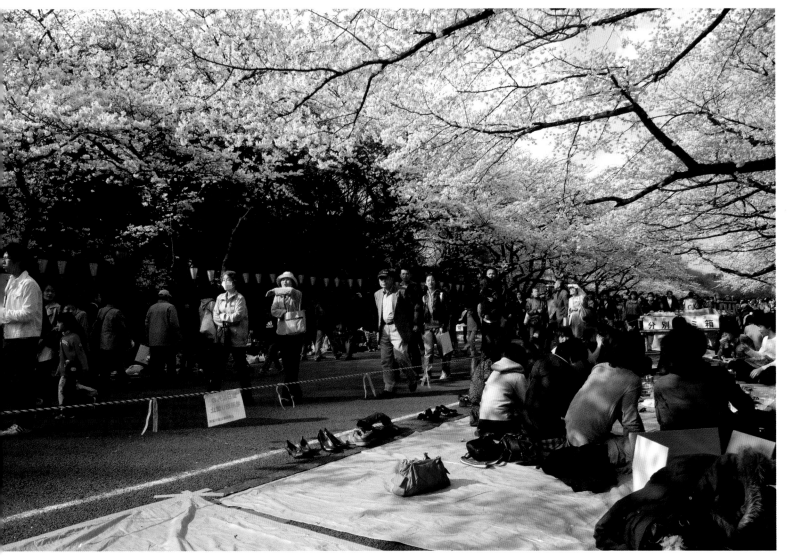

▲ Traditional Japanese *Hanami* (Flower viewing) under a blue sky, on blue plastic and with lots of others looking on (Ueno park) | Traditionelles japanisches *Hanami* (Blumenschau) unter blauem Himmel mit vielen anderen auf blauen Plastikplanen | ブルースカイの下にブルーシートを敷き、人込みに紛れて座り込む日本の伝統的な行事 (上野公園)

◀ Pink *Sakura* cherry blossom branch in perfect bloom | Pinkfarbene *Sakura*-Kirschblüte in voller Pracht | 完璧に咲き誇る桜の枝

ロボット

Robots | Roboter

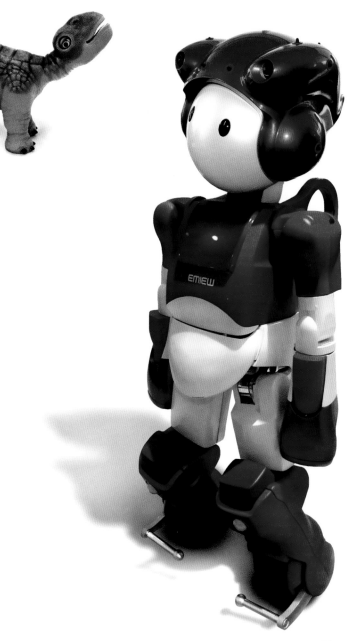

It seems as if science fiction fantasies have finally made it into our world. Now that the hurdle of walking upright has been finally overcome, let's design them how we want them to be. Not that these creations actually do anything helpful yet (beyond walking or dancing), but tech-loving Japan is definitely at the forefront of accepting them as cuddly—ahem—things. Robo-Dino with touch sensors is supposed to understand just that.

Es sieht so aus, als würden Science-Fiction-Fantasien so langsam wahr. Jetzt, nachdem die große Hürde des aufrechten Gangs überwunden ist, nehmen die Geschöpfe langsam die gewünschte Gestalt an. Nicht, dass sie bisher irgendetwas Hilfreiches tun (von Gehen und Tanzen mal abgesehen), aber hier im technikverliebten Japan haben die Menschen sie längst als niedliche – naja – Dinger ins Herz geschlossen, worüber sich besonders Robo-Dino mit seinen berührungsempfindlichen Sensoren freuen kann.

ついにSFの世界が現実になったかのよう。直立歩行という難問をとうとうくぐり抜けた今、自由自在にロボットをデザインしようではないか。歩いたり踊ったりするだけで、今のところ何かの役に立つわけではないけれど、テクノロジー万歳の日本人にはこの子たちがかわいくてしょうがない。タッチセンサー付きの恐竜ロボならその気持ち、きっと汲み取ってくれることだろう。

PLEO, the first fully-wired Camarasaurus | PLEO, der erste voll verdrahtete Camarasaurus | 世界初、フル配線されたカマラサウルス「プレオ」　▲

EMIEW (Excellent Mobility and Interactive Existence as Workmate) ▶
Size 80 cm | Größe 80 cm | 身長80センチの「EMIEW（エミュー）」

Remote controllable dancing robot with hundreds of complex poses ▶▶
Ferngesteuerter Tanzroboter mit vielen komplexen Posen
リモコン操作できるダンスロボットは数百パターンのポーズが可能

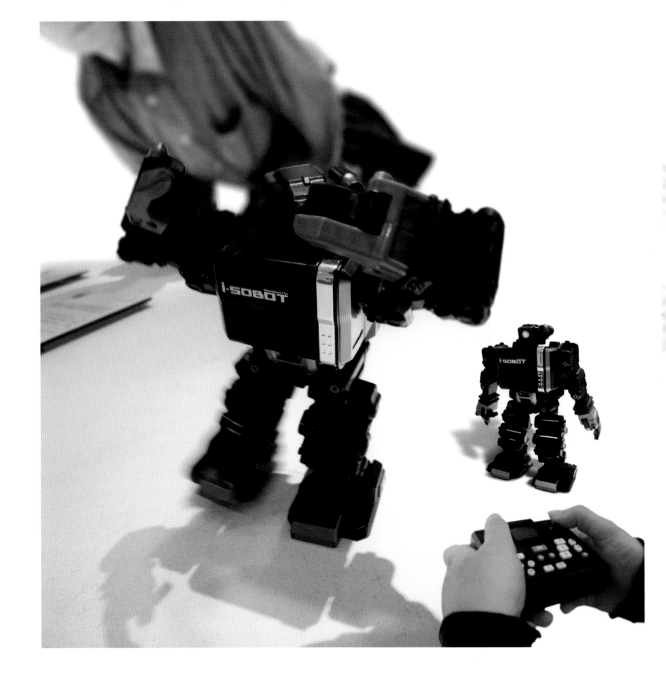

ヒーロー

Heroes | *Superhelden*

There is a long history of giant monster-defeating heroes from the 60's and 70's in Japan, and along with their truly entertaining superpowers there still is a honorific following of action figures, comics and even real life alter egos like this P-Man here, to protect the kids and their parents who have just as much fun playing along.

Seit den 1960er und 1970er Jahren gibt es in Japan eine ganze Reihe riesiger, monstervernichtender Superhelden, die mit ihren höchst unterhaltsamen Superkräften nach wie vor eine treue Gefolgschaft an Action-Figuren, Comics oder sogar lebendigen Nachahmern haben, die, wie P-Man hier, Kinder und Eltern beschützen. Wobei die Letzteren genauso viel Spaß daran haben.

日本では60〜70年代から、巨大な怪獣をやっつけるヒーローたちの歴史が刻まれてきた。純然たるエンターテインメント性、絶大なるヒーロー人気の副産物として登場したアクションフィギュアやコミックスは今もなお大勢のコアなファンを魅了している。ついには子供たちを守り、同時に大人たちを楽しませる「Pマン」が現実の世界に登場。

◀ P-Man at toy fair (Odaiba) | P-Man auf der Spielzeugmesse
お台場のトイフェアに登場したPマン

Melrose, Mirror Man, Spectrum Man, Iron King, Red Baron, and ▶
mum in the background | ...mit Mutti im Hintergrund | メロス、
ミラーマン、スペクトルマン、アイアンキング、レッドバロン、背景に母親

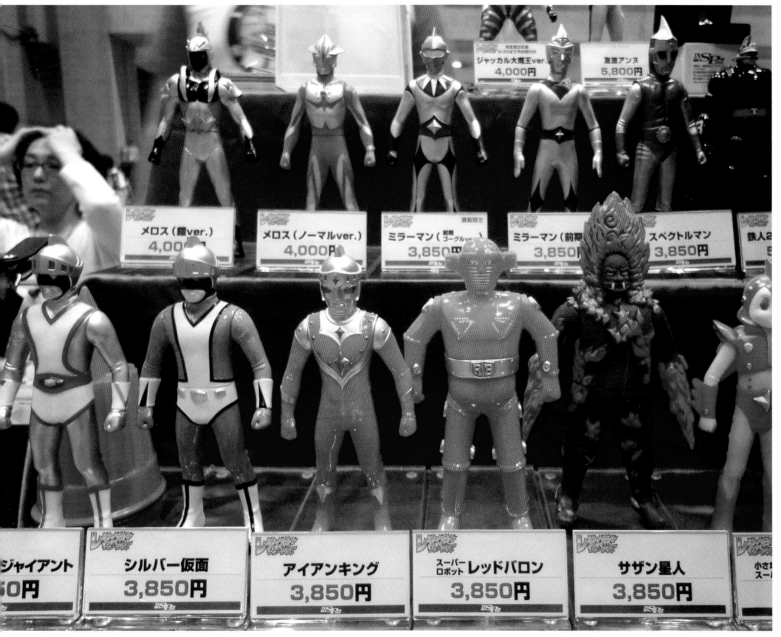

ジャッカル大魔王ver.
4,000円

友里アンヌ
5,800円

メロス（銀ver.）
4,000円

メロス（ノーマルver.）
4,000円

ミラーマン（初期
ゴーグルver.）
3,850円

ミラーマン（前期）
3,850円

スペクトルマン
3,850円

鉄人2

ジャイアント
50円

シルバー仮面
3,850円

アイアンキング
3,850円

スーパー
ロボット レッドバロン
3,850円

サザン星人
3,850円

小さな
スー

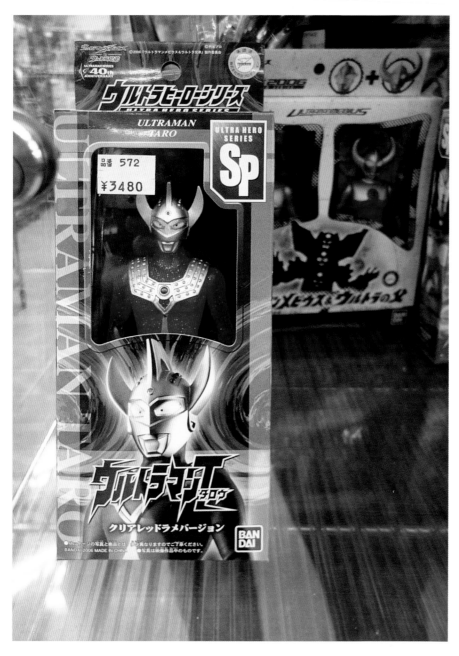

スーパーパワー
_{su pa pa wa}

Superpowers | *Superkräfte*

By far the most popular superpower giant hero series is the Ultra-Series featuring this Ultraman Taro from 1973: weighing 55,000 tons at a height of 53 meters, he can fly at a lightning mach 20 and run at 1200 kph, delivering jaw-dropping attacks like "Swallow Kick," the "Atomic Punch," or "Ultra Nenriki." Why not try those at home after a dose of super high value "ZENA" energy drinks? But beware: superpowers come with a price tag.

Die mit Abstand beliebteste Superhelden-Saga ist die „Ultra"-Serie, hier repräsentiert von Ultraman Taro von 1973: 55 000 Tonnen schwer, 53 Meter groß, kann er mit sagenhaften Mach 20 fliegen, 1200 km/h schnell rennen und dabei massenweise „Swallow Kicks", „Atomic Punches" oder „Ultra Nenrikis" austeilen. Nach einer ordentlichen Dosis „ZENA" Energy Drinks könnte man das vielleicht mal zu Hause nachmachen? Aber Vorsicht: Superkräfte haben ihren Preis.

スーパーヒーロー物で最も人気があったのは、なんといっても1973年から放映されたウルトラマンタロウが主役の「ウルトラマン」シリーズ。体重 5万5000トン、身長 53メートル、飛行速度 マッハ20、走行速度 マッハ1（時速1240キロ）で、「スワローキック」、「アトミックパンチ」、「ウルトラ念力」など奇想天外な技を繰り出す。高級栄養ドリンク「ゼナ」を一気に飲み干したなら、家で自分の必殺技を試してみては？ ただしスーパーパワーには値札が付いているので、ご利用は計画的に。

◀ Pricey Ultraman toy figure | Teuere Ultraman Spielfigur
ウルトラマンフィギュアは安くない

Costly energy drinks on a drugstore shelf | Kostspielige Energy- ▶
drinks im Drogeriemarkt | 薬局に並ぶ高価な栄養ドリンク

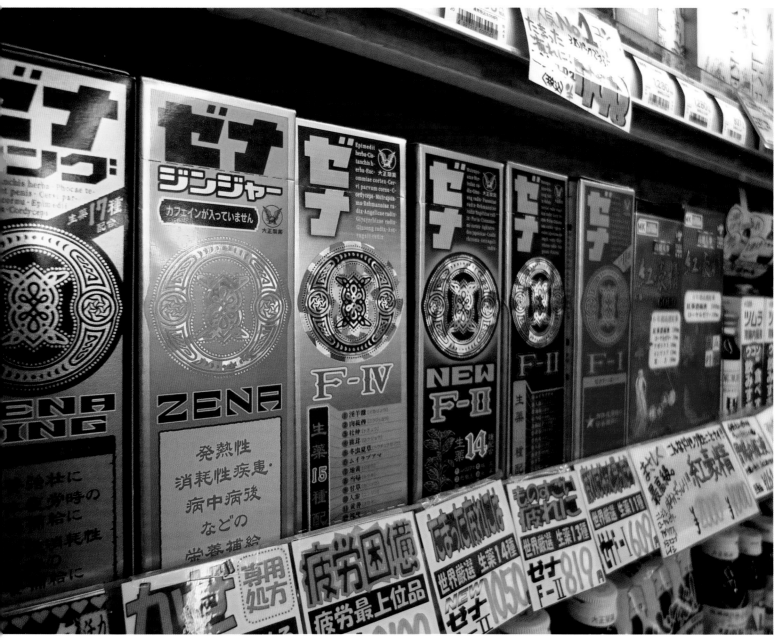

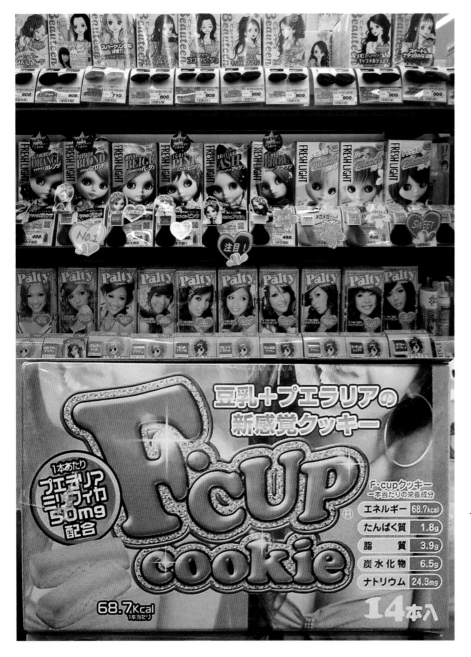

Although plastic surgery is widely accepted as a means of cosmetic improvement, we should wisely turn to the drugstore to test less invasive methods beforehand. You can be sure to find treatments for all your problem areas, especially for the ones that are just culturally imposed. You're pretty sure to find some for your doggie as well.

Obwohl Schönheitsoperationen hier fast zur Kosmetik zählen, sollte man vorher die etwas weniger invasiven Methoden aus dem Drogeriemarkt probiert haben. Hier gibt's Behandlung für sämtliche Problemzonen, insbesondere die kulturell auferlegten. Da ist bestimmt auch was fürs Hündchen dabei.

整形手術は改善策として世間に受け入れられてはいるけれど、その前にまず、ドラッグストアで買える程度のものから試してみるべきだろう。気になる個所への何かしらの対策方法が見つかるはず。日本の多くの人たちが抱えているような悩みであれば特に。犬用だって、きっと見つかるのでは？

ba d(e) i bu su ta

バディーブースター

Body boosters | *Körperpflege*

◄ (Supposedly) breast enlarging cookies | (Angeblich) brustvergrößernde Kekse | 豊胸クッキー

Pet aspirin | Aspirin für Haustiere | ペット用アスピリン ►

Foot plasters, that make your feet happy again | Pflaster für ►
glückliche Füße | 足裏用の絆創膏で、足の元気を取り戻そう

Shark extracts—a folk remedy for general health | Hai-Extrakt – ►►
unterstützt angeblich die allgemeine Gesundheit | 鮫エッセン
ス配合、トータル健康食品

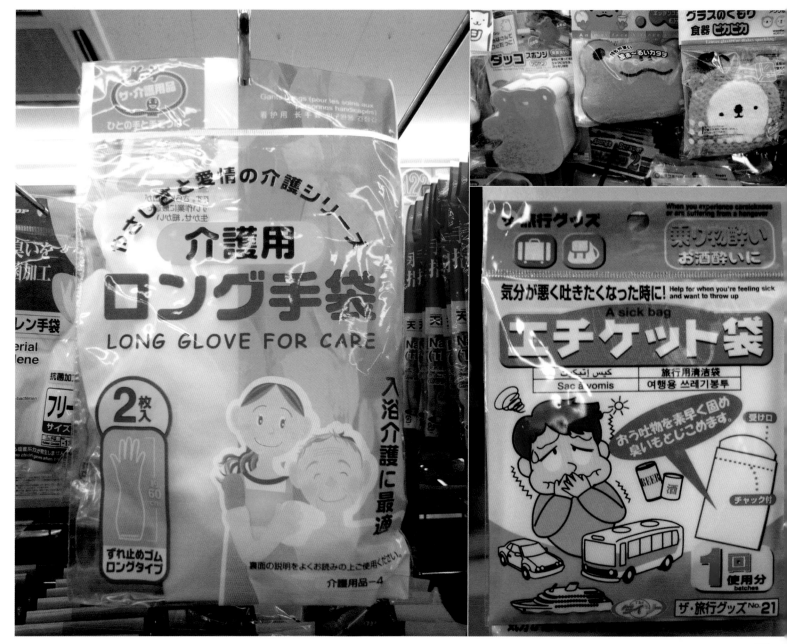

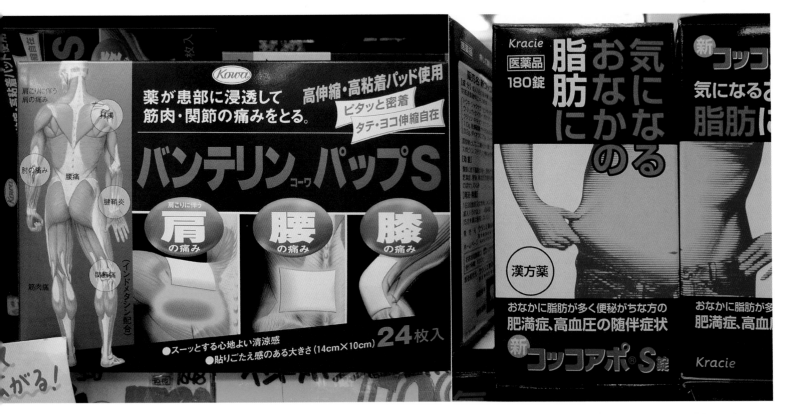

◀ No further explanations needed | Keine weitere Erklärung nötig | 説明不要

▲ These treatments get under the skin | Behandlung, die unter die Haut geht
これらの治療は皮膚の下に効く

Drugstores look almost like playgrounds sometimes, offering product illustrations that seem perfectly adapted to the emotional context of the issue. Care for the elderly might still be fun, but sore muscles and joints definitely need professional treatment.

Im Drogeriemarkt fühlt man sich fast wie auf dem Spielplatz, mit bunten Verpackungen, die jeweils perfekt auf den emotionalen Kontext des Problems zugeschnitten sind. Altenpflege mag ja noch lustig sein, aber schmerzende Muskeln und Gelenke verlangen definitiv nach professioneller Behandlung.

薬局は時として、まるで遊び場のよう。商品のイラストは人々が抱える問題や心理状況までをも見事に取り込んでいる。高齢者介護はそれほど苦じゃないかもしれないけれど、筋肉痛や関節痛には専門家によるケアがどうしても必要。

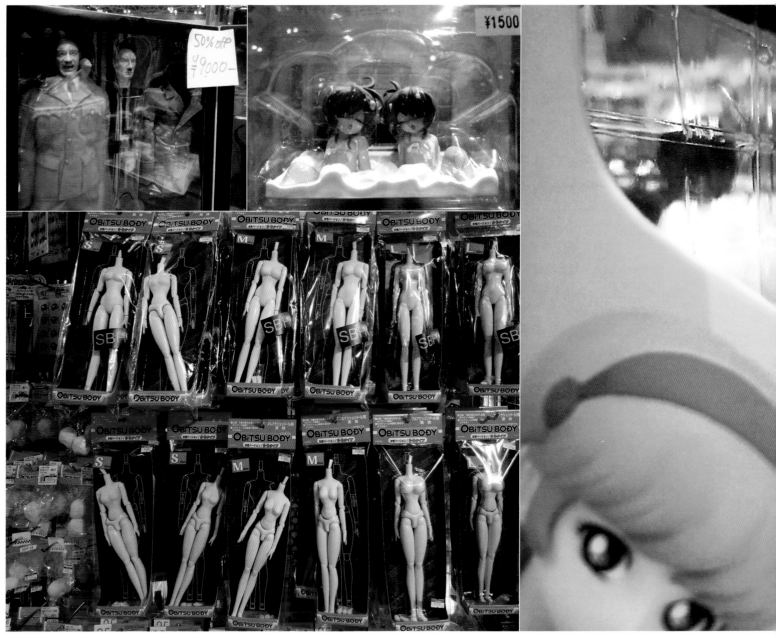

ドール
do ru

Doll | Puppe

If you can't get it in real life, just get it in plastic. No fantasy is left untouched when it comes to the Japanese doll industry. Whether you're re-staging the latest action movies, WW2 or just your sweetest dreams, here are your supplies. Forget Barbie girls—this is for grown-ups.

Wenn schon nicht im echten Leben, dann wenigstens aus Plastik. Von der japanischen Puppenindustrie wird bestimmt keine Fantasie übersehen, egal ob man die neuesten Action-filme nachstellen, den Zweiten Weltkrieg reinszenieren oder einfach nur seine süßesten Träume wahr werden lassen will. Vergesst Barbie, Mädels – das hier ist was für große Jungs.

本物が手に入らないならプラスチック製を。日本のドール産業は、人々が思い描くすべての願望を商品化。最新のアクション映画でも第二次世界大戦でも、甘美な妄想でも、何もかもがそこにはあるだろう。バービーとは全く別物だと思ってもらったほうがいい。このドールたちは大人のおもちゃ。

▲ Hand-made dog puppet | Handgemachte Hundefigur | ハンドメイド職人によるドッグパペット

◄ Encaged doll waiting for customer release | Verpackte Puppe wartet auf Erlösung durch den Käufer | 誰かに買われ、解き放たれる日をじっと待つ女の子

◄◄ Bad guy and nasty girls for sale at toy fair (Odaiba) | Böser Mann und kecke Mädels auf der Spielzeugmesse | お台場のトイフェアで購入者を待つ悪者と悪女

◄◄ Female doll body parts in all desired sizes (Akihabara) | Puppenkörper für jeden Geschmack | 好きな大きさの女性ボディーパーツが購入できる (秋葉原)

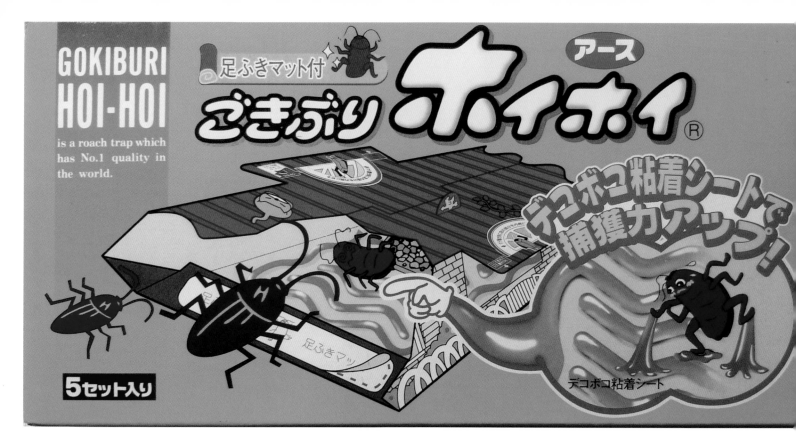

There is more than one way to fight the bugs. While some will appeal to the bloodthirsty (the kind attracted by fight clubs and horror movies), others use more sophisticated techniques. This green, box-shaped trap simulates a nice little house for the vermin, with red roof, fold-out windows, and even real miniature carpets to wipe their feet before entering (and sticking better to the glue). Come on in, buggy!

Ungeziefer lässt sich auf vielerlei Arten beseitigen. Manche Fallen sind eher blutrünstig (für Horrorfilmliebhaber und Actionfans), andere strategisch ausgefeilter. Die grüne Schachtel beispielsweise simuliert ein nettes kleines Häuschen mit rotem Dach, aufstellbaren Fensterchen und echten kleinen Fußabtretern, an denen sich die Biester ihre Füßchen säubern (um besser kleben zu bleiben). Hereinspaziert!

虫退治の方法は様々。「Fight Club」やホラー映画好きには血の流れるようなやり方を。もっとスマートで高度な技術を用いたものも。緑色の箱型トラップには赤い屋根と窓、害虫たちにとっては理想のマイホーム。お家に入る前に足を拭くカーペットまで完備…これでばっちり、糊で足裏を接着して逃がさない！ さあ虫さんたち、いらっしゃい。

▲ "Gokiburi Hoi-Hoi" (come here cockroach!), a sweet invitation into cozy deathtrap | Komm her, Kakerlake! Eine nette Einladung in die getarnte Todesfalle | マイホームへの憧れをおとりに死へと誘う「ごきぶりホイホイ」

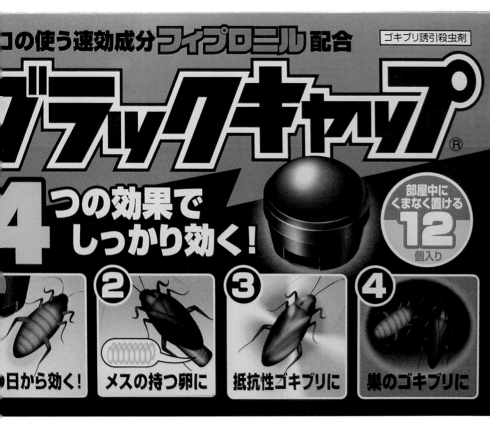

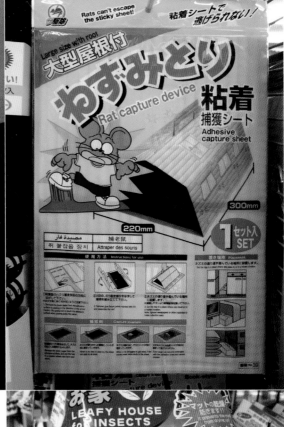

bi su to
ビースト

Beasts | *Biester*

▲ *Brakku Kyappu* ("black cap"), a strong insecticide | "Schwarze Kapsel", ein starkes Insektenvernichtungsmittel | 「ブラックキャップ」誘引式殺虫剤

Works for cockroaches and works for bigger: rat trap from the 100 YEN shop ▲ Rattenfalle aus dem 100-Yen-Shop | ごきぶりにも効く、100円ショップのねずみ捕り

Interior decoration for insects | Inneneinrichtung für Insekten | 虫用インテリ ▶ アデコレーション

As Japanese is hard and slow to read even for many Japanese, explanatory pictures are fantastically helpful, especially in situations calling for a spontaneous decision. And of course for kids and the rest of us.

Da Japanisch selbst für Japaner manchmal schwierig und langwierig zu lesen ist, sind erklärende Bildchen äußerst praktisch, vor allem in spontanen Entscheidungssituationen. Natürlich besonders für Kinder und den nichtjapanischen Rest der Welt.

日本語ネイティブにとっても、やはり文字の力には限界がある。衝動買いに直結させるには、視覚に瞬発的に訴えかけるほうが効果的。子供や日本語が読めない人にとっては特に。

◄ Mango-milk candy | Mango-Milch-Drops | マンゴーもママの味

Cough drops, bath capsule with a surprise | Hustendrops, ►
Badekugel mit Überraschung | のど飴、サプライズ付きバスボール

Cooling gel pad, milk biscuits, sushi gummies | Kühlendes Gel- ►►
Pad, Milchkekse, Sushi-Gummidrops | 熱冷却シート、ミルクビ
スケット、寿司グミベアー

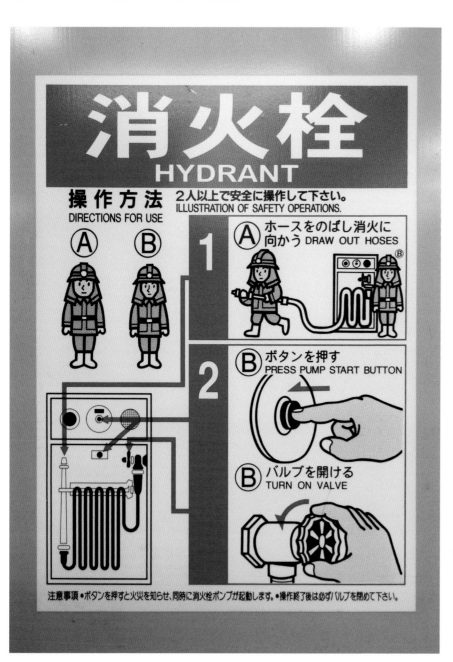

消火栓
HYDRANT

操作方法 2人以上で安全に操作して下さい。
DIRECTIONS FOR USE ILLUSTRATION OF SAFETY OPERATIONS.

Ⓐ Ⓑ

1 Ⓐ ホースをのばし消火に向かう DRAW OUT HOSES Ⓑ

2 Ⓑ ボタンを押す PRESS PUMP START BUTTON

Ⓑ バルブを開ける TURN ON VALVE

注意事項 • ボタンを押すと火災を知らせ、同時に消火栓ポンプが起動します。• 操作終了後は必ずバルブを閉めて下さい。

The literal translation of manga means "whimsical pictures," which are applied to literally anything from safety instructions to health care education. Since manga magazines are a major form of media consumption for all ages, why not use them for those unreadable tax return forms?

Übersetzt bedeutet Manga so viel wie „kuriose Bildchen", die wiederum von Sicherheitshinweisen bis zur Gesundheitsaufklärung fast überall eingesetzt werden. Manga-Magazine sind zudem generationenübergreifend dermaßen populär, dass man am besten sogar die unverständlichen Steuerformulare damit ersetzen sollte, oder?

今日では安全の手引きから健康管理教育まで幅広く使われるようになったが、漫画とは本来「気の向くままに絵を描く」という意味。漫画雑誌は幅広い年齢層に愛されるメディア媒体。そんなに浸透しているのなら、いっそのこと解読不能な納税証明書も分かりやすくマンガにしてしまうのはどうだろうか？

◄ "How to operate a hydrant" at a Tokyo government building
Gebrauchsanleitung für den Hydranten in einem Amtsgebäude
東京都庁の壁に貼られた、消火栓の操作説明書

Brochure on drug abuse by the Tokyo police department ►
Broschüre über Drogenmissbrauch von der Polizei in Tokio
警視庁が作成した、覚せい剤の害を訴える冊子

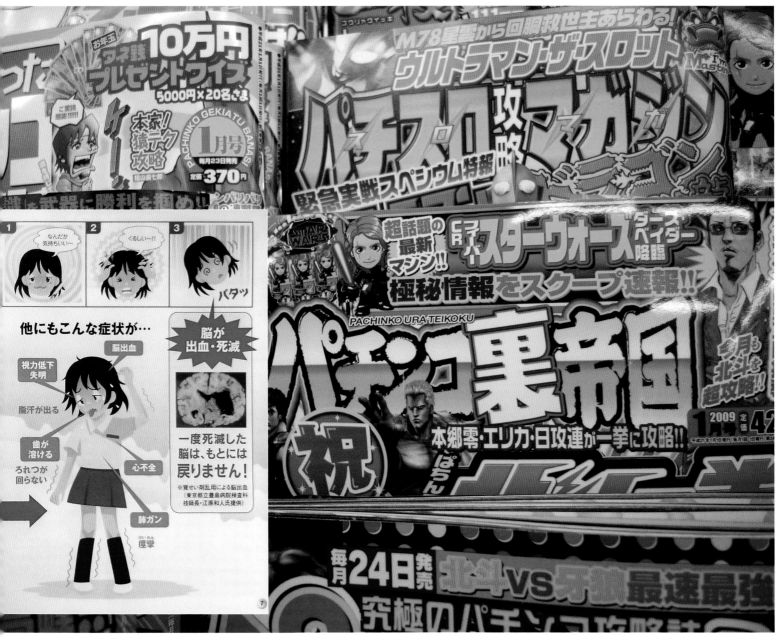

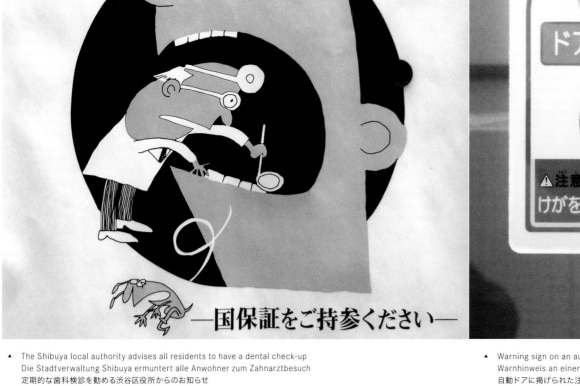

渋谷区役所・渋谷区歯科医師会

—国保証をご持参ください—

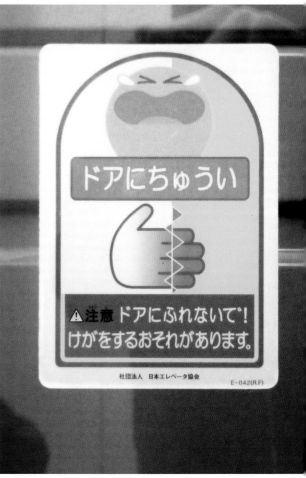

ドアにちゅうい

⚠注意 ドアにふれないで！
けがをするおそれがあります。

社団法人 日本エレベータ協会

E-042(R.F)

▲ The Shibuya local authority advises all residents to have a dental check-up
Die Stadtverwaltung Shibuya ermuntert alle Anwohner zum Zahnarztbesuch
定期的な歯科検診を勧める渋谷区役所からのお知らせ

▲ Warning sign on an automatic sliding door
Warnhinweis an einer automatischen Schiebetür
自動ドアに掲げられた注意事項

Official education on the various types of guide dogs ▶
Amtliche Aufklärung über verschiedene Arten von Hilfshunden
様々な種類の補助犬に関する教育的ポスター

ほじょ犬（身体障害者補助犬）とは…

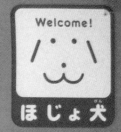

Welcome!

ほじょ犬

目や耳や手足の不自由な人の生活のお手伝いをする、
「盲導犬」「介助犬」「聴導犬」のことです。
特別な訓練を受けた犬たちで、『身体障害者補助犬法』に基づき認定されています。

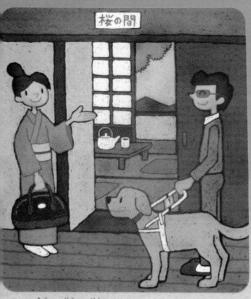

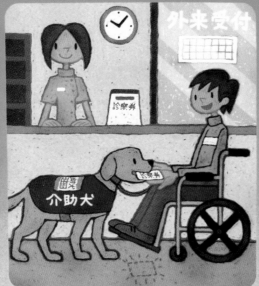

盲導犬
目の不自由な人が安全に街なかを歩けるように、段差や曲がり角などを教えます。胴体にハーネスをつけているのが特ちょうです。

介助犬
手足が不自由な人に代わって、落としたものを拾ったり、ドアを開けたり、スイッチを押したりします。着がえも手伝います。

聴導犬
耳が不自由な人に代わって音を聞き、それを知らせます。車のクラクションやドアチャイムの音、非常ベルなどを教えます。

「身体障害者補助犬法」の一部が

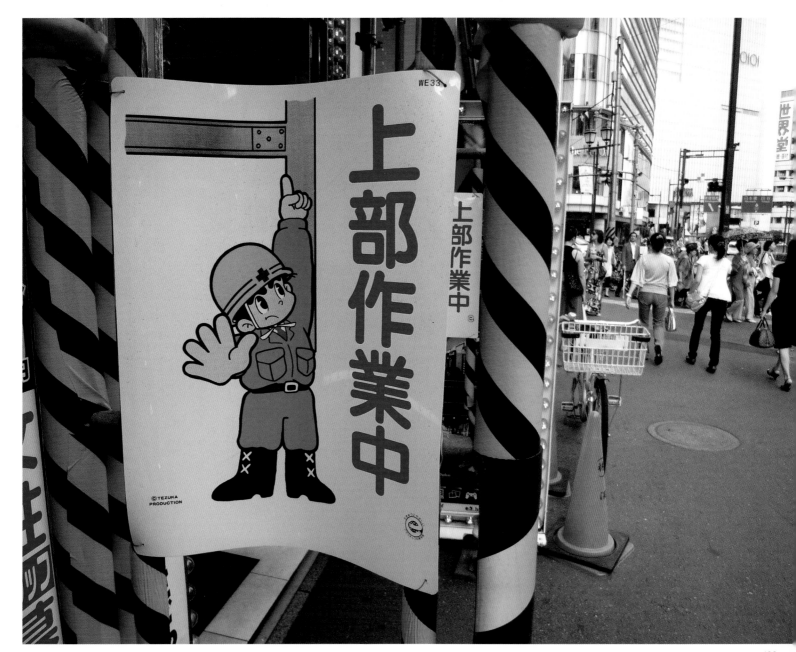

バンピング
ba n pi n gu

Bumping | Beule

Many dangerous things come from above—even more so if there is so much building going on. But actually it's not only about falling things here, but more about bumping one's head. Especially for foreigners who don't comply with the standard average Japanese height.

Alles Gute kommt von oben? Von wegen! Hier wird's eher gefährlich, hauptsächlich wegen der vielen Baustellen. Aber herabfallende Dinge werden zur Nebensache, wenn man sich ständig den Kopf stößt. Insbesondere wenn man nicht der japanischen Durchschnittsgröße entspricht.

多くの危険は天から舞い降りてくる。建築中のビルがそばにある場合、その可能性はより一層高まる。ただし、実際危険なのは落下物だけではなく、至る所で頭をぶつけてしまうことだ。日本人の平均身長から考えて規格外となる外国人の場合は特にそう。

◄ Dangerous scaffolding (Shinjuku) | Gefährliches Baugerüst
危険な建築現場 (新宿)

Danger from above (Shinjuku Gyoen) | Gefahr von oben ►
天からの危険物 (新宿の公園)

ガード
^{ga} ^{do}

Guards | Aufpasser

Tokyo seems full of police. But in fact, most of the blue uniforms you encounter in the streets have no law enforcement authority whatsoever. But hey—if you are working as anti-smoking officer, parking guide or security waver at a construction site, you are happy for every scrap of credibility. And happy you've not been replaced by the next robot, yet.

In Tokio scheint es von Polizisten nur so zu wimmeln. In Wirklichkeit haben nur die wenigsten Uniformträger, denen man auf der Straße begegnet, überhaupt irgendeine gesetzliche Autorität. Aber hey – jeder Parkplatzwächter, Rauchpolizist oder Baustellen-Sicherheits-Winker ist froh über jedes noch so kleine bisschen Glaubwürdigkeit. Genauso froh wie über die Tatsache, dass er noch nicht durch den nächsten Roboter ersetzt wurde.

トウキョウは警察だらけのように見えるかもしれないが、街中で青い制服を着ている人すべてが警官というわけではない。彼らに法的強制権はないけれど、禁煙運動職員でもパーキングの案内人でも工事現場で旗を振る交通誘導係でも、制服がもたらす信用効果には満足しているはず。それは、人の存在意義がロボットによって奪われていないことにあなたが安堵感を覚えるのと同じだろう。

◄ Safety robot waving its arm to warn of street construction (Shinjuku) | Sicherheitsroboter warnt mit winkendem Arm vor Straßenbauarbeiten | 新宿の工事現場で腕を振るロボット警備員

Anti-smoking officers (Shinjuku) | Rauchpolizei ►
路上喫煙禁止運動部隊 (新宿)

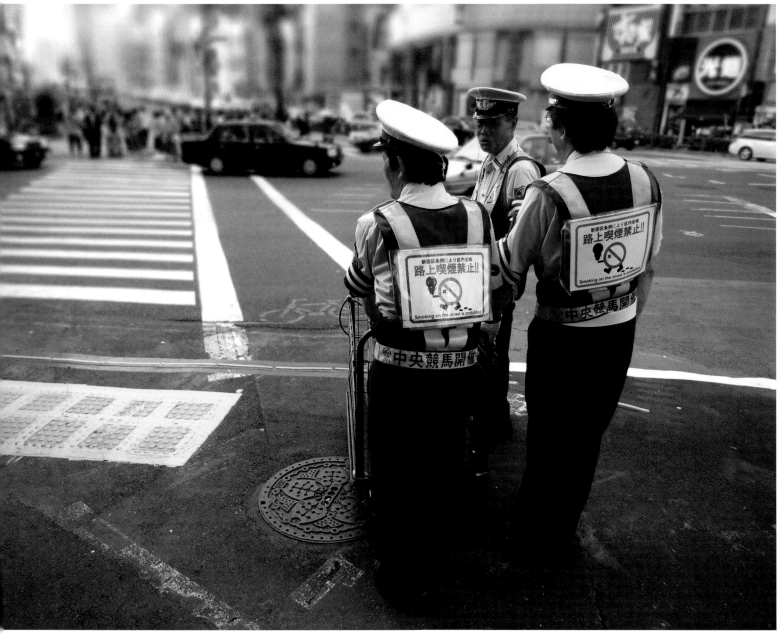

バイシクル
ba i shi ku ru

Bicycle ｜ Fahrrad

If you are ready to face the ultimate adrenaline ride through Tokyo's downtown traffic, practice tight-corner evasion maneuvers and bring a loud bell. You will be spending most of your time on the crowded sidewalks trying to avoid passersby, tiny dogs, and parking delinquents. And remember to do it in style.

Wer bereit ist für den ultimativen Adrenalin-Ritt durch Tokios Innenstadtverkehr, sollte spontane Ausweichmanöver üben und eine laute Klingel mitbringen. Man radelt ohnehin die meiste Zeit auf überfüllten Bürgersteigen und weicht Passanten, kleinen Hunden und Parksündern aus. Aber bitte mit Stil.

トウキョウの繁華街の真っ只中で究極のアドレナリン・ライドを試してみるなら、急カーブに耐えうる運転技術と大音量のベルが必要。側道を行き交う人々や小型犬、違法駐車の車をよけることに、ほとんどの時間を費やすことになるのだから。くれぐれも、どんな状況でもスタイリッシュに。

Fancy triangle-shaped minibike (Ebisu) ｜ Ausgefallenes Dreieck-Minirad ｜ おしゃれな三角形ミニバイク (恵比寿) ▶

A full fleet of police bikes at Hachiko Police Box (Shibuya) ｜ Polizeiflotte ｜ 出陣の日を待つ警察自転車 (渋谷ハチ公警察署) ▶▶

Minimalistic theft protection ｜ Minimale Diebstahlsicherung ｜ 最小限の盗難対策 ▶▶

A German folding bike (Ebisu) ｜ Deutsches Klapprad ｜ ドイツ製折りたたみ式自転車 (恵比寿) ▶▶

Giant advertisement truck (Shibuya) | Riesiger Werbelastwagen | 巨大な広告トラック (渋谷)

a do ba ta i zu me n to
アドバタイズメント

Advertisement | *Reklame*

Escape is not an option. Commerce is lurking everywhere and it's by far the major cause of colors stimulating your retina. After all, it brightens up the daily grind, so what's wrong with shopping?

Flucht ist unmöglich. Knallbunter Kommerz, verantwortlich für fast alle Farbreize des Tages, lauert überall. Und von derart erfrischender Abwechslung zum grauen Alltag mal ganz abgesehen: Shopping ist doch gar nicht so schlecht!

「逃げる」というのは選択肢にない。絶え間なく網
膜に映り込む広告がなければ、トウキョウの街に
色はない。日常に飽きたら、気晴らしに買い物へ。
その発想に何の矛盾もない。

クリスマス

<small>ku ri su ma su</small>

Christmas | *Weihnachten*

Christmas is not so much a spiritual moment of peace, love, and tranquility, but more another opportunity for splendid displays of economic radicalism. Whether you call colorful "illumination" a beauty or a beast might depend on which side of the counter you're leaning on. Just don't call it redundant.

Die japanische Weihnachtszeit hat mit Liebe, Ruhe und spirituellem Frieden nur am Rande zu tun. Mit gefühlsduseliger Zurschaustellung überschwänglicher ökonomischer Reize dafür umso mehr. Ob man die quietschbunte Beleuchtung als Segen oder Fluch empfindet, hängt meist davon ab, auf welcher Seite der Ladentheke man steht. Überflüssig ist sie aber nicht.

この国のクリスマスとは平和や愛、穏やかさに象徴されるようなイベントではなく、派手なディスプレイで狙う大いなるビジネスチャンスだ。街を彩る極彩色のイルミネーションを美女に例えるか野獣に例えるかは個人の主観によりけり。いずれにせよ、無用の長物なんて言ってはならない。

◄ All clichés united (Shibuya) | Alle Klischees versammelt
クリスマスと言えば (渋谷)

Christmas illumination *irumineishon* (Shibuya 109) | Weihnachtsbeleuchtung | クリスマスイルミネーション (渋谷109) ▲

Pink is the new red in ATRE mall (Ebisu) | Pink ist das neue Rot im ATRE-Einkaufszentrum | 赤もいいけど、これからはピンクの時代？ (恵比寿アトレ) ►

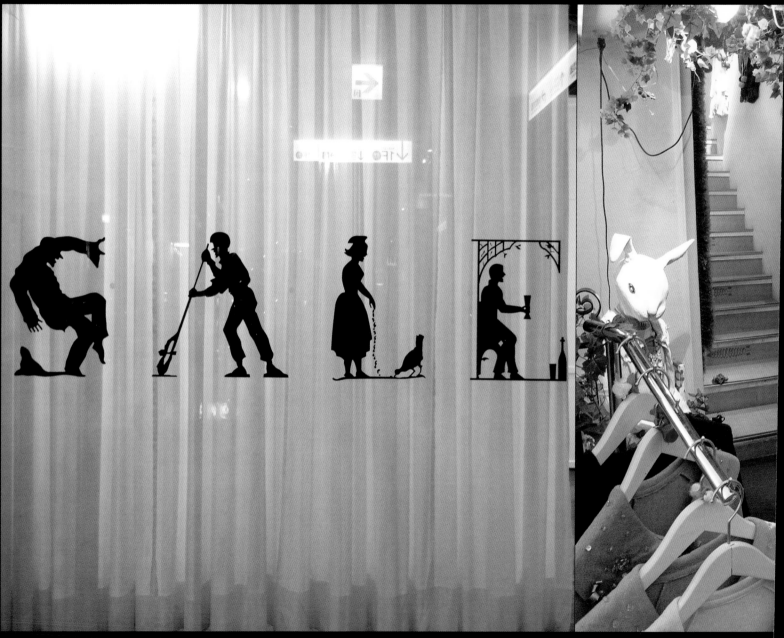

ba　ge　n

バーゲン

Bargain ｜ Angebot

Of course, all the usual sales tricks sell here as well: Bold colors, half-naked ladies, and large price labels with lots of nines. But every now and then you'll find them disguised in such charming style, it's hard to resist.

Natürlich funktionieren hier die gleichen Tricks wie anderswo auch: gewagte Farben, nackte Haut und riesige Preisschilder mit vielen Neunen. Aber hin und wieder wird man auf derart charmante Art und Weise verführt, dass es schwer ist, zu widerstehen.

もちろん、いわゆるセール商法は日本でも同じこと。派手な色、半裸の女性たち、「9」の数字が並ぶ値札。しかし時として、こんなにチャーミングな扮装に遭遇してしまったら、もうお手上げだ。

◀ Bunny shop entrance (Harajuku) ｜ Eingang zum Hasenshop
店頭でウサギがお出迎え (原宿)

◀◀ Alternative to bold red letters (Omotesando) ｜ Alternative zu fetten roten Buchstaben ｜ 派手な赤文字の代わりに (表参道)

エレクトロニクス

Electronics | Elektronik

Such a thing really shouldn't exist, but here it is: tired of love handles but too tired to step? Hop on the comfy hobby horse for some exercise in front of the TV. We haven't found a horse-shaped one, but the giraffe should get you close enough to the wild.

So etwas dürfte es eigentlich gar nicht geben, aber hier gibt's es dennoch: Hüftspeck, aber zu faul für den Stepper? Spring aufs gemütliche Sitzpferd und mach's dir zum Sport vor dem Fernseher bequem. Der ist zwar als Pferd gerade nicht lieferbar, aber die Giraffe ist nah genug dran an der Wildnis.

常識を覆すような現実がここに。おなかの肉が気になるけれど、運動はちょっと？ だったら、テレビを見ながらインドア乗馬を試してみては？ 馬の形をしたマシンはまだ発見されていないけれど、このキリンを一緒に買っておこう。より野生の気分を味わえるはず。

◀ Electrically powered horsebacks (BIC CAMERA) | Elektrischer Pferdesattel | 電気稼働式馬の背中（ビックカメラ）

Crossbreed between soft toy giraffe and television set ▶
Halb Stoffgiraffe, halb Fernseher | テレビとキリンのハーフ

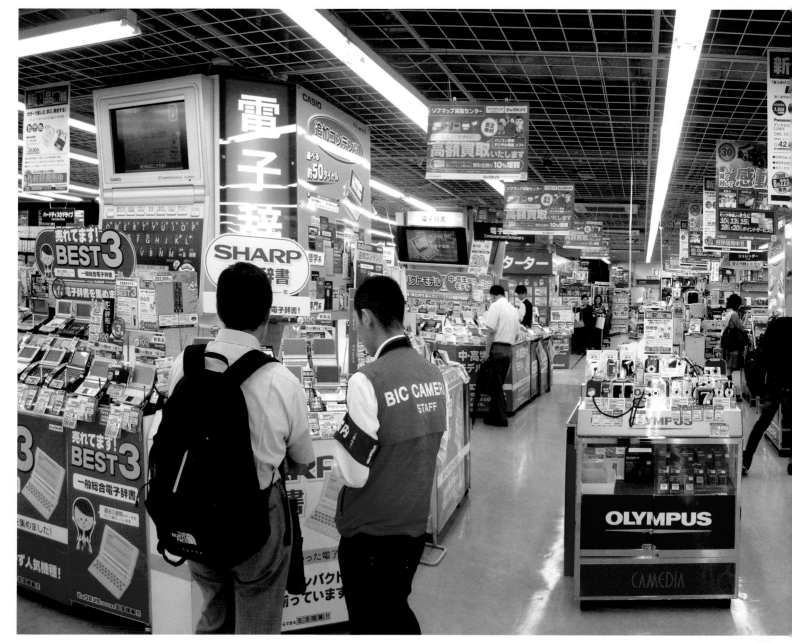

ビックカメラ

Bic Camera

A visit to a large Tokyo electronics store like BIC CAMERA is literally an overwhelming experience. Apart from floor and ceiling, there is no single spot in the room not launching a message aimed at your eyes. And if that wasn't enough, every one of them seems to be repeated through loudspeakers, just in case you overlooked it.

Der Besuch eines großen Elektronikfachgeschäfts wie BIC CAMERA ist ein buchstäblich beeindruckendes Erlebnis. Es gibt keinen einzigen Fleck im Raum, abgesehen von Boden und Decke, der nicht mit einer passenden Botschaft bestückt ist. Und als wäre das nicht genug, scheint fast jede einzelne durchgehend von Lautsprechern wiederholt zu werden, nur für den Fall, dass man sie möglicherweise übersehen hat.

「ビックカメラ」のような大型家電量販店に行ってみるというのは、まったく圧倒される体験だ。床と天井以外のすべての場所には何かしらのメッセージが書かれ、客の視界を直撃する。あたかもそれだけでは不十分であるかのように、メッセージがスピーカーからも大音量で繰り返し流される。お客様が大切な何かを見逃してしまうかもしれない可能性に配慮しているのだ。

◀ One of seven floors of a large BIC CAMERA store (Yurakucho)
Eine von sieben Etagen eines großen BIC CAMERA-Geschäfts
七階建ての「ビックカメラ」有楽町店本館のワンフロア

チョイス

Choice | Auswahl

◀ A classic choice of sushi | Klassische Sushi-Auswahl | 一般的な寿司メニュー

▼ 29 different kinds of golf balls (BIC CAMERA, Yurakucho) | 29 verschiedene Golfballsorten | 29種類のゴルフボール (「ビックカメラ」有楽町店)

Beyond basic supply lies the beauty of choice: more is more in the land of the plenty, and information overkill means nothing when the very act of selecting is being celebrated. Whether you need 29 different types of golf ball is not the question. Which one is yours? That's it.

Jenseits grundlegender Bedürfnisse liegt die schöne Qual der Wahl: „Mehr ist mehr" ist das Motto der Möglichkeiten, Reizüberflutung unbedeutend, wenn der Auswahlprozess selbst gefeiert wird. Ob man 29 verschiedene Golfballsorten wirklich braucht, steht nicht zur Debatte, welche davon deine sein wird, darum geht's.

過剰供給がもたらす美学、それは選択の自由。選択肢は多ければ多いほど良いに違いない。不足という概念のないこの国では情報が多すぎるということはなく、その中から選ぶという行為そのものが美徳なのだ。29種類のゴルフボールが必要なのかどうかが問題なのではなく、どれが自分のボールなのか、ということが重要だ。

▼ Array of *Gyoza* dumplings (Sunshine City, Ikebukuro) | Angebot für *Gyoza* (japanische Maultaschen) | 池袋「サンシャインシティ」の餃子メニュー

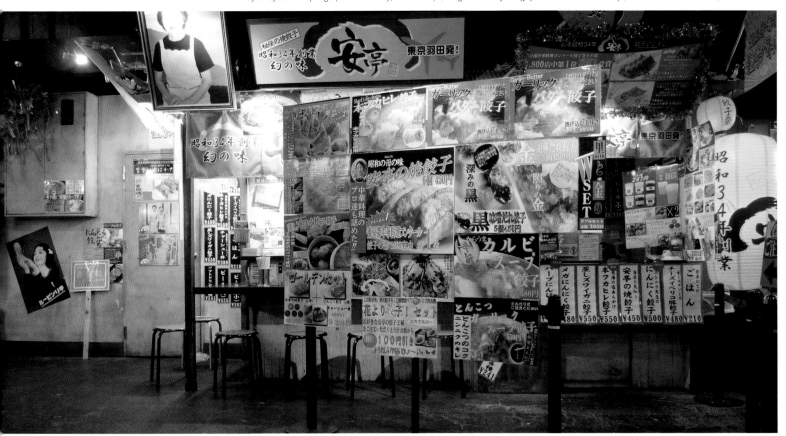

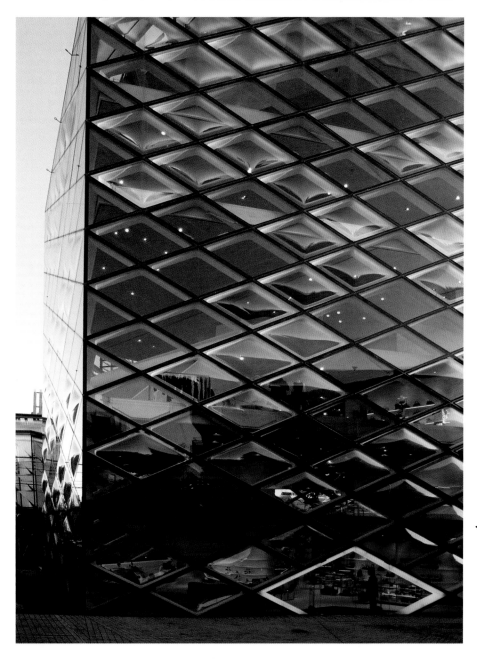

ブランド

Brand | *Marke*

For those who think they already have everything:
you don't. Why get a new car, when there is a watch
for the same price? Walk into the diamond-shape
Prada superstore, try out the latest L&V bags while
sipping Cristal and popping serious grapes.

An all diejenigen, die glauben, bereits alles zu haben:
Ihr habt noch lange nicht alles. Warum ein Auto,
wenn man zum gleichen Preis eine Uhr haben kann?
Trefft euch im diamantenen Prada Superstore, testet
die teuersten Louis-Vuitton-Taschen und schenkt
euch mal ein paar ernstzunehmende Weintrauben.

たとえ何もかもすでに持っていたとしても、すべてを手に入
れたわけではない。同じ価格で時計が手に入るのに、どう
して新車を欲しがったりするのだろう？ ダイヤモンド形の
「プラダ・ブティック」を訪れ、クリスタルシャンパンを楽し
み、最高級のブドウをつまみ、最新の「ルイ・ヴィトン」の
バッグをチェック。

◀ Prada Flagship Store by Herzog & de Meuron Architects (Minami-Aoyama)
ヘルツォーク＆ド・ムーロン設計の「プラダ・ブティック」青山店

A must-have for the Tokyo ladies: L&V bag | Eine L&V-Tasche ist ein Muss ▶
für Ladies in Tokio | トウキョウで暮らす女性の必需品「ルイ・ヴィトン」のバッグ

First-class grapes for ¥ 10,500—luxury watches for ¥ 6,510,000 ▶
Wahrer Luxus: Trauben für 10 500 YEN – Uhren für 6 510 000 YEN
1万500円の最高級ブドウ／651万円の高級時計

bu ra i su

ブライス

Blythe

A disatrous flop in the United States, the large-eyed doll became a massive success in Japan, even making it onto the drugstore shelf. Nowadays, there is a whole market section devoted to Blythe and her copycats (right), with tailored clothes, hair, accessoires, and of course, large eyes. Here's looking at you, kid.

Die großäugige Puppe war ein katastrophaler Flop in den USA, aber ein Erfolgsschlager in Japan, der es sogar bis ins Drogeriemarktregal geschafft hat. Seither gibt es komplette Bastel-Abteilungen, die sich ausschließlich Blythe-Puppen und ihren zahlreichen Nachahmerinnen (rechts) widmen. Mit der entsprechenden Auswahl an Kleidung, Haaren, Accessoires und – großen Augen. Schau mir in die Augen, Kleines.

北米マーケットでは惨敗だったこの大きな目の人形も日本では大当たり。ドラッグストアの棚にまで並んでいる。今ではブライスとそのコピー製品（右）のためにDIYコーナーが作られているほど。専用のお洋服に髪の毛、アクセサリー、そしてもちろん大きな瞳。ほら、彼女があなたを見つめてる。

◀ Blythe hair bleach "mega-mega" in drugstore ｜ Blythe-Blondierung „mega-mega" im Drogeriemarkt ｜ ヘアブリーチ「メガメガ」はプラチナブロンドの「ブライス」ドールをモデルに起用

Selection of large-eyed dolls (Akihabara) ｜ Knopfaugenpuppen- ▶ Auswahl ｜ 大きな目をした人形のセレクション (秋葉原)

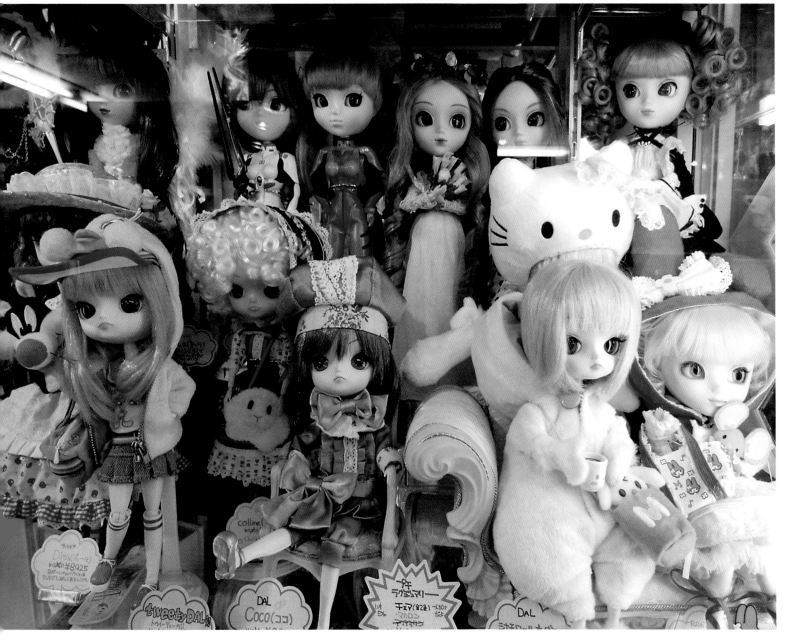

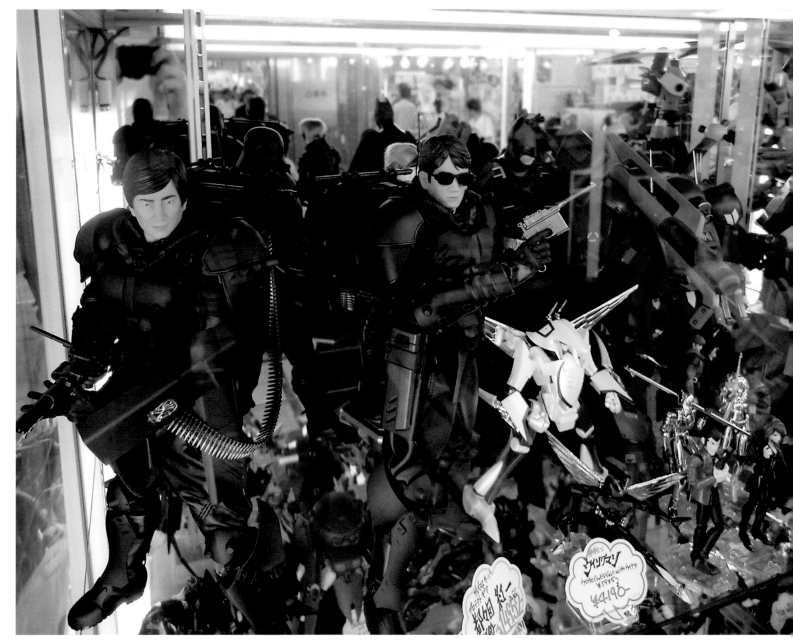

ウェポン

w(u) e po n

Weapons | *Waffen*

There are three major kinds of weapons in the
Japanese toy industry: the brutal action gun, the
mystical sword (or stick or scepter or ...) and—
probably most powerful of them all—cute sexiness.
Strangely enough, they all seem to be aiming at
the same target group: lonely adult males.

In der japanischen Spielzeugindustrie gibt es im
Wesentlichen drei Waffenkategorien: die brutale
Schusswaffe, das magische Schwert (oder Zepter
oder Stab oder ...) und – die wahrscheinlich
stärkste von allen – Sexappeal. Interessanter-
weise zielen mehr oder weniger alle auf ein und
dieselbe Zielgruppe: einsame erwachsene Jungs.

日本のおもちゃ業界の武器は大きく分けて三つ。それは
残忍な戦闘射撃もの、神秘的な剣（または杖など）、そ
しておそらく一番強力な武器はキュートなセクシーさ。
どれも寂しい成人男性を対象ターゲットとしているのが
面白いところ。

◀ Martial action dolls (Akihabara) | Bis an die Zähne bewaffnete
Actionfiguren | 武装した人形 (秋葉原)

Sweet action dolls (Akihabara) | Unschuldige und weniger ▶
unschuldige Actionfiguren | キュートな人形 (秋葉原)

防災クマさん

デンジャー

de n j(i) ya

Danger | *Gefahr*

Frequent trembles remind the city of the constant danger lurking underneath. While a huge effort is made to analyze seismic oscillations to forecast earthquakes—which still remains controversial—preparing the crowds for ground-shaking inconvenience seems equally essential. And so much more fun.

Viele kleine Beben in Tokio erinnern an die ständig präsente Gefahr aus der Tiefe. Während seismische Erschütterungen mit großem Aufwand und zweifelhaftem Erfolg analysiert werden, werden die Massen mit ebenso großer Sorgfalt auf drohende Unannehmlichkeiten vorbereitet. Allerdings wesentlich unterhaltsamer.

頻繁に街を襲う小さな地震は、地下に常に潜む危険を人々に警告する。賛否両論はあれど、地震を予測するために多大なる労力が費やされる中、トウキョウで暮らす人たちを地震に備えさせることも同等に重要。むしろ、そっちの仕事のほうがよっぽど楽しそうだ。

◄ Teddy bear, stuffed with emergency supplies (Tokyu Hands)
Teddybär, gefüllt mit Notfallset │ 非常用品の詰められたテディベア (東急ハンズ)

Earthquake simulation room (Tokyo Game Show) │ Erdbebensimulationsraum │ 地震シミュレーション室 (東京ゲームショウ) ►

For safety reasons, this fireplace runs on red light and steam. ►►
Dieser Sicherheits-Kamin versprüht nur rotes Licht und Dampf
安全のため、暖炉の火は赤い光とスチームで代用

ラーメン

<ruby>ラ<rt>ra</rt></ruby> <ruby>メ<rt>me</rt></ruby> <ruby>ン<rt>n</rt></ruby>

Ramen noodles | *Ramen-Nudeln*

Everything about this delicious dish of noodles conveys the rustic flavor and atmosphere you would expect from a traditional Japanese dish. Simply ignore the fact that it originates from China, and even the fake interior will feel homemade. Because the noodles usually are.

Eine herrlich schmackhafte Nudelsuppe transportiert genau die rustikale Stimmung, die man von einem traditionellen japanischen Gericht erwartet. Denk einfach nicht dran, dass Ramen-Nudeln eigentlich aus China stammen, und schon fühlen sich selbst die Pappwände an wie hausgemacht. Die Nudeln sind es nämlich.

飾り気はなくとも確かに旨い、ダシの効いたスープとその中を泳ぐ麺のコンビネーション。伝統的な日本料理であるかのようなこだわりと店構え。ルーツは中国であるという事実さえ無視してしまえば、偽物のインテリアからだってぬくもりが感じられる。国境も時間も超え、ラーメン職人の心は麺に宿る。

◄ Pig *tanuki* (Kabukicho) | Schweine-*Tanuki* | 歌舞伎町のブタヌキ像

◄◄ The ramen "museum," (Yokohama) | Das „Ramen-Museum"
新横浜ラーメン博物館、略して「ラー博」

まつり

Festival | *Volksfest*

Prepare for smoke, color and crowds at
one of Tokyo's thousands of local summer
festivals. And don't leave your head-wrap
at home, it can serve as a handy alternative
to an umbrella on these wet days.

Auf Rauch, Farbe und Menschenmassen
sollte man gut vorbereitet sein bei einem
der tausend regionalen Sommerfestivals
Tokios. Und am besten das Kopftuch nicht
vergessen, es könnte eine praktische
Alternative zum Regenschirm werden.

数えきれないほどあるトウキョウの夏祭りを飾る
煙、色、そして人。雨天の際には、傘の代わりに頭
に巻ける便利な手ぬぐいの準備もお忘れなく。

◄ *Matsuri* snacks (Roppongi) | 六本木祭りの串焼き屋台

Origami roses from the local community | Origamirosen ►
aus dem Viertel | 地元のコミュニティーによる折り紙のバラ

Roppongi *Matsuri* | 六本木祭り ►►

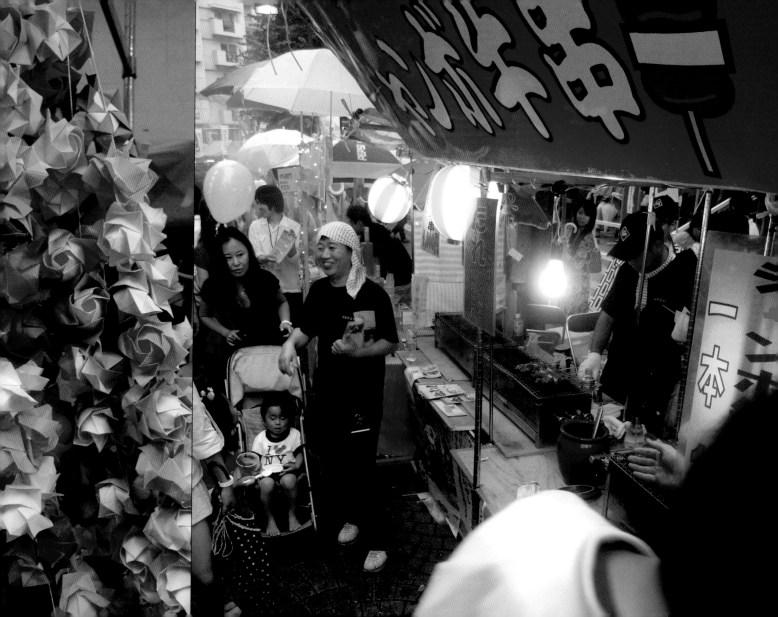

Pick your poison: fish on a stick, noodle omelet or crispy squid. Any of these grilled delicacies will put you in the right mood to enjoy the traditional flavor and gently ignore all the fancy plastic flowers.

Stockfisch, Nudel-Omelette oder knuspriger Tintenfisch – du hast die Wahl. All diese gegrillten Leckerbissen würzen die ohnehin traditionelle Stimmung und überdecken den stellenweise etwas kitschigen Geschmack der bunten Plastikblümchen.

毒を食らわば皿まで。串刺しの魚、オムソバ、またはカリカリのイカ。熱々の食べ物を頬張れば、気分もすっかり祭りモード。鮮やかすぎる色合いの造花には、あえて触れないでおく優しさも大切。

Tradition meets plastic flowers | Tradition trifft auf ▶
Plastikblumen | 伝統的な祭りの風景と造花のミスマッチコラボ

Squid meets grill | Tintenfisch trifft Grill | 焼きイカ ▶▶

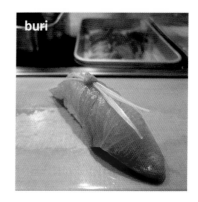

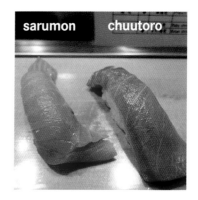

saba: Mackerel, tender fish, tastes like fresh seawater | Makrele, zartes Fleisch. Schmeckt wie frisches Meerwasser | 鯖：柔らかい歯ごたえの身に固めの皮、新鮮な海の味

aji: Japanese jack mackerel, aromatic, tender, juicy, tasty | Japanese Makrele, würzig, bissig, saftig, lecker | 鯵：芳しい香り、身は柔らかくとてもジューシー

hokkigai: Surf clam, looks funky with a firm bite. The dark piece is the mouth | Trogmuschel, sieht irre aus, hat Biss. Der dunkle Teil ist der Mund | ホッキ貝：ファンキーな外見に確かな歯ごたえ、黒い部分は口

kanpachi: Greater amberjack, clear, light, delicate. Sweetish, fresh, fish | Junger Gelbschwanzfisch, zart, leicht, süßlich, frisch. Fisch | カンパチ：クリアで軽く、繊細な味、新鮮な甘みのある魚

uni: Sea urchin, creamy texture, special taste | Seeigel-Eierstöcke, cremige Konsistenz. Sehr spezieller Geschmack | 雲丹：クリーミーな食感、特別な味

maguro: Bluefin tuna, the classic. Firm texture, aromatic. | Thunfisch, klassisch. Feste Konsistenz, aromatisch | 鮪：寿司の代名詞、しっかりした食感と食欲を誘う香り

buri: Yellowtail, buttery, fluffy, glides into the stomach | Gelbschwanzfisch, butterig, fluffig, gleitet förmlich in den Magen | 鰤：脂が乗ってフワフワ、滑るような喉越しで胃の中へ

sarumon: Salmon, tastes like raw salmon at home, just better | Lachs, schmeckt wie roher Lachs bei uns, nur besser | 鮭：生の鮭の味だが、抜群においしい

chuutoro: Medium-fat bluefin tuna belly, fluffy piece of tuna. Melts on the tongue | Halbfetter Thunfisch, fluffiges Bauchfilet. Zergeht auf der Zunge | 中トロ：柔らかな舌触りは芸術品並み、フワリと舌の上でとろける

shira-uo: Icefish, cute little fish, slippery and al dente | Breitling, niedliche kleine Jungfische, glitschig und „al dente" | 白魚：かわいらしい小さな魚、つるつるながら適度な歯ごたえ

unagi: Conger eel, sweetish, looks like brain, goes down like butter | Meeraal, süßlich, sieht aus wie Gehirn, geht runter wie Butter | 鰻：見ためは脳味噌、甘くてバターのような喉越し

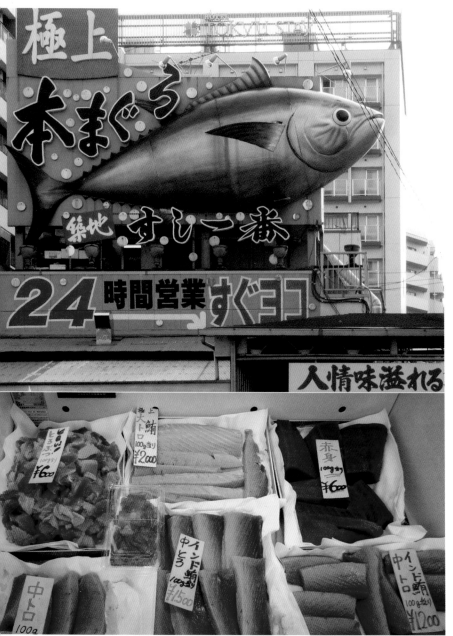

すし

Sushi

Wandering across Tokyo fishmarket—the largest in the world —is both a visually stimulating and a mouth-watering treat. But the cherry on top is a treat by its local chefs, trained for years in the arts of slicing fish, selection, and forming rice before being even allowed to serve the freshest and purest delicacies the sea has to offer. Forget California rolls.

Über den Tokioter Fischmarkt – den größten der Welt – zu spazieren ist gleichermaßen visuell wie olfaktorisch ein Genuss, der einem das Wasser im Mund zusammenlaufen lässt. Aber das Sahnehäubchen ist ein Besuch bei einem der lokalen Sushi-Chefs, jahrelang in der hohen Kunst der Fisch-Auswahl, des Zerlegens und des Reisbällchen-Formens ausgebildet, bevor ihm überhaupt erlaubt wird, die frischesten und reinsten Delikatessen zu servieren, die das Meer uns zu bieten hat. „California Rolls" sind lächerlich dagegen.

トウキョウの魚市場は世界最大規模。歩き回ると、視覚からの刺激でみるみるおなかが空いてくる。魚をさばき、選び、シャリを握る修業を何年も積んだ寿司職人によって調理される採れたての魚は、海の幸を楽しむための最も贅沢な方法。カリフォルニアロールなんていう単語が喉まで出かかったとしても、今はぐっと飲み込んで。

▲ When you see this sign, you are at Tsukiji, the largest fishmarket in the world
Wenn du dieses Schild siehst, bist du am Tsukiji, dem weltgrößten Fischmarkt
この看板が目に入ったら、そこは世界最大規模の魚市場「築地市場」

◄ Various tuna qualities | Verschiedene Thunfisch-Qualitäten
一口に鮪と言っても、質は様々

165

アニマル

Animals | *Tiere*

The roles are cast. We are on one side of the fence and funny looking creatures on the other, serving as great targets for projecting our emotions. The humorous cuteness with which they are mostly portrayed beautifully disguises even more serious issues.

Die Rollenverteilung ist klar: Hier stehen wir, auf der einen Seite des Zauns, und auf der anderen seltsam aussehende Kreaturen, die uns eine wunderbare, emotionale Projektionsfläche bieten. Die verspielte Niedlichkeit, mit der sie hier meist dargestellt werden, verschleiert selbst ernste Themen auf wundersame Weise.

配役は決定済み。こちら側には人間がいて、あちら側にいるおかしな外見の生き物たちに、人は心を引き付けられる。ユーモラスなかわいらしさとは裏腹に、結構困った問題を引き起こしているのも事実。

◀ Pig-shaped air humidifier (Tokyu Hands, Shibuya) | Luftbefeuchter in Schweinform | ブタ形加湿機 (東急ハンズ渋谷店)

Delicate detail in an advertisement for a proctologist (Nara) | Delikates Detail einer Proktologie-Reklame デリケートな部分を扱う肛門科医の広告 (奈良) ▶

Don't throw away waste, as it attracts apes. (Mt. Takao) ▶▶ Keinen Müll wegwerfen, da dieser die Affen anlockt. エサを与えないでください (高尾山付近)

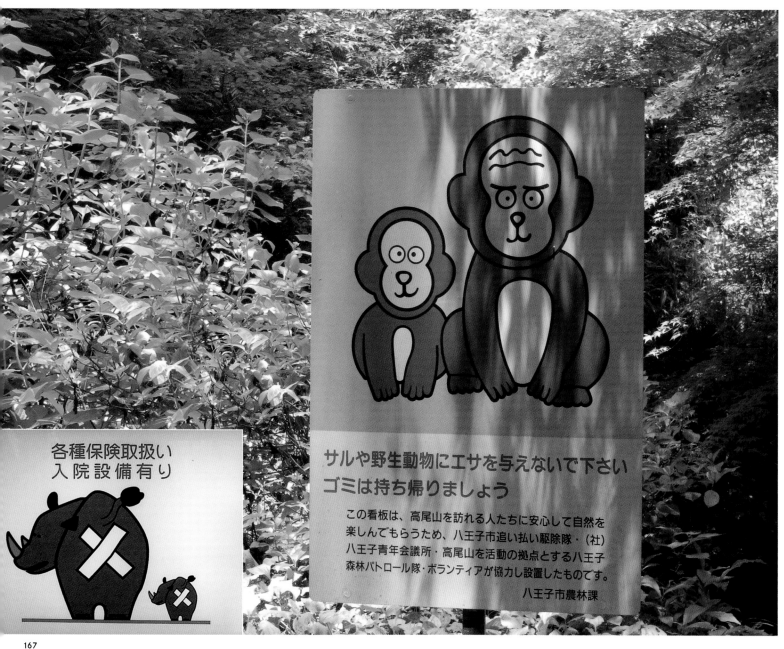

各種保険取扱い
入院設備有り

サルや野生動物にエサを与えないで下さい
ゴミは持ち帰りましょう

この看板は、高尾山を訪れる人たちに安心して自然を
楽しんでもらうため、八王子市追い払い駆除隊・（社）
八王子青年会議所・高尾山を活動の拠点とする八王子
森林パトロール隊・ボランティアが協力し設置したものです。

八王子市農林課

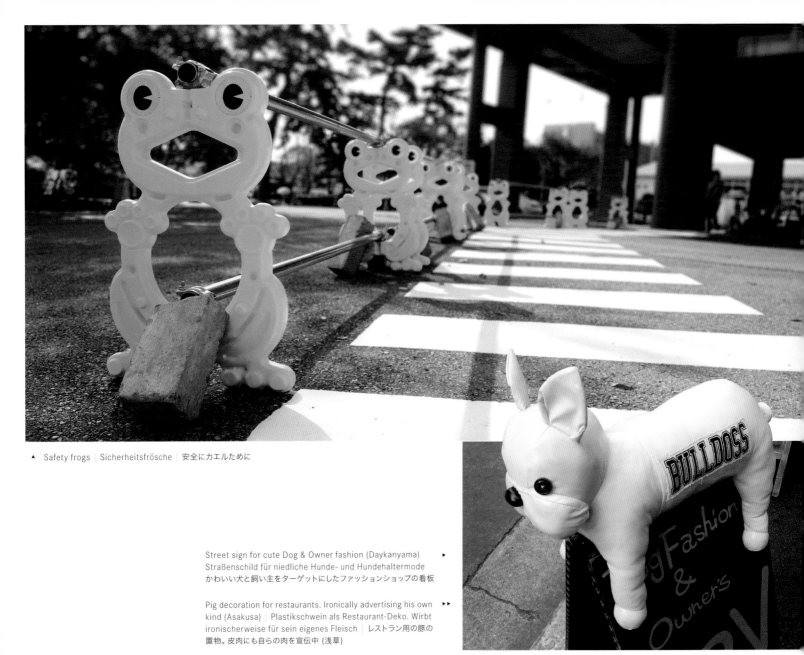

▲ Safety frogs | Sicherheitsfrösche | 安全にカエルために

Street sign for cute Dog & Owner fashion (Daykanyama) ▶
Straßenschild für niedliche Hunde- und Hundehaltermode
かわいい犬と飼い主をターゲットにしたファッションショップの看板

Pig decoration for restaurants. Ironically advertising his own ▶▶
kind (Asakusa) | Plastikschwein als Restaurant-Deko. Wirbt
ironischerweise für sein eigenes Fleisch | レストラン用の豚の
置物。皮肉にも自らの肉を宣伝中 (浅草)

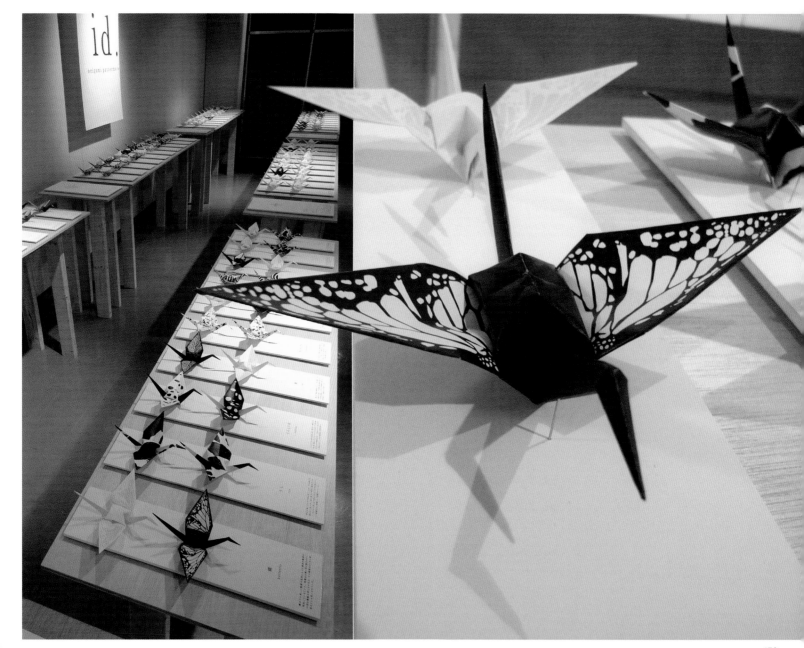

おりがみ

Origami

Originating from traditional roots that go back to 1300 AD, things have changed for paper cranes: contemporary design patterns, mathematically calculated structures, and fingerbending folding craft all result in creatures where the original paper square can hardly be surmised.

Ursprünglich aus traditionellen Wurzeln um 1300 v. Chr. stammend, haben sich die Zeiten für Papierkraniche gewandelt: Zeitgenössische Design-Patterns, mathematisch berechnete Strukturen und fingerverbiegende Faltkunst ermöglichen Resultate, bei denen das ursprüngliche Papierquadrat kaum mehr zu erahnen ist.

1300年ごろから始まったとされる折り紙文化は、今もなお進化を続けている。折り鶴一つとってもそう。現代的なデザイン、緻密に計算された構造、そして生き物の形を生み出す手技からは、最初に確かに存在したはずの四角い紙が一体どこへ行ったのか見当もつかない。

◄ A designer's contemporary interpretation of origami cranes (Musashino Art University) │ Zeitgenössische Design-Interpretation des Origami-Kranichs
現代的デザインの折り鶴 (武蔵野美術大学)

Origami animals (Ebisu Garden Place) │ Origami-Tiere ►
折り紙アニマル (恵比寿ガーデンプレイス)

カモフラージュ

Camouflage | Tarnung

For giving cover in the streets, this army green is by no means very promising. It's actually counterproductive. As a counterpart to "cute," martial art style and camouflage can definitely boost your street credibility if applied correctly.

Besonders vielversprechend ist es nicht, sich mit Armee-Grün in den Straßenschluchten zu verstecken. Es ist eher kontraproduktiv. Als Gegenstück zur weiblichen „Niedlichkeit" dient der Martial-Art- und Camouflage-Style eher dazu, deine Street Credibility zu verteidigen, sofern er richtig angewendet wird.

街の景色に紛れたいなら、軍服の緑は逆効果だ。格闘技スタイルや迷彩服は「かわいい」ものに対するアンチテーゼ。うまく使いこなせば、街での人気度アップに一役買ってくれるはず。

◀ Military-style bike (Ebisu) | Roller im Military-Look
ミリタリースタイルのバイク (恵比寿)

Soldier figures (Akihabara) | Soldatenfiguren ▶
兵隊フィギュア (秋葉原)

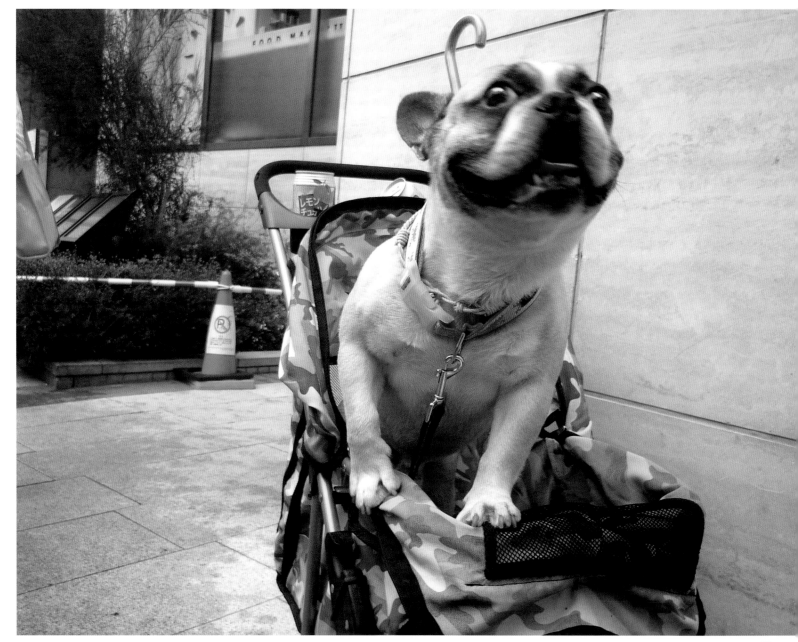

If your pooch isn't butch (or cute) enough to bolster your ego, consider this. Since almost every mutt is dressed up in haute couture nowadays, you might want to try some more serious action. Put him in a camouflage shirt with a glittering skull, train him to bark, and you bet he's gonna open the doors for you.

Ist dein Hündchen nicht brutal (oder süß) genug, um dein Ego zu pushen, dann versuch's doch mal hiermit. Da heutzutage fast jeder dahergelaufene „Bello" mit feinen Stöffchen herausgeputzt wird, sollte man ruhig mal was Härteres ausprobieren. Zieh ihm ein dreckiges Camouflage-T-Shirt mit Totenkopf über, bring ihm das Bellen bei und „Wuff" – schon stehen dir sämtliche Türen offen.

自分のペットの残忍さ（またはかわいらしさ）にいまいち自信が持てなければ、こんなのはどうだろう。多くのお犬様たちが一流デザイナーのお洋服を見事に着こなしている今、そろそろ次のステップへ踏み出してもよいころかも。輝くドクロマーク付きの汚れたカモフラージュシャツを着せて、迫力のある吠え方をマスターさせれば、次に進むべき道は犬が教えてくれるはず。

◄ Dangerous dog shirt in a pet shop (Odaiba) | Starkes Hundeshirt aus einer Tierhandlung | 危険な犬用シャツ（お台場のペットショップ）

◄◄ Rough-looking dog in Roppongi | Gefährlich aussehender Hund 六本木のわんぱく犬

A strictly Japanese phenomenon is the split-toe boot found mostly on construction workers' feet for controlled scaffold climbing. Its actual purpose is to give the wearer a better feel for what's underneath, but myths include improving ninja skills for sneaking, fighting, and climbing. Modern urban street warriors enjoy style-enhancing features, too.

Solche Zehenschuhe, meist an den Füßen kletter-erprobter Gerüstbauer und Handwerker, sind ein rein japanisches Phänomen. Deren eigentlicher Sinn ist es, dem Träger ein besseres Gefühl für den Untergrund zu vermitteln, aber es ranken sich Mythen um gesteigerte Ninja-Fähigkeiten wie Schleich-, Nahkampf- und Kletterkünste. Moderne Mode-Ninjas freuen sich hauptsächlich über den extravaganten Style.

つま先が割れたブーツは日本の専売特許。建築作業員の利便を追求して開発された。忍者が忍び寄ったり、戦ったり、よじのぼったりする際に便利なように作られたと都市伝説的には言われているものの、実際の目的は足場の感触をより分かりやすくするため。最近はデザインも多種多様になり、ストリートファッションとしても脚光を浴びているとか。

ji ka ta bi

じかたび

Split-toe boots | *Zehenschuhe*

▲ Original *jika-tabi* for contruction workers | Echte Bauarbeiter-*jika-tabi*
建築作業員用元祖地下足袋

◄ Japanese workers' trousers | Japanische Arbeiter-Knickerbocker
日本人労働者のニッカーボッカー

The lifestyle *jika-tabi* variant on display (Odaiba) | Modische *jika-tabi* ►
現代風にアレンジされた地下足袋 (お台場)

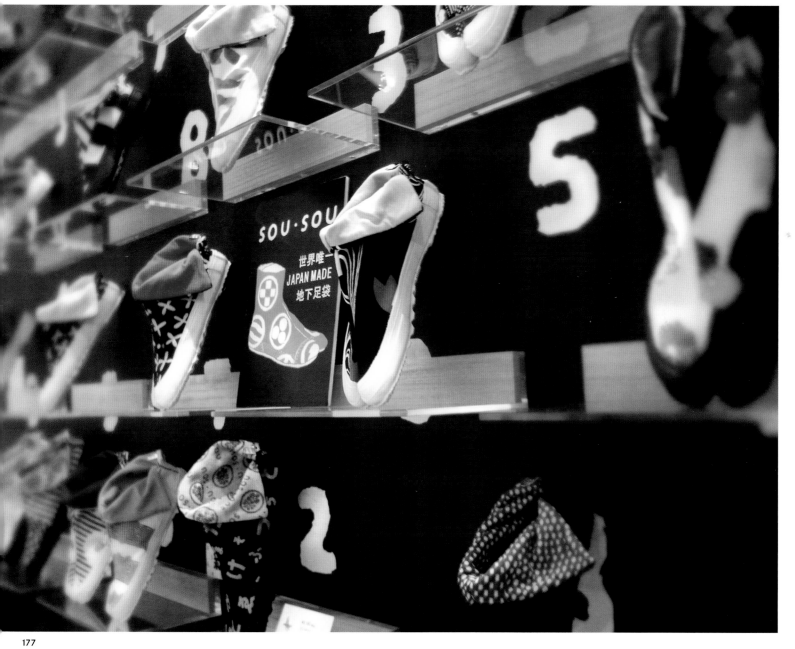

Koi Varienty By Forever-Mango.com

ドイツ Doitsu	べっ甲 Bekko	浅黄 Asagi	銀紅白 GinRin Kohaku
Kawarimono	Hikari	五色 Goshiki	紅白 Kohaku
九紋龍 kumonryu	Kujaku	苟衣 Goromo	銀松葉 Gin Matsuba
Sanke	オレンジ黄金 Orenji Ogon	プラチナ黄金 Platinum Ogon	藻葉 Ochiba
Tancho	Tancho Sanke	昭和 Showa	秋翠 Shusui
Utsuri 写り			Yamabuki Ogon 山吹黄金

ka ra

カラー

Color | Farbe

What immediately hits your eye when entering Japan is the extensive use of highly saturated and joyful colors. Since traditional Japanese art is rather pale, the advance of chemical coloring seems to have literally boosted the desire to stand out against things that already stand out. Only the colorful attract the crowd.

Gleich bei der Ankunft in Japan springt der ausgelassene Umgang mit grellbunten und fröhlichen Farben unmittelbar ins Auge. Während die traditionelle japanische Kunst sich eher blass und farblos präsentiert, hat die chemische Farbindustrie das Bedürfnis nach auffallenden Kontrasten enorm beflügelt. Unter so viel Buntem sieht man nur noch das Bunteste.

日本に入国してすぐに注意を引かれるのが、豊かで楽しげな色彩。素朴な色合いの日本の伝統芸術とは対照的に、ケミカルカラーの発展はもうすでに目立っているものよりもさらに目立とうとするカラーリング競争を激化させたようだ。人はカラフルなものに憧れる。

◄ Ad for "blob," a colorful computer game on color-splashing creatures | Reklame für „Blob", ein farbenfrohes Videospiel über farbklecksende Kreaturen | 色をまき散らす生き物を操るカラフルなコンピュータゲーム「ブロブ」の広告

◄◄ A single, colored koi waiting for food (Koukyogaien) | Ein einzelner bunter Koi, auf Futter wartend | 食べ物を求めて泳ぐ一匹の色付き鯉 (皇居外苑)

つぶあん

抹茶
シフォンケーキ
Powdered Tea
Chiffon
Cake

カスタードクリーム

栗あん
餅入り

商品見本
銘菓詰合せ
18個1,050円(税込)

つぶあん餅入り

銘菓
ひなの菓立ち

銘菓
ひなの菓立ち

銘菓
ひなの菓立ち

栗 菓子詰め合わせ

銘菓
華

銘菓
華

銘菓
華

東京旅ひといろ

Yes,we can
OZAMA
オザ

いっちゃん
まんじゅう
CHANGE!

¥630

スーベニア

Souvenir

Wherever you go, bring something home. It would be shameful to return empty-handed, since you left all the others working hard at the office. Of course you were thinking of all your mates, while sipping margaritas at sunset, trying to forget the fact that your average holiday only lasts 18 days a year.

Wohin es dich auch verschlägt, bring immer was mit nach Hause. Es wäre ja beschämend, mit leeren Händen zurückzukommen, während man all die anderen hart arbeitend zurückgelassen hat. Natürlich hast du an all deine Kollegen gedacht, während du, Margaritas im Sonnenuntergang schlürfend, versucht hast, die dir zustehenden lächerlichen 18 Urlaubstage pro Jahr zu genießen.

どこへ出かけようと構わないけれど、お土産なしでは戻れない。手ぶらで出かけたり、手ぶら帰ってくることは恥ずべき行為。自分がいない間も他の人たちが会社で必死に働いていることを忘れずに。お土産とは、夕暮れ時にマルガリータを飲んでくつろぎながらも友人たちことが頭をよぎったことを証明してくれる存在。本当は1年間の平均休暇日数がわずか18日だということを忘れようと必死だっただけだとしても。

◄ Rice cakes for the politically motivated | Reisküchlein für politisch Motivierte | 政治への「餅ベーション」を上げるために

◄ Grandiose souvenir package (Tokyo Tower) | Pompöses Souvenir-Paket | 大げさなお土産パッケージ（東京タワー）

A rich range of souvenirs (Okinawa) | Reichhaltiges Souvenir-Angebot | よりどりみどりのお土産が並ぶ、沖縄のお土産屋 ►

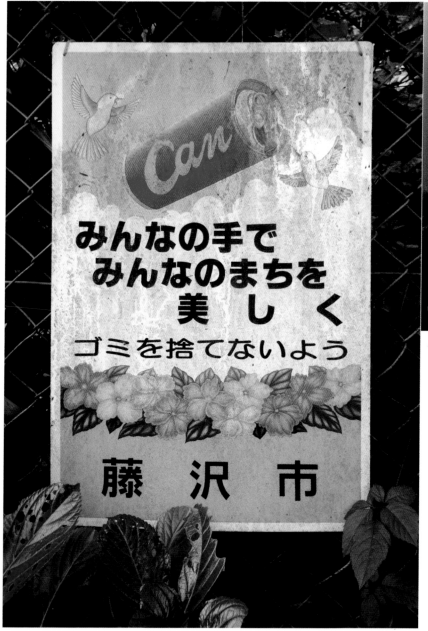

◄ Flying cans are a no-no (Enoshima Park) │ Dosen werfen verboten
空き缶飛行禁止令 (江ノ島公園)

ka　　n

カン

Can │ *Dose*

▲ The full choice of drinks on the sidewalk | Getränkeauswahl am Straßenrand | 路上でもこんなに豊富な選択肢

▲ Fully-equipped drink dispenser, with touchscreen, infomercials, mobile phone, and RFID-card purchase. | Voll ausgestatteter Getränkeautomat mit Touchscreen, Infomercials, Handy- und RFID-Karten-Zahlungsmöglichkeit タッチスクリーン、インフォマーシャル、携帯電話対応、ICカード対応のフル装備自動販売機

There is no such thing as a thirsty Japanese. Effective and widespread drink supply is guaranteed throughout the entire country. Delivering juicy liquids, refreshing tea, and STRONG black coffee—if you can't spot one of these vendors nearby, you must be in the wilds: and be so kind as to leave nothing behind.

Durstige Japaner gibt es nicht. Die Getränkeversorgung ist effizient über das ganze Land hinweg sichergestellt. Egal ob erfrischender Eistee, schwarzer Kaffee (STRONG!) oder fruchtige Flüssigkeiten – sollte einmal kein Getränkeautomat in Sichtweite sein, dann ist man definitiv in der Wildnis. Den Müll aber bitte schön wieder mitnehmen.

喉が乾いている状態が長く続くことは日本ではあり得ない。清涼飲料水の自動販売機が設置されていない場所は、日本中どこを探しても存在しないのだ。フルーティーなジュース、リフレッシュできるお茶、そして濃いめの缶コーヒー。自動販売機が視界に入らなくなったなら、遭難の可能性が高いので注意。なお、立つ鳥跡を濁さず。ゴミは持ち帰りましょう。

バス&タクシー

Bus & Taxi

◄ Perfect all-round visibility for the Hachiko Bus driver
Perfekte Rundumsicht für den Hachiko-Busfahrer
「ハチ公バス」の運転手は周りのすべてをお見通し

▼ The Shibuya Hachiko Bus at Hachiko Square │ Der Shibuya-Hachiko-
Bus an der Hachiko-Kreuzung │ ハチ公付近を走る渋谷「ハチ公バス」

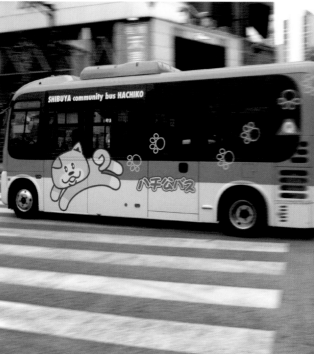

While you obviously can't expect the perfect timing of the Tokyo trains here, you can expect perfection in every other way when entering a Tokyo cab or community bus. For just 100 Yen (for the bus, of course), you can hop into traffic and admire the dedicated passion of the uniformed driver, even wearing shining white gloves as he drives you smoothly towards your desired destination. And don't bother to tip the cabbie, as the standard fares will empty your pockets anyway.

Die Pünktlichkeit der Tokioter Nahverkehrszüge lässt sich hier zwar nicht erwarten, aber in jeder anderen Hinsicht kann man sich auf Perfektion verlassen, wenn man in Tokio Taxi oder Bus besteigt. Für läppische 100 Yen kann man sich mit dem Bus ins Verkehrsgetümmel stürzen und die hingebungsvolle Leidenschaft des uniformierten Fahrers bewundern, der mit weißen Handschuhen sanft dem gewünschten Ziel entgegensteuert. Das Trinkgeld für den Taxifahrer sollte man sich getrost sparen, der Standardtarif zieht einem das Geld ohnehin aus der Tasche.

トウキョウの電車が完璧なタイミングで動き続けるのには無理があるにしても、トウキョウでタクシーやコミュニティーバスに乗れば、マナーが完璧であることは期待できる。100円という高額（バスにしては、という意味）を支払ってバスに乗り込むと、制服を着込み、白がまぶしい手袋をはめた献身的な運転手が目的地までスムーズな運転でご案内。タクシーでは運転手にチップは不要。いずれにしても、表示された料金を支払うだけで財布は空になるだろうしね。

The famous Tokyo taxi lace doilies for international comfort
Die famosen Spitzenbezüge der Taxis in Tokio sorgen für internationalen Komfort
国際的なくつろぎを演出する、かの有名な東京のタクシーのレースカバー
▼

The standard yellow cab looks antique, but drives on liquefied gas and opens its doors automatically Die gelben Taxen sehen zwar altertümlich aus, fahren aber mit flüssigem Gas und öffnen die Türen automatisch 標準的な黄色いタクシーはアンティーク風ながらLPガスで走り、ドアは自動開閉される

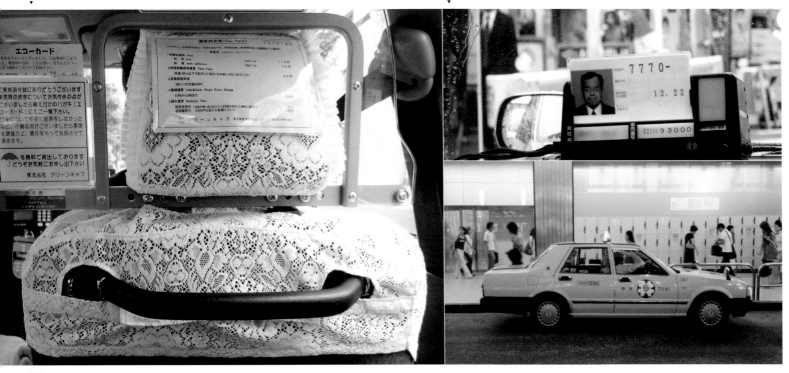

スピード
<small>su pi do</small>

Speed | Geschwindigkeit

This city is a continous multi-directional roller coaster. It will keep buzzing around your head even when you're standing still, so keep up with its pace. Average traveling speed is actually pretty low (you'd feel strange with a yellow "Forza" in congested traffic), but the sum of the hive makes the difference here. To cope with the average 20 million commuters a day, some Tokyo trains run every 2 minutes. That's fast.

Diese Stadt gleicht einer ununterbrochenen Achterbahnfahrt in sämtliche Richtungen. Sie hört nie auf, sich zu drehen, selbst wenn man stehen bleibt, also gewöhnt man sich besser an ihren Rhythmus. Die tatsächliche Reisegeschwindigkeit ist dabei ziemlich niedrig (mit dem gelben Forza käme man sich im Stau eher komisch vor), allein die Menge der Bienchen im Schwarm macht hier den Unterschied. Um die etwa 20 Millionen Pendler zu bewältigen, fahren Tokios S-Bahnen im Zweiminutentakt. Das ist verdammt schnell.

この街は多方向に向かって走り続けるジェットコースター。ぼやぼやしていると、取り残されるだけ。このペースに合わせるよりほかに選択肢はない。平均速度は目を見張るほどではないにしろ（黄色い「フォルツァ」が渋滞に巻き込まれるなんて奇妙な光景だ）、その合計値は想像以上。2000万人の電車通勤者や通学者を運ぶため、トウキョウでは2分ごとに電車が走る路線だってある。それがこの街のスピード。

Customized Honda Forza scooter (Ebisu) | Personalisierter Roller ▶
Honda Forza | カスタムスタイルの「ホンダ・フォルツァ」スクーター(恵比寿)

A short halt at the large scramble crossing (Hachiko Square, Shibuya) ▶▶
Kurze Pause an der riesigen Hachiko-Kreuzung | ハチ公前のスクランブル
交差点で信号を待つ人たち (渋谷)

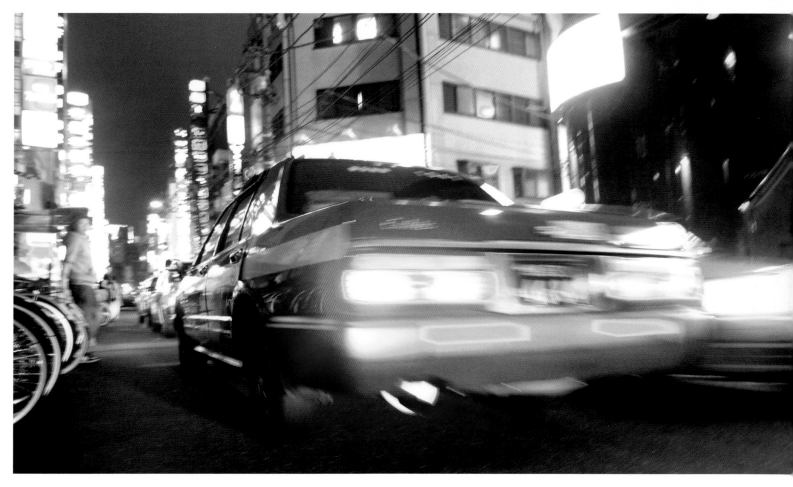

ドライブ

Drive | Fahren

Japan is a nation of driving technology, but its spirit of mobility is often more about practical issues than the ultimate freeway ride. And because of Tokyo's crowded downtown traffic, you might consider alternative technology anyway. Battery-driven offroad quads anyone?

Japan ist ein Land der Fahrzeugindustrie, aber diese orientiert sich deutlich stärker an reiner Praktikabilität als an rasanter Autobahnfantasie. Und das Verkehrschaos in Tokio lässt ohnehin an alternative Technologien denken. Wie wär's mit batteriebetriebenen Offroad-Quads?

日本の高性能な自動車技術は世界的に有名だが、車に対する情熱はハイスピードで滑走することよりももっと実用的なことに注がれている。トウキョウの渋滞に巻き込まれたなら、車以外の交通手段について、ついつい思いを巡らせてしまう。バッテリー駆動のオフロード四輪なんてどうだい？

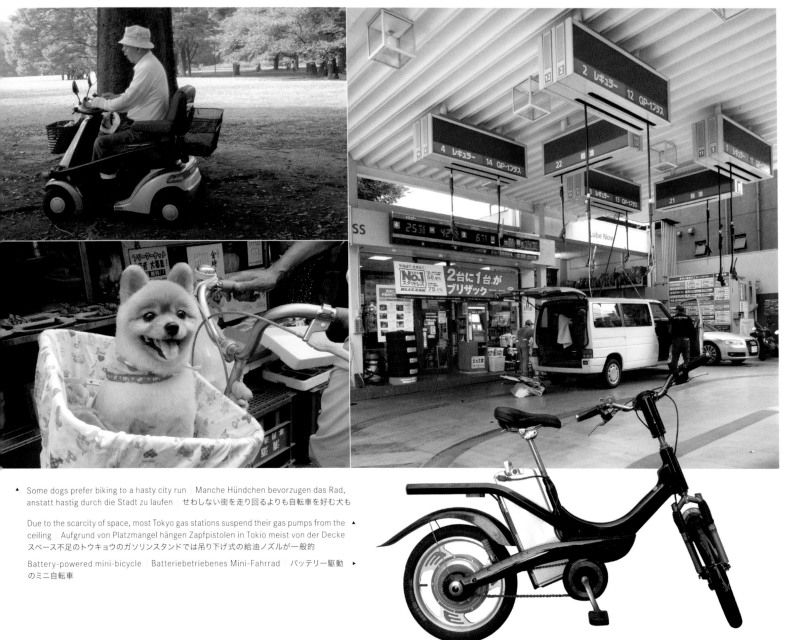

▲ Some dogs prefer biking to a hasty city run │ Manche Hündchen bevorzugen das Rad, anstatt hastig durch die Stadt zu laufen │ せわしない街を走り回るよりも自転車を好む犬も

Due to the scarcity of space, most Tokyo gas stations suspend their gas pumps from the ▲ ceiling │ Aufgrund von Platzmangel hängen Zapfpistolen in Tokio meist von der Decke スペース不足のトウキョウのガソリンスタンドでは吊り下げ式の給油ノズルが一般的

Battery-powered mini-bicycle │ Batteriebetriebenes Mini-Fahrrad │ バッテリー駆動 ▶ のミニ自転車

Tokyo Clash. Japanese Pop Culture

© **2010 Tandem Verlag GmbH**
h.f.ullmann is an imprint of
Tandem Verlag GmbH

Concept, text, images, and layout:
Ralf Bähren, Cologne
Translation into Japanese:
Kaoru Tagawa, Tokyo
Typesetting:
Akari Luig, Ralf Bähren, Cologne
Cover design & illustration:
Ralf Bähren, Cologne
Editing:
Yoko Otsuka (Japanese)
Carl Caulkins (English)
Claudia Bähren (German)

Project manager:
Isabel Weiler
Overall responsibility for production:
h.f.ullmann publishing,
Königswinter, Germany

Printed in China

ISBN 978-3-8331-5699-1

10 9 8 7 6 5 4 3 2 1
X IX VIII VII VI V IV III II I

If you would like to be informed about
forthcoming h.f.ullmann titles, you can
request our newsletter by visiting our
website (**www.ullmann-publishing.com**)
or by emailing us at:
newsletter@ullmann-publishing.com.

h.f.ullmann, Im Mühlenbruch 1
53639 Königswinter, Germany
Fax: +49 (0) 2223 2780 708

ありがとう
a　ri　ga　to　u

Thank you | Danke

Hide Tsukishiro for his hospitality and help in Japan
Akari Luig for loving support and additional photography
Minja Toeniges & Matt Romaine for company and input
Max Hodges for the great insights into Kabukicho
Yoko Otsuka for proofreading and creative input
Sean Peron for creative input and valuable comments
Melanie Huland (p.108) and Brit Leissler (p.171) for
additional photography
All Japanese Designers for their inspiring work on the
featured products, posters, signs, and artworks.
All others who accompanied me during my stay in Japan
and provided valuable insights
Bodo von Hodenberg for his professional encouragement
Isabel Weiler and the crew at Ullmann Publishing for
their patience and straightforward support
My parents

All photography was shot with Ricoh Caplio GX100